It's Good For You

ORLA
KELLY
PUBLISHING

by Adrian Wistreich

Orla Kelly Publishing,
27 Kilbrody, Mount Oval,
Rochestown Cork
Ireland.

Contents

Chapter One: It's Good For You i

Chapter Two: Stan 1

Chapter Three: Ellen 35

Chapter Four: John 93

Chapter Five: Preparing for the Flood 117

Chapter Six: The Party 128

Chapter Seven: The Rains 142

Chapter Eight: The Ark and the Flood 166

Chapter Nine: High Water 176

Chapter Ten: Riding the Storm 186

Chapter Eleven: Dry Land? 200

Chapter Twelve: Janice 206

Chapter Thirteen: A Pork Pie 212

Chapter Fourteen: Rising Waters 220

Acknowledgements 237

Other Books by Adrian Wistreich 238

Please Review 239

CHAPTER ONE

Stan

During his PhD, Stan's brilliant work on computer modelling and genome research helped his college raise substantial commercial funding, and he worked closely with some of the best minds in AI and genome mapping. Richard Vaunt, an economics graduate with a fascination for multivariate analysis and modelling was one of his closest colleagues, and together with Art Bellingham, a geneticist, they built an economical mapping technique, storing the individual's genome information on an implant, about the size of a rice grain. The prototype chips were implanted in a colony of mice which allowed the team to study group behaviour and breeding choices in real time, simply by tracking the output from the chips, without having to disturb the colony or intervene, other than to map and chip new-born mice. This became a chore which they could delegate to a team of postgrads, and by the time they began to discuss a commercial future together, there was a readymade pool of recruits who couldn't get enough of their expertise.

They didn't publish their findings, and they resisted taking commercial funding for their research, but instead, Stan drew down his inheritance. He could have used his hacking skills to acquire criminal assets, but had already agreed with himself that his future lay in legal power, not organised crime. Stan, Richard and Art formed their partnership into a company called Genomica, with Stan's money, and he had the sense to demand a controlling interest. The business moved to London within a year, to a highly secure warehouse in an industrial complex in Vauxhall. By 2025, Genomica employed sixty people, and Stan had patented both the genome chip and the concept of the Probability Quotient for Healthy Offspring. It took six more years of hard graft and advancement of AI to bring Genomica to a suitable point for launching mass market mapping and chipping for humans.

The business was set up to market healthcare services to high-end private insurance policy holders looking for real-time healthcare support. Those with heart conditions, diabetes and especially the wealthy elderly bought into the concept as an on-board personal alarm, and Genomica set up supply arrangements with several healthcare contractors offering call-out medical services. Once that business was generating good returns, Richard began working on a set of algorithms to correlate the genome data for any two people, to establish what factors led to healthy offspring. Art wasn't sure about this line of research.

"So, Richard, you're becoming an advocate of eugenics now? Do you have us breeding to order in future maybe? You and Mengler would've gotten along well."

"Come on Art, that's a bit rich, coming from the great nature over nurture advocate. We all know that the combined genetic code of two parents affects health in children, don't we? And we all know that the healthcare industry depends on keeping people healthy to minimise their bills. And the healthier someone is, the less they cost the insurance industry. What we need is a way of predicting the sort of children two people might make by creating probability scores for health and combining them. I'm not talking about controlling who breeds with whom. Simply helping the industry to better understand the factors which lead to healthy offspring will allow them to promote better choices."

Richard was the sort of creative coder who understood the dynamics of probability. He was completely naïve about how his work might be seen though.

"Yes, Richard. That's an interesting idea… for colonies of mice. But when it comes to people, there are so many other factors which affect health – wealth, environmental conditions - all the 'nurture' factors." Art's anthropology research was well known to the Directors.

Stan had been listening in silence. They often had three-way informal brainstorming sessions in which he dominated decision-making because

of the company finances, but this was a rare occasion when he was feeling expansive about new research, since Genomica had an unhealthily large deposit account which he was keen to see doing more work.

"OK Art, we know it's not two dimensional, but if we identify the key environmental drivers, and we can measure them, we can build a model which predicts good parents. Perhaps the chip can collect environmental data and we can set up an algorithm which puts it all together and forecasts the health of the children. Isn't that what you're thinking about, Richard?"

"Yes, that's exactly what I have in mind. I've been playing with the idea. I want to spend some time on it, and see what can be created. I know it sounds a bit off the wall, but I'm thinking in terms of a biometric dating agency."

Art's mouth fell open and he started rolling his eyes.

"Oh for God sake! Are we really going to move from the healthcare industry into the dating agency business? You'll need to give me a lot more meat on that one before it gets my vote."

"OK, just bear with me while I put some meat on those bones. I'll come back to you both once I've gotten a bit further with the idea."

Stan sat quietly, doodling on his tablet. He had a bit of a smile which Richard thought better of questioning. He'd often challenged Stan and been put back in his box, and he knew that if Stan was smiling, it was because he had some clever idea. Richard glanced across at the screen in front of Stan and read upside-down the word Gene-match, which Stan was busy turning into some sort of a logo.

Richard spent a week in his office, coding, and when he next emerged to talk with Stan, the business model for a sort of dating service, called G-Match was already evolving in Stan's mind. They agreed to go ahead, despite Art's concerns, and Richard developed the algorithms which would serve that business opportunity, while Stan talked to potential investors, like Strasbourg Insurance.

It had been a roller coaster for a long time, and Stan, who wasn't a man at ease with himself or his surroundings, was a hard boss. He'd struggled and fought his way to the top of his field, and had always been treated as the outsider by academics, as he had by most of the stiff upper lip Brits he dealt with, and their politicians. Genomica was considered to be a somewhat arcane science research house until the team decided to present their genome chip in the business press. The Minister for Health picked up on the opportunity, and mapping was suddenly in the spotlight for potential defence contracts, mass-market modelling and manipulation, political support services and the like. Genomica would be able to fulfil many functions for government which would save money, and put problems at a remove for the politicians. It could become a backbone supplier for the UK's right wing strategies, or it could plough its own furrow. Stan resisted invitations to tender for government contracts while the development work on G-Match was at a critical stage, but he knew there were huge rewards for fairly simple data manipulation and sharing of tracking information on large groups of people. The problem was the bureaucracy involved, and the loss of control which the contracts entailed.

Compared to his experience of central control and totalitarianism in Russia, Stan found the British way to be far too soft and woolly. He wanted quick decisions about contracts, and he wasn't interested in competitive tendering or non-competes. Already Genomica had some exclusive and ground-breaking algorithms in its portfolio, and rapidly increasing databanks of personal biometric and behavioural data, and Stan began to realise that if he wanted things his way, he needed to exert his influence more. Decisions were being made behind closed doors, in corridors of power, through the old boy network. Unlike the Politburo and the Kremlin, which was rigid and predictable in its decision-making, Britain's democratic process was a messy game of chess in which party politics, electioneering and favours played a huge part. The game was more subtle and required a less confrontational approach than he had appreciated. In order to play, you needed to host soirees and attend social functions, donate to charities and be seen with an attractive partner on your arm.

His social status had never featured as a priority in Stan's life, and since he'd left home fifteen years ago, he'd made no real friends. If he bothered to think about it, he had only colleagues and adversaries. Though he didn't envy his colleagues, their superficial relationships, the sort of social circles he saw Richard and Art indulging in, Stan knew he had to try and create a front for himself. Art had friends among the Cambridge academic fraternity, went to classical concerts and took tea in the houses of Dons. He was dating a young lecturer in Sociology when Genomica moved to London, and he opted to work remotely from a village in Suffolk, travelling less and less to the London office. Richard was already married, to a woman he'd met in Cambridge, and they had a ten year-old son. When Genomica moved to Vauxhall, Richard and his wife bought an apartment in Clapham. Stan never made the effort to socialise with them, even though they were kind and generous and often asked him over to parties and dinners. He rented a one-bed in Stockwell, so he could walk to work, and was rarely at home during those first years, choosing instead to sleep on a couch in his office, or to work all night in the lab, checking on the mice or tweaking the implant software. It was there that he started sleeping with one of the technicians, because she was happy to oblige, with no strings attached, and then with another and another. It was more a matter of convenience and physical need than an interest in them as people. He had a reputation for starting into the Stolychnaya once the staff had gone home, not to get drunk, but to help him concentrate. Whenever he invited a late shift technician to share his couch, it was clearly for sex and nothing more. He rarely made any effort to engage in conversation with his sleeping partners, several of whom had dreams or aspirations to become more than a quickie to the boss.

Mary Greenham joined Genomica quite soon after the move to Vauxhall, in 2022. She'd been working for the Dolby labs in Stockwell, and had read about Stanislav Janekowski and his amazing new business in Wired. She had a Masters in computer science and had aspirations to become a coder. As soon as she saw what Stan was doing with the genome chip, she wanted to work for him, and took the first job they posted on

their website for which she was qualified: administrator for the G-map marketing roll-out. If anything, she was completely overqualified, given her academic background, but accepted the role because she hoped it would lead her closer to the awe-inspiring Stan. She worked long hours and was ignored by the scientific team, being seen as a clerical worker or at best a marketeer, even though she was responsible for tens of thousands of people's mapping and chipping procedures across the country.

Mary was fascinated by Stan, and sought out staff prepared to talk about him. She had studied his work online as far as she could, but working at Genomica helped her to realise how mercurial he was as a leader and how creative as a systems architect. There were very few senior managers working with Stan, which was partly because the company had grown quickly in the labs and behind the computer screens but was lagging behind on infrastructure. Though Mary was quite junior in her marketing role, there was no Marketing Director to report to and Stan seemed to make all the decisions on expenditure. Her head of department, Marek Orbinski, was mainly involved in PR and damage limitation over leaks and rumours about what Genomica was doing. It wasn't long before she found herself in meetings with the chip roll-out team and Stan would drop in to listen.

"Doctor Janekowski, can I introduce the new head of marketing for G-Map, Mary Greenham?" said Marek. "Mary is going to handle our advertising spend and recruitment drive, and she'll be administering the regional roadshow."

"Yeah, fine, Marek. It's up to you who you hire, but I want you to stand over the roll-out figures, and I want them updated daily on the system. We need to hit 100,000 in the first three months and a million by the end of the year. Is that clear? You're in charge, so it's you I hold responsible. Mary, is it? Make sure you're on top of the roll-out. We can't afford to let anything slip here." Stan didn't look at her once during the exchange, and as he got up to leave the meeting, he glanced only briefly at her before answering his Nimbus. After he'd gone, everyone breathed an audible sigh of relief.

"Wow! Is he always that blunt?" said Mary. "It's a crazy target to meet unless we spend a lot on marketing. Can you do anything with the PR to encourage sign-ups, Marek?"

"We're going to open up the chipping service to security companies and the armed forces, which will immediately ramp up the numbers, and there are discussions between Genomica and the Tories to see if it can't become obligatory for all public sector workers to be G-mapped. Don't worry about the roll-out, Mary. Just keep up and it'll become self-fulfilling."

Mary thought Stan was unfriendly and far too intense to be running a company, but he commanded such respect from everyone and was so indifferent to the status of anyone important in the public eye, she found him strangely attractive. A week after their first meeting, Stan walked past her desk at 8pm, carrying a bottle and two glasses. He beckoned her to follow him to his office, where he poured out the neat Stolly. She agreed to have sex with him after her second glass of vodka, which she had gulped down while trying not to be sick, because he asked her outright and she liked that. It was all over in twenty minutes and he left the room to wash. She was clearly expected to leave before he came back.

He usually found her at her desk after the other staff in her department had left, because she was working all the hours, and because she wanted it that way. He liked Mary more than the others, because she was open and bright, and because she was both kind and attractive. By 9 pm, he was usually eating a takeaway which he invariably ordered from the local Chinese, washed down with neat vodka, and they would sit across his desk from one another without talking. It wasn't that Stan thought she wouldn't understand what he was thinking about, though she might not, but that he couldn't be bothered to explain himself to people and was completely used to working out his plans alone. Mary would share his takeaway, but after their first encounter, she refused the drink as she thought neat vodka was one of the most revolting drinks imaginable.

They'd been sleeping together over a couple of months when she came to his office late one Friday evening.

"Could I have a word with you Stanislav?" she was standing in the dark doorway to his office where only one Anglepoise lamp shed light on his desk.

"Not now, Mary, I'm busy."

"It won't take long. I wanted to let you know that I'm pregnant. It is yours. I don't expect you to participate in any way, but I wanted to tell you that I have decided to keep the baby. It will be born in May."

Stan stopped reading and looked up, expressionless. He stared blankly at her face and her abdomen and then smiled slightly.

"Thanks for letting me know, Mary. Let me know if you need anything. You know, stuff for the baby, money, somewhere bigger to live or whatever? And do call me Stan, can't you?"

"OK, Stan. Bye."

Mary hadn't expected some declaration of love or even an argument about whether to have an abortion. She had at least expected him to be surprised or interested, but as soon as she stepped back from his doorway, Stan had his head down in his papers again.

A week later, he called her in the middle of Monday morning to come to his office. She expected it was to review the latest sign-up stats for mapping candidates and went armed with the latest figures.

"Hello, Mary. I wanted to have a word with you about... well, about our child." Stan was still reading his computer screen which clearly had some work on it.

"Oh really? I didn't think you were interested." Mary was quite irritated by this off-hand summons, but Stan seemed to want to talk about his role as a parent.

"I don't know what gave you that idea, but if I have been distracted,

my apologies. I have been thinking that we should legitimise the child and marry. What do you say?"

Mary sat down in the visitor's chair and stared at Stan. It was so completely unexpected, and given his distant approach, she found it impossible to consider that he was expressing any feelings by proposing.

"Well, I have to say 'why?' I don't understand what your motives are, and I would prefer to know before I decide. I assume you're being serious."

"I'm completely serious. I'm proposing we get married because you are single and I am single and we will have a child due in May. I'm a Russian citizen as you know, and you're British, according to your HR file. Genomica is growing quickly and its future is very exciting. I should like to have someone to pass on my shares to, and I think you would also be someone I would be pleased to spend more time with. If we were to marry, you might like to consider moving. I certainly would have no objection. I should be entertaining more, which is impossible in my small apartment."

"And what are the foundations of our marriage going to be? You are widely considered to be unemotional and driven only by success. Should I assume that you have no feelings for me and that you see this proposal as some piece in a jigsaw puzzle? Do you think that you should be married and that I might as well be your wife?"

"I haven't tried to analyse it in any detail. I do know that I would like to pass on many things to my offspring, and to usher someone into the world that I am helping to change. If you are looking for a declaration of love, I'm not the right person for you. If you would like to be part of my world, and to have our child brought up with every opportunity and privilege, I can provide those."

As usual, his offer was succinct, honest and uncluttered, which Mary liked. So she agreed to marry Stan, without any pre-nuptial contract, and without expectations of passion. Then she agreed to move to a large house in St John's Wood which she chose and Stan paid for with the proceeds of

one of his many new contracts, one in which Genomica would assess the impact of ethnic cleansing in the West Bank on the Israeli economy.

He didn't bother to visit the house until Mary had supervised a complete refurbishment and shopped for everything she could think of needing, using Stan's credit card. Stan chose to marry Mary as much to get his UK passport as to legitimise the birth of their daughter, Jade, and even though he'd said nothing to undermine their plans, Mary was disappointed. Part of her wanted the sort of romantic basis for her marriage that her parents had had, but she was a scientist and a realist. She believed that making a good team was more important than being dreamy-eyed. Stan might be a bit of an automaton, but he was a reliable man with a huge drive to build for the future. The papers were filled every day with begrudging commentary on Genomica's approach to controlling everyone's lives, and scaremongering articles on Stan's increasing power over governments. Mary understood what Stan was driven by, and it was neither money nor absolute power. He wanted to make life better for people, and rather than try to do that by charitable good works or advisory waffle at strategic conferences, he preferred to apply his unique intelligence and skill to engineering improvements. Genomica had set out to conquer medical administrative inefficiencies which had brought the health service to its knees, and to try, through predictive techniques, to streamline the health supply chain.

In their first year together, following a quiet registry office wedding and no honeymoon, Mary lived alone most of the time, as Stan failed to return from work most nights. She knew he was ensconced in his office with his vodka and she thought he was probably inviting one or another of the burgeoning development team into the inner sanctum for sex. Certainly, as she became more obviously pregnant, he showed no interest in maintaining their intimacy.

On the few occasions when they spent an evening together, and even fewer when they could spend that time without others present, Mary wasted no time in small talk.

"I heard from Marek that you've been building a central processing unit to try and match couples who would produce healthier children. Is that right?"

"Actually we had this plan some time ago, but it is only now that we have the information flow from the chips, we are able to demonstrate that the probability quotient algorithm which I developed can recommend matches which would result in fewer unhealthy progeny. It can also process risk factors arising from behaviour outside the norm."

"Like what?"

"In theory, anything which affects a person's safety, or their likelihood to endanger others."

"Are we talking predicting criminal activity before it happens, like in that old Tom Cruise film, or is it more about tracking someone as they break into a bank vault and alerting the police?"

"Yes, both, and so much more. But I sense you're not doubting my ability to make this possible, Mary. You are doubting whether it is a good idea. No?"

"Stan, my dear. I know you well enough to know that anything you have spent a lot of time on is possible. If it wasn't this, it would be interplanetary migration or nanobots or something. But you're right, I am concerned about the way this will be used, once you unleash it. I trust your own motives, but not those of many of your clients."

"I have considered not only how I will make use of this but also how others would like to use it, should they ever have access to it. I have become more aware of this now that Strasbourg Insurance is taking over Genomica. It is a global corporation with shareholders whose only interest is in maximising their return, as all these organisations are. While I had a controlling interest in Genomica, I have relinquished that to gain the investor, and of course it makes everything somewhat harder to protect. I

am now a substantial shareholder in the parent, and I have full control of the approval process for integrating the IP with other Strasbourg services, or how it is made available to others. According to my investment advisors, I should be pushing this new product into every tin-pot dictator's hands. However, if you know me as you say, you will know I am not interested in maximising my financial return, and I would not dream of helping to ruin the world by making this powerful tool available to others. It is, for me, about maximising the advancement of our wellbeing."

"So, is G-Match some kind of dating service, or are you looking at a eugenics programme to create a race of super-humans, Stan? Or are these two compatible objectives?"

"Ah Mary, you are always considering that I am some sort of master manipulator. If I wanted to create super-humans, I would be spending all my time in the CRISPR laboratory, meddling with chromosomal editing. This is more about offering people help with their choices. You know, like Nimbus always said 'people who like this book might also like that book.' So I say if we can guide people towards those with whom they can make good babies, we can save them many mistakes, and much wasted time."

"You mean like me and you?"

"We did not make any plans for our match, Mary, as I recall. You and I could be said to have fallen into that together, and the result is Jade. But I can already tell you that her biometrics are excellent. Well above average. I would say that G-Match might have paired us anyway."

"Perhaps your algorithm would pair us to make Jade, but would it pair us as compatible for each other? Does it try to do that? What does it use for compatibility?"

"You ask such good questions. In fact, I did not dictate the factors. The data streams on which it relies are multiplying, and it chooses the most potent ones. Richard instructed the algorithm to process the probability quotients of those who have been partners for a long time, and compare

them to those who have not managed to stay together for very long, and to find what factors differ. So far, we only have a short historical profile for adults, based on the early adopters of G-mapping, which, as you know is just two years old. Even within this short time period, for the 2.7 million users we have already monitored, we can see patterns emerging. Within a few years, we will have much finer historical data for adults, and just imagine when Jade is a young woman and is beginning to date, how much easier it will be."

"So is it all about lust, or is there a biological basis for attraction, based on biometrics, behaviour, attitudes, family history?"

"All those factors, and geo-demographics, and economic status and let us not forget good luck."

"I doubt very much if you ever believed in luck, Stan."

The Janekowski family were originally tenant farmers without any of their own land. Throughout the nineteenth century, they'd been tenants of a minor noble landowner with several farms and forests to his name. They had been given their smallholding after the revolution, as part of the Stolypin land reforms, and after their landlord had been taken out by the Bolshevics and hung from a tree. Stanislav's grandfather, Dimitry, was brought up on their farm as a Kulak when his father opted to fight against the taxes imposed by Moscow. The small-holding of just twelve hectares had expanded to over fifty because Dimitry was a shrewd negotiator and a bully, and rose to power in his local community by extorting other farmers of their smallholdings and aggregating his estates into a tight little empire. Stalin's men eventually confiscated the land, but by then, Dimitry had moved his money to the Ukraine and established himself as a timber merchant under an assumed name, in Lwow. Stan's father, Alexei, and his two brothers were all educated at the Kronenberg High Business School, and all three joined their father in the timber business in the fifties. The

business continued to supply timber to the Soviet authorities, though it had been decimated by the Nazis and was the subject of a compensation claim settled in the early sixties when Dimitry was paid off. Alexei returned to Moscow to rebuild the timber business, and to marry, and by then was able to take back the family name of Janekowski without recriminations. Alexei and his wife, Anastasia, had eight children, over twenty eight years, seven of whom survived. The oldest boys went into the timber business after their military service, and the girls married well. Stan was the youngest, born in 1988, five years after his brother Yaroslav, and a late surprise. Anastasia spoiled him like a pet, and Alexei, already retired from the business, spent all his time and plenty of money indulging Stan's interests. He'd been born into a middle class household with academic aspirations. His father had driven the older siblings into vocational training, but by the time Stan came along, he was given a much wider choice. Russia's special schools for gifted children had been established in the late nineties, and Stan was encouraged to apply. He was extremely capable at mathematics, chemistry and biology, and his inclinations led him into the burgeoning computer programming field. The school had a computer club, internet access and a visiting expert in programming to teach the children.

Stan wasn't interested in girls and dating, even though he didn't fit the classic profile of nerdy teenager. He spent his spare time building toy robots and playing with radio controlled cars, with his aging father watching proudly.

He matriculated top in his academy, and gained a scholarship to study at the National University of Science and Technology Institute of Computer Science and Economics, which had become well known across the region as an incubator for technical talent. During his first undergraduate year, he learned to programme in Visual Basic, Java and PHP. By the time he graduated, with a First in computer science, he was considered by his professor to be the best C++ programmer of his generation. He was snapped up by GRU, the Russian Intelligence Directorate which supported the Russian military and hosted a number of informal cybersecurity operations.

Stan quickly found himself working for Fancy Bear, a Russian hacking outfit backed by GRU, and in the five years he spent in Moscow, he hacked government information sites across the world, pulled contact emails of thousands of politicians and financiers in the west, and delivered threats to powerful people on behalf of his bosses. He wasn't the sort of person to do what he was told unless he saw some benefit to himself, and he decided it was worth being there, to build up an in-depth understanding of both who was important in political and economic circles in Russia, the US and Europe, and to learn how to manipulate large databanks. Moscow was not keeping up internationally with artificial intelligence research, and Stan felt that the obsession with military robotics which the GRU had was boring. GRU's Automated Weapon Systems division wanted him to work on its incipient drone programme, which he did for a while, but Stan wasn't interested in using his skills for war. He wanted to be rich. Moscow had become impossibly expensive, and his colleagues ridiculously materialistic and competitive. GRU paid unexciting wages, and Stan began to supplement his income through hacking. He tried most methods, from card phishing to hacking his bank account to alter the credited sums. It wasn't as challenging as he'd expected, and nor was it fulfilling. Stan realised that he wasn't happy unless he'd earned his money fair and square, and preferably doing something so difficult that only he and a few others could appreciate it.

In 2014, aged 26, he had had enough of hacking and processing data, and he was interested to learn more about AI, and to expand his horizons beyond computing. He was beginning to feel more under surveillance from the West than from his own bosses, and he knew that Moscow wasn't the place to build a career. He decided it was time to leave Russia and try to find his niche overseas. Using his hacking skills, he managed to book himself a flight to Johannesburg under an assumed name, and to order a passport for the new person. Once he settled himself in a downtown apartment, courtesy of funds transferred from a fictitious Russian bank account, he threw away his return ticket and concentrated on how to expand his education. He enrolled for a Masters in bioengineering at Witwatersrand,

having studied the subject online, and subsequently won a scholarship to Cambridge for a PhD, electing to study genomics, bio-informatics, neural networks and AI, working between the computer science department and biological sciences. Moving from Russia to South Africa had been a culture shock, and involved a crash language course in Afrikaans and English, but moving from Johannesburg to the sleepy city of Cambridge in England was more like interplanetary travel.

During the months that Mary was pregnant with Jade, Genomica, already involved in due diligence with Strasbourg, managed to push through proposals to have all babies mapped at birth. This became a legislative issue, and one which would influence voting in the upcoming general election. The news media focused on the dangers of universal monitoring, and the Tories focused on the huge cost savings which might come from knowing in advance of potential medical and security problems. Labour saw only the implications of greater use of AI in terms of job losses, and under pressure from the collapsing unions, which were prepared to throw everything they had at the redundancy and universal income debate, were campaigning on the need to curb AI, and to minimise access to personal biometric data. It was going to be a showdown between the traditionalists, who were being branded luddites by some, and the Brave New World Conservatives. For years, the right had been trying to reposition itself as the party of the future, and Stan's AI had given them the chance to do so. Anyone with money wanted to see cost savings and greater centralisation. The self-employed who had built their businesses on limited government intervention were supportive of the proposed easing of severance terms, and welcomed the dramatic reductions in their costs through adopting AI. Automation in catering and deliveries, cleaning, waste disposal, recycling and small-scale production was revolutionising the way people did business. Everyone had 3-D printers and packaging was created on demand, along with paper and plastic products, clothing, household items and office furniture. Small biomedical developers were printing medicines to order, and saw the G-map chip as manna from heaven, so long as Genomica-Strasbourg would allow them access to the data.

The Tory party was ready to force all maternity hospitals and clinics to acquire mapping equipment from Strasbourg, and to warrant that they would conduct the chipping process within three days of birth on all newborn babies. The digitisation of birth certificates was introduced at the same time, so all children born in the UK were registered and chipped. Immigrants with children were all required to be G-mapped and chipped as part of their visa application process. A land-slide Tory victory was going to allow the Home Office to force through these changes, and that gave Stan some bargaining chips in the negotiations. By the time G-mapping became obligatory, Stan agreed that the copyright in tracking data would belong to Genomica, rather than supplying the service under contract to the government. It was a crucial turning point in the company's fortunes, and formed the centre-piece of the valuation of Genomica in the Strasbourg sale.

As Marek had predicted, the programme for mapping grew faster than anyone at Genomica could have predicted, and without the sale to Strasbourg, the costs would have been unsupportable. Marek was now heading a team of sixty people, backed up by a sophisticated computer service which logged all genomes, compiled datasets from the continuous feedback sent by chips, and fed everything to Richard's Probability Quotient algorithm. Once Strasbourg brought its might to bear on the Genomica phenomenon, the volume and value of information grew exponentially.

When Mary went into labour, the maternity ward administrator sent messages to the numbers she'd been given for Stan, but for several hours he wasn't accessible. He was finally tracked down in meetings at the MoD, which he didn't choose to curtail, and it was late evening by the time he visited her in The Portland. He stayed barely half an hour and he visited only once. He seemed charmed by Jade and moderately interested in Mary's experience, but after a short time in the room, he began to fiddle with the pieces of equipment he found there, and as soon as he was able to find a doctor prepared to give him some time, he wanted to know all about the information on mothers and babies provided by the monitoring

machines. He also became fascinated by the incubator room where about twenty new-born babies were in their cribs, all monitored centrally. Within a week, Strasbourg had a team building econometric models for robotic incubator centres and a suite of new medical support services for private maternity units.

Mary told Stan that she would like to return to work for Marek and to hire a nanny for Jade, but Stan didn't support that idea, instead insisting that she stay home. Fighting him was like moving granite, and even though Mary scanned the job ads, planning to circumvent Stan's control over her re-appointment in Strasbourg, she knew he would have a hand in stopping her being employed elsewhere too. Coding jobs were becoming hard to find, as AI had developed, and Mary's skills were already rusty. Even her original job of administration had been completely automated, with chip readers in birthing units delivering full profile data direct to Strasbourg's database without human intervention. As for marketing the G-map project, that had fallen by the wayside now that the compulsory birth certification was in place. She wanted for nothing at home, and Stan was happy for her to employ a nanny regardless, provided he could vet their scores before Mary hired them.

Jade was G-mapped and chipped, along with all the other babies, but unlike any other baby, her chip reported direct to Stan's computer so that he could monitor her vital signs at any time. He could pinpoint her location when the nanny took her out for a walk or to visit people, and he liked to have her ECG trace in the corner of his computer screen while he was working. It wasn't until two years later that adults and older children were gathered into the G-mapping programme, and Mary, along with everyone else in their circle, became trackable. Stan could, if he wanted, monitor her biometrics, location and various aspects of her behaviour simply by logging into her chip. This was something he didn't have the time or inclination to do, but later, when they were going through the divorce, historic analysis of her chip feedback became the evidence he needed. Had Mary wanted evidence of Stan's infidelities, she would not

have had access to his records in the same way, because Genomica owned the data, and besides, Stan was one of the small inner circle of VIPs who could switch off their chips at will.

Ten years later, out of boredom, loneliness and anger at Stan's indifference, Mary began an affair with a Labour politician who showed her more attention and consideration than Stan had ever done. Stan hadn't even tried to hide from her his string of sexual liaisons which, as far as she could tell, hadn't abated at all once they were married.

Morgan Edwards had been in line for the cabinet in the '34 election, which Labour had lost by a mile, and it was in the run up to that election, before the defeat, that he'd been invited to one of Stan's famous parties in St John's Wood. Mary hardly knew about these events before they arrived, as Stan's private secretary and current sexual partner, Genevieve, organised everything from invitations to caterers. Mary was usually side-lined, and expected to make sure Jade was off the premises for the night. The parties usually brought together senior members of Genomica and their key suppliers and clients with influential politicians and investors. At the time of the party, Morgan was still considered to be in a key position if Labour were elected, and he was happy to attend one of the legendary bashes. Mary and he had met several times at conferences and larger presentations when she was at Genomica, because he had been a supporter of the G-mapping programme when he was shadow health minister. Mary had been responsible for presenting the roll-out at various pitches. At the last such all-party committee hearing, at which Stan presented, Mary was the sidekick, sitting just behind him, ready to pass her tablet to him with statistics he might need, or to swipe images to the main screen as required.

Alistair Prim, the incumbent Home Secretary, was chairing the meeting which had been called to discuss funding for the G-mapping roll-out, prior to the introduction of compulsory chipping at birth. The Tories were gung-ho for it. They wanted to use the new services to supply police with criminal profiling, location tracking and 'known associate' reporting, but they didn't want Strasbourg to own the data.

"Dr Janekowski, can you explain to the committee why you've provided a menu of charges for these services, as though Strasbourg was some sort of restaurant? I think I speak for the Government's concern that the data you are offering us would be in private hands, given the importance it has to national security. We have terror cells operating in the capital which we have struggled to monitor effectively, and the G-map project, which we have given our full support to, will help us to keep the country safe."

Stan continued to draw small doodles on the tablet in front of him, without looking up.

"I'm sorry, Dr Janekowski. Am I boring you? I think the committee would like an answer to the question."

" Mr Chairman. I forgot the question when you began the party political broadcast. Are you asking why Strasbourg is offering a commercial service, or why the party you represent doesn't own the IP?"

"I am asking you to justify to this committee, which I would remind you is an all-party committee, why we should agree to your company controlling the single most powerful anti-terrorist intelligence this country has ever had."

"Mr Chairman, I think this committee fully understands why. Because I designed the G-map chip and Strasbourg owns the probability quotient IP, through its subsidiary, Genomica, and because we wish to offer you, as a client, the opportunity to buy our proprietary service, along with other clients such as the Saudi and Israeli governments, the USA and Spain. None of our products have ever been sold. We are simply licensing access to analysis and our consulting services."

Morgan Edwards caught Alistair's eye.

"Mr Chairman, perhaps I can intercede here?"

"Yes of course, Morgan." Alister looked as though he was sucking a lemon.

"Dr Janekowski. As I understand it, you are seeking the approval of this committee for the introduction of a bill which ensures compulsory G-mapping at birth for 100% of UK citizens and for compulsory chipping of all people entering the country on work visas, and for permanent residency applications."

"That is so." Stan smiled at Morgan, simply to annoy Alistair.

"And this bill will ensure that the health-watch service you have until now been providing to individual subscribers and private healthcare insurance holders, as well as other special needs groups, will become a universal service?"

"Certainly, if the government of the day chooses to subscribe to it on behalf of the people you represent. I don't mind whether it is you or Mr Prim there with whom I will be dealing in future."

"Yes, well that remains to be seen. And can I clarify with you that Strasbourg's quid pro quo for providing this health-watch service is ownership of the probability quotient IP, the data generated by universal chipping and the means of distribution of that data as a commercial asset?"

"I couldn't have put it better myself."

Stan returned to his doodling, as though the conversation was over.

"And what would you estimate this will cost the taxpayer in the next three to five years?"

This question came from the Chief Secretary to the Treasury, standing in for the Chancellor, who was fire-fighting a threatened general strike over the planned mass redundancies in education and the introduction of Universal Income for five million public sector workers deemed surplus to requirements.

"Mary, could you bring up those figures?"

Stan leant across to touch Mary's hand. It had been only a week since their first evening together, and he wanted to touch her, even though he rarely touched anyone in public. Morgan watched the gesture from behind the podium and wondered whether Mary was spoken for. Mary saw his look, and did not withdraw her hand.

Mary scrolled through the presentation she'd created for this crucial meeting and swiped a complex graphic to the wall display. Everyone turned to view it as the lights dimmed.

"The blue line is an estimate of charges we at Strasbourg would make to you for security modelling and tracking services, assuming current levels of activity in the market. You understand that I don't take any account of the sort of civil unrest which your boss is busy dealing with today, or the threats we have seen from a growing number of subversive hackers involved in cyber-attacks. This should be compared to the red line which represents our view of your expenditure on security services. As you can see it is declining as our costs are increasing. That indicates that the information we supply you will dramatically reduce the costs the taxpayer must bear for security.

The orange line is the healthcare cost per capita as it is now and taking into account our expected launch of upgrades to the PQ in the coming year. Even though this doesn't show the impact of a number of new initiatives we have been working on in terms of genetic engineering, you can see the dramatic reduction in per capita health expenditure. The green line indicates ... "

"Thank you. I've heard enough." Morgan was looking at Mary and Stan, and, "As far as Labour is concerned, the health benefits of the PQ are overwhelming, and the security benefits are, from your figures, cost-neutral. The more we can bring AI to bear on these burdensome overheads in the exchequer, the better we can serve the public in areas where they

need support, like education, cultural opportunities and so on. We will back the bill, and given the current concerns over Universal Income and rising unemployment, I would suggest, Alistair, that you've enough on your plate without blocking the introduction of this bill."

Labour's strong showing in the polls in the run-up to the forthcoming election made this declaration pivotal in the committee's decision to support the bill, even though Alistair Prim felt it was ceding too much power to Strasbourg. The Bill subsequently passed, and When Morgan became Shadow Home Secretary, after the election, he continued to keep in touch with Mary through Strasbourg, even though he had no need to be involved since Alistair was Strasbourg's client.

Now Mary wasn't working at the firm, Morgan hadn't crossed paths with her for a long time, until the party.

Mary had always enjoyed Morgan's attention, and when she got a glimpse of the invitations, she was pleased to see his name. Stan's motives in choosing the list were never completely clear, but he spent a lot of time briefing his team to ensure that the right people were drawn into the right corners together and recorded so that invaluable information could be gleaned.

By mid-evening, the canapes had been served, the buffet had been demolished and the massive fridge full of champagne was almost empty. Most people had switched to wine and spirits from the open bar in the dining room. The caterers had retreated to the kitchen and guests were spread throughout the house, in couples and groups, talking. Morgan and Stan's colleagues from the public sector evaluations team set themselves up for their discussion in the library during which he disputed Strasbourg's view that large numbers of police, teachers and local authority workers were now unnecessary, since their work was being done more efficiently and cost-effectively by AI. From Strasbourg's standpoint, it was a simple

economic imperative to remove waste and replace it with cost-effective machines.

Morgan's political stance was in defence of employees' rights, and at odds with the economic arguments which Stan's PR team had been putting in the media.

Stan's model for the introduction of Universal Income played into the hands of the Tory party, offering as it did the prospect of endless leisure time and unearned income for the redundant workers while taxing the multinational AI companies, including Strasbourg, which were delivering huge profits. Labour wanted to see limits put on redundancies and no privatisation of the NHS. The meeting got quite heated, fuelled by copious quantities of Stan's champagne, and when Mary came into the room, she found Morgan sitting with his head thrown back and a bloodied handkerchief held over his nose. She assumed that someone had hit him, and ordered everyone else from the room, only to find that he'd simply become over-excited and had had a nose bleed.

She took him into the cloakroom and made him take off his shirt so she could wash out the blood. Morgan's nose had stopped bleeding and he was drunk enough to stand behind her at the sink and rest his hand on her hip, making it eminently clear where he wanted things to go. She was a little surprised, and flattered, and after years of being side-lined, she decided to respond. Within minutes they were tussling in the small room, pulling off each other's clothes and having sex, with Morgan sitting on the toilet seat, and Mary straddling him and looking straight at a photograph of Stan and King William, at a polo match. She closed her eyes, as much to concentrate on her first orgasm in months as to blot out the image of Stan watching her. When they'd finished, Morgan dressed in his damp and wrinkled shirt and trousers, was about to slip out of the room ahead of her when Mary stopped him.

"Thank you. That was enjoyable, if a little cramped. Another time I would prefer a more comfortable location, if there is going to be another

time. Are you going to run a mile from me next time we meet? You know that Stan won't care, don't you? He was doing the same thing with half the women in Genomica long before I came along, and ever since."

"It was enjoyable, wasn't it? I've been thinking about doing that ever since that day in the Commons Select Committee when you caught my eye. No, I won't run a mile, unless you prefer me to keep my distance. Perhaps we could meet at my apartment in Westminster in future, though. I must say I do feel a bit uncomfortable continuing in the lair of the Prince of Darkness."

"Really? Is that what Stan's called in Westminster?"

"That's the polite nickname."

"We must share some of the others. Thursday evening? I'm supposed to be learning to play Bridge on Thursdays, but frankly, I've no interest."

"I'll make sure you know how to bid."

So Thursdays became something of a routine which Morgan and Mary both loved. They spent the first hour in bed, or on the sitting room floor, or up against the wall inside Morgan's front door and then Mary cooked for him, something she had missed out on with Stan, while they talked about politics and what The Prince of Darkness was up to. Once the election was over and the Tories were in power, Morgan had more time, and in opposition, was far more interested in holding Strasbourg to account. Mary passed Morgan any titbits she heard, or read about in documents Stan left on his desk at home, because she liked to see someone casting a close eye on Strasbourg's activities. It wasn't that she assumed Stan was up to no good. On the contrary, she still trusted his ethical values, even though she knew him to be heartless and unwavering. Morgan treated her and her leaks with respect, and became quite dependent on any information about Stan's plans which Mary could find for him. To check out what Strasbourg was doing, Mary spent more and more of her spare time, while Jade was at school, rekindling relationships with staff who had

moved from Genomica with Stan, whom she knew from her time there, to find out more. Since she was the boss's wife, she had to be careful, and never tried to be heavy-handed with her ex-colleagues in case her questions were relayed to Stan. She even agreed to open a private v-mail channel with Morgan so she could send him files she managed to access, and so they could message one another while he was sitting through boring debates.

Richard Vaunt became central to the Genomica business as soon as he'd written the most elegant algorithm for the PQ score. Stan always tried to keep up with Richard's coding, as well as running the operations, but as time went on, he just wasn't able to. Richard wasn't over-protective of his work, and always provided copies for Art and Stan, so when Stan negotiated the sale of Genomica to Strasbourg, Richard's work became part of the valuation. It was easy for Stan to assume ownership of the work when he supplied a copy to Strasbourg's Director of Technology as part of the due diligence.

"Dr Janekowski, your work is tremendous. This algorithm is the work of a genius, and in our view, justifies the price of the Genomica acquisition" wrote Geoffrey Grainger, CEO of Strasbourg. "The attached heads of agreement require that you assign the source code and all IP which you own in relation to this algorithm. Please confirm that you are in a position to do this."

Stan had begun putting pressure on Richard in a pre-meditated way when investors started circling the company, because Richard could have a claim on key parts of the source code for the product, and might slow down or challenge any deal. Stan was completely ruthless with copyright when it came to his staff, and had the coders on contracts which effectively meant he owned their souls, But Richard, as one of the founding partners, had never signed away his rights. Over the months of negotiation with Strasbourg, Stan made Richard's life difficult, demanding copies of the PQ algorithm be held on Genomica's servicers and nowhere else, and constantly changing security on the servers so that Richard had to ask him for passwords before he could work on his own code. By the time

the deal was tabled, Stan had forced Richard to sign over all his rights, or find himself locked out of the system. Richard agreed to sign, but not to continue his work, resigning his Directorship and selling his shares to Art and Stan at a nominal price. Stan had the lawyers pursue him with threats of litigation if he even considered using the software he'd developed for any other purpose, and he also used his considerable influence to make sure Richard didn't work again. The toll it took on Richard's health was terrible, and he became withdrawn and depressed. Within three years, he had died of heart failure, leaving his wife and son to manage on Universal Income. His son, John, was just fifteen when Richard died, but he was old enough and bright enough to read all the correspondence between his father and Genomica's lawyers and to know who had killed him.

Stan became an overnight celebrity when he sold NetCast an exclusive for the news that he had successfully developed a formula for adding twenty years' life expectancy to every generation. This wasn't strictly true, but it was a great headline grabber, since longevity continued to be the obsession of the wealthy, and ever-improving healthcare the obsession of the middle classes. For the rest, the growing morass of unemployed, it was all about cost savings. Richard's original PQ algorithm didn't link to health insurance – that came later – but Stan understood that the holy grail of longevity could be monetised, and that investors would bite his hand off to control the source code.

John Vaunt was still in school when Stan came out with that. Dr Janekowski was rarely out of the news, and nobody else in the company got mentioned. Given what Richard had told him in his last years, and the effort which Stan had gone to to keep Richard quiet, John concluded that the PQ algorithm was written by his father, not by Stan. Though he tried after his father's death to find a copy of the original code on his computer or held in the cloud, or on a hard disc in a safe, even though his understanding was very limited then, he was unable to. Genomica had been cute with investors and were able to fend off the first predators

while building the PQ and G-Match concepts and licensing the algorithms to institutions with deep pockets. But sooner or later, a strategic partner was inevitably going to take over—some behemoth with global reach and endless capacity.

After Richard left, most of the development work fell on Stan and Art. When the power of the algorithm became known, there were a lot of very heavy-handed military types hanging around, and Art became completely paranoid about being hacked. He began working from his bunker at home, off-line, and carrying his work on a hard drive wherever he went. He spent nearly all his time in Suffolk, and slipped further and further out of reach. It was clear that Art wasn't functioning properly any more, and Stan realised he had to find a replacement team to take on Art's work, because he was no longer able to put in the time to keep up to speed, and run the company at the same time. Art eventually hung himself with a computer cable, rather than open the security door to the imaginary hit squad which he thought he could see on his security cameras, stalking his property at night.

Nobody really missed Art, except Stan, because nobody knew that he was still involved in the core development, or even in the company.

The company began to build irresistible business models for using the PQ algorithms to predict consumer behaviour, and for use in war games, elections, migration patterns and anything else driven by trends in mass behaviour. Every indebted nation and highly leveraged commercial entity wanted to use its predictive capabilities to pre-empt costly decisions. Once the markets began to understand Genomica's power, the stock took off, the company was everyone's darling, and Stan was feted.

Stan negotiated his Board position as Director of Research at Strasbourg with the acquisition, and his Genomica stock was converted into Strasbourg shares, making him a multi-millionaire. At that time, the probability quotient took account of about a hundred variables, nearly all of which were biometric, and therefore unalterable.

But then Strasbourg began to build their models of insurance determined by PQ, and in doing so, expanded their algorithms to take account of all first and second level family ties. The weightings applied within the quotient had already started to develop a strong bias towards psycho-genetic measures. Once the government contracts came in, the marketing team at Strasbourg found that most of the requirements on the business were in recruitment and deployment of security forces. In the selective culling of state employment, decimating the numbers of teachers, medics, lawyers and local government staff, these factors were critical.

Vast numbers of public sector workers were identified as candidates for redundancy, and the PQ modelled the most cost-effective way to decimate the workforce. Stan took his new responsibilities at Strasbourg seriously and began spending more and more time with government ministers and opposition politicians. He started by wanting to have more say in how the business could serve their needs, and quickly realised that they didn't have any vision for the future. It would be possible to provide them with the vision and direct them towards whatever best suited Strasbourg's objectives. He was shocked by how easy it was to present and get approval for a model for social change which was driven by huge savings to government and huge profits to Strasbourg. He knew that these weak, short-term thinkers wanted only to get economic problems off their plates and into the private sector. He knew that the most costly elements of the budget were healthcare and social security, which encompassed policing, and so he began to work on an all-embracing strategy to take over responsibility and financial control in these areas.

"So, Alistair, what exactly would you need us to provide in order for you to award Strasbourg the universal income health provision contract? More wine?"

Stan was hosting Sunday lunch at home for The Right Honourable Alistair Prim, Home Secretary, and his wife Harriet. Alistair was a typically arrogant Conservative minister with a public school education, a private

income and a mansion in St John's Wood, right next door to Stan and Mary's place.

"Yes please, Stan. It is excellent, as always. And let me say I love what you've done with the house. We're considering a similar extension next door." Alistair rarely answered business questions directly, and never in public.

"Mary, perhaps you and Harriet would prefer to take a walk to the park or something? Alistair and I have some business to discuss."

Stan saw nothing wrong in dismissing his wife and Alistair's because he had little interest in socialising on a Sunday and would otherwise be locked in his office. Once Mary had cleared the table and the women had left the room, Stan offered Alistair a cigar and a glass of brandy and they took their drinks to Stan's study.

"Look Stan. I've read the submissions you made to the Cabinet on behalf of Strasbourg. I see there are strong arguments for the provision of a 360-degree service which incorporates preventative measures. You track people's health and you encourage them to continue being healthy, using the carrot and stick. You're already helping us pick suitable candidates for the security services, which is proving effective. You're also carrying out psychological profiling for all public sector staff which is definitely helping us to identify areas where we can reduce cost in the workforce, not to mention recommendations on deportations. That's already a lot of our eggs in your basket. Now you're asking me to recommend Strasbourg to the Cabinet for the contract to supply all healthcare services to UI recipients. That'd be several times as much work as we've already put your way."

"Yes I am, Alistair. You need to appreciate that we've already developed the model for optimising dietary supplements, at least cost, and we're working with Nimbus to ensure that the UI catering services deliver. We've re-modelled G-Match for the UI cohort, to minimise long-term cost. The PQ algorithm no longer prioritises longevity or maximum fertility for this

cohort, but emphasises minimising health costs. We've even looked at the Spanish situation where immigrants from Morocco have intermarried with Spaniards which has improved resistance to infections and UV tolerance. We've been assessing their situation with a view to strengthening the gene pool here and improving the resilience of people on Universal Income. Short of the enforced terminations which the extreme right elements are calling for, everything is going in the right direction."

"I know, Stan. You're right. It's all going in the right direction... on screen. It's just that the unemployed aren't on our side. They just don't seem satisfied with all their needs being taken care of. God knows, it's not as though they've got much to worry about. I'd love to not be working all the time. I just don't see why they can't enjoy having no work demands. When it comes to voting us back in, they're now a huge problem for us. We need to give them what they want, but we can't afford free education and recreation."

"These things take time, Alistair. You have to re-position peoples' expectations, then let them get used to the new reality, then they'll become dependent on what you're offering them. Look, fear of attack is a much stronger driver than the wish to be entertained. Hunger is a stronger driver than fear of attack, and sex is the strongest driver of all. So if you have a say in all the variables, you can manage expectations and hopes."

Alistair looked tired. He'd spent the week beating his head against the treasury wall, trying to get approval for an overhaul of the technology available to police in London, to control increasing numbers of homeless troublemakers, and at the same time had called on Stan to come up with ways of reducing civil unrest through his PQ model. He sat back and stared up at the chandelier, not realising that he was looking directly into the wide-angle lens of a security camera. Stan had been recording all conversations in this room ever since he and Mary had bought the place. The value of 'leverage' could not be underestimated in political negotiation, and Stan liked to hold all his private discussions with key contacts here at home, rather than in the more public space of the office or The Commons.

"OK, so back to UI. What numbers are we talking about, and how will your new PQ impact the subvention?"

"As you know, Alistair, the UK employment rate is running at a little over 25%, and UI provides for the other 75%, plus their families, which brings the total Universal Income numbers to 54 million. We forecast this will peak at 65 million by 2051, based on current trends in private sector employment, and assuming you get back into power for another term. The forecast assumes that you will be able to let go the majority of security staff once the PQ and security services AI are fully integrated next year. We should be able to minimise the need for physical interventions. I've even had a private look at using the chip to enforce security measures. We'd need to modify it to send a small electronic pulse to the brain, as well as collect feedback as it does now, and that would mean replacing chips for those who were arrested, deported or whatever. We could also institute a change for all new births which would allow penalties to be enforced remotely—temporary, or in more extreme situations, permanent penalties, using the pulse. I haven't distributed information on that yet, as I have to take it to the Strasbourg Board before I do. It's so tedious being part of a public company. Genomica was much more autonomous. I've been holding back on the process, because it didn't seem like a good time, coming up to the election."

"I have been reading the reports, and I must say I would be interested in that proposal, in due course, but you know that's not what I'm asking. I have a budget of £800 billion this year for UI, which is now five times the budget for health. You've got your fingers in both of those pies, and what you're giving us on healthcare savings, we're spending on incremental social security because your AI is helping us to lay off more and more people. And that doesn't include the increasing life expectancy rates. If half those people died at 80 or 90, like they used to, we wouldn't have such a big problem on our hands."

"That may be so, Alistair, but Strasbourg is still paying vast corporation taxes on its profits and the AI sector taxes we pay are designed

to underwrite growing unemployment. My fingers are clean when it comes to laying people off. You know that Strasbourg has under 2000 staff, and we haven't let more than a few hundred go in the last three years, while over the same period, since you got elected, you've been behind the stripping back of, what is it, seven and a half million local authority workers, teachers, armed forces personnel and healthcare professionals. And that doesn't take into account the net deportation and emigration numbers. The thing is, Alistair, you've always had my complete support, and I've provided your government with access to the best resources money can buy when it comes to scenario planning."

"OK, Stan, keep your shirt on. I'm very grateful for your support, and there's no doubt you're the man when it comes to finding savings and taking messy problems off our hands. So, to get back to the numbers. I've got an £800 billion UI budget for the 50 million claimants, and by the time we call the next election, it'll have to pay for 65 million. That's a 30% increase in numbers for no increase in budget. And you've already optimised food costs. How the fuck do you expect us to be re-elected on those numbers? You know that the unemployed don't generally vote Tory, despite the law and order pitch. If we cut UI any further, we can kiss goodbye to a fourth term, and you know what that means for Strasbourg!"

"Alistair, you know what your problem is? You've always been short-sighted. Always looking for a four-year solution, never seeing the future. You're what, 55? I'm older than you, and I've seen a lifetime of changes in the last ten years – hell, I've been responsible for quite a few of them – but we're only beginning. Full artificial general intelligence is just around the corner. Already my developers are sitting back and watching the computers re-write their programs to be better, smarter, more efficient than my guys could ever make them. Between you and me, mate, most of those guys will be joining the ranks of the unemployed within the next year because they can't keep up with the AI."

"OK, Stan. I'm ready to go with you on the basis that you've got the track record. If I can keep my budget at no more than £800 billion into the

elections and beyond, and you can find ways to cope with the extra 30% unemployed without costs rising, Then you have my vote… But you know I could really do with a little help next door with my building project."

"No point re-inventing the wheel Alistair. If you like what Mary and I have done here, I'll send my architect in to talk through what you have in mind with yourself and Harriette, and we can put the building work through Strasbourg's maintenance account. Don't you want to know what I have in mind for the evolution of universal income?"

"No, I don't really. It's probably beyond my short-sighted ignorance. Just make sure you have your ducks in a row when I come to push it through Cabinet, though. Ah, here's the ladies back from the park. We should be going. Thanks for the lunch, Stan. A pleasure as always."

Ellen

Ellen checked through her wardrobe on her Nimbus to see if anything caught her eye. Her lightest, shortest, sexiest skirt needed pressing and so she dropped the image into her express dry cleaning box app for one-hour turnaround. No point wearing her new informagear top, as the party would be off-grid. Just time to grab a bite to eat and change before the 9 pm M-rail into town. She messaged the fridge-micro to have her low cal linguine ready for eight. If she could only leave work on time, she'd be able to go over to Tower Hamlets for an hour before getting herself ready to go out.

She should have time to drop into the flat and check on her parents, have a chat with George and see that Elsie was eating enough, without having to stay for a meal herself. Friday was her day for visiting after work, and sometimes she stayed to eat with them, but only if she took the food with her, as they only ever had enough for themselves and Jodie. 'Tonight is party-night' she thought, 'I'm not going to spoil my preparations by staying too long.' Visiting George and Elsie always brought her down. It's fine when you're out and about and making waves, but their world was dead. Tower Hamlets had been re-designated an Unsafe Zone, and unless you were just travelling through, you had to give reasons, which was a rigmarole. Not to mention the walk from the M-Rail to their block was horrible.

She had been feeling guilty for ages about doing so little for them, since George lost his job, and then they were forever laying all their woes at her feet, and expecting her to solve everything for them and even for Jodie, who was twenty-two, for Christ sake, and should be looking after

herself. Also, she'd been subsidising Elsie's VR entertainment for months, and now she was chipping in for Jodie's medication as well, which meant she never seemed to have enough herself.

Ellen's supervisor, Jade, had invited her to the party, to celebrate her engagement to some rich guy she'd met at a Strasbourg staff social. She'd been on a high for weeks, after her dad had agreed they could ignore the PQ and get married. He was rich enough to cover their premium, and besides, he controlled the whole shooting match anyway and could take them out of Strasbourg's database if he chose to. Jade's dad and Jasper's dad were on Strasbourg's Board together. Jasper had been a visitor to the house even when Jade was only a teenager, and Stan felt OK about him marrying his only daughter, despite their less than perfect PQ score.

Ellen wasn't sure she liked Jade much, even though she was usually OK to work with and fair as a boss. Jade had a habit of putting herself first, and was known for being ice-cold when it came to work decisions. She certainly got that from Stan. Jade's boss, the Head of Insights Department at Strasbourg, who reported directly to Stan, had announced yet another round of staff cuts last month. Unsurprisingly, given her family connection, Jade was 'above the line', in the inner circle, but Ellen was not. Stan wouldn't let his own daughter go, however hard-nosed he was, and Ellen knew that Jade was a chip off the old block, and would probably end up on the Board. She had an evangelical attitude to Strasbourg's mission of being the leading insurer, the most sophisticated controller of risk in society, the power behind the seat of government.

They were still prevaricating about who would be let go at the end of the month, and despite being one of the top performers in the team, Ellen knew that it was only a matter of time before the PQ algorithm replaced the insights team altogether and then she'd be on UI along with the rest of her family. Insights Department had shrunk in size every year since she'd joined. When she got the push, she'd have to move back in with George and Elsie, back into her old room, sharing with Jodie again after all their years apart. It used to be fun, once, sharing with her little

sister, when they were teenagers. But now, with Jodie's problems, and her own independence, it'd be hell. They'd undoubtedly fight all the time, and without Ellen's income, Jodie would have to cut down on the medication, and that would be the beginning of all sorts of problems. The difference between Ellen's flat and George and Elsie's was huge. Tower Hamlets was like hell on earth compared to Stockwell. Her low rise block was clean, modern, secure and air-conditioned, while their tower block was on a huge and dangerous estate, with filthy communal areas. It had been built in the twenties, and it was always overheated, and claustrophobic. The lifts smelt of piss and the communal areas were all threatening. In Stockwell, she had almost as much square footage to herself as they had for a family of four, and she loved her own space. How would she manage to adapt to UI living, without medication?

The party would probably be a bit of a free-for-all, with a couple of hundred people expected, because the venue was huge and it would cost Jade nothing to invite so many. They'd all chipped in their fifties on Partypak for the venue, and nibbles and a couple of drink vouchers. There would be loads of other Strasbourg people around, some of whom she was friendly with, and hopefully some new men. Ellen had been single for too long, even counting one-night stands, let alone a serious boyfriend. Since she'd started using G-Match, she'd had a couple of first dates recommended by the system, which had been disastrous, and she'd resolved to find her own potential partners at a party like this, or in a bar, or through friends. If you wanted to meet the right person, as George kept telling her, you had to go about it the old-fashioned way, and find out if you liked them first, before G-Matching them to assess their prospects.

The party promised to be hot, and she wanted to look cool. Jade had booked the Bond Street Piccadilly line platform bar, a hundred metres down, which meant no aircon. Long after the tube trains stopped running, and were replaced by the M-rail, the Tube never lost its dry heat. Against that, the lack of online access meant no proximity monitoring, so informagear would be useless and she could do what she wanted, with

whoever took her fancy, without raising her Subverse Score for mixing with the wrong type of gate crasher. She could do with a bit of excitement.

She tried to focus on her job for the last hour of the afternoon by scrolling through the matches in her segment on G-Match. There were so many women looking for men with a bit of something about them, but within their score range. In Ellen's view, the few men within the segment who were available and in range were all ugly, stupid, congenitally challenged or very dull. Unlike the ads for the service, which showed perfectly healthy, loving couples meeting online and ending up married and cuddling their perfectly formed children, for most people with average PQs, it was compromise all the way. The balance of manageable scores and attraction was the game she helped to manage. Once you get outside your PQ range, there might be good looking, bright, interesting men, who seem to be suitable, but have something lurking in them: a propensity to instability, a dangerous or aberrant streak, or perhaps a biological weakness which would manifest itself in a less than able child. Either that, or you simply couldn't afford the insurance premium associated with dating them.

Ellen's Insights Analyst job entailed vetting and approving 'marginal matches' in the 26-30 age range in South Central London. Born in 2018 and being just 29, Ellen was managing a segment she understood. This was her own demographic segment, on her home turf, which was why she'd been given it. The whole Insights team tended to work on matches within their own age range or slightly older, and across a geographical area that they would be familiar with, as it produced better results than matching people they might have had less affinity for.

Insights was always seen as the career stepping-stone to Claims Strategy or Deportation, both of which tended to attract the Oxbridge graduates and the high flyers, most of whom were men. To succeed in Strasbourg, you needed to be cut-throat, connected, hard-working and male. Ellen knew she didn't stand much of a chance of promotion because her PQ demonstrated a softer side to her character, because she didn't have a daddy on the Board, and because she lacked the requisite tackle. She

worked hard because the alternative was joining Jodie on the "happies" in Tower Hamlets.

The strike rates for successful matches were compared continuously between human and AI managers, with a view to reducing the company's dependence on human involvement as soon as AI outperformed people. A success was deemed to be a match which lasted at least three months, comprising at least three dates, and there were bonus points for six and twelve-month matches. A marriage resulting from a match earned you more points, but most people on the team were happy achieving their three-month targets and keeping their jobs. It used to be about first dates, and helping to get new G-Match registrations, but that all fell by the wayside as the algorithms became more sophisticated and took into account the truth that fancying someone on a first date was a poor indicator of the chances of a longer term relationship. Everybody knew this to be true, but nobody really understood why.

Jade led a team of twelve, soon to be six, PQ Analysts. If she was going to make the cut at the end of the month, Ellen would probably be given 30-35s as well, since Strasbourg preferred to push analysts up the age range, rather than down. If you have to help match younger people, you tend to bring your own history into it, and you make poorer choices because you hold romantic memories of how things might have been, or downhearted memories of how they were. But matching older people is easier. Nobody looks at the future through rose-tinted spectacles, after all.

Ellen had always tried not to make biased decisions based on her own taste in men, but to go with the analytics and how well the couples looked together on screen. It was an intuitive process, and she was pretty successful at choosing. If that wasn't the case, the algorithms would have replaced the whole department long ago, as the computer would have a higher strike rate than its operator. The algorithm was already able to make initial matches infinitely more quickly, and the basics were always right for first dates. People met and liked what they saw, and got together for dating, as G-Match advertised. But it was later, when the first, biological

attraction wore thin that the auto-matches tended to fall down, and the Analyst matches tended to be more resilient. Everyone in Insights had their own theories.

"One of my guys has been on about twenty first dates, and a few second dates, but he finally chose this girl I wouldn't have expected would be right for him. She scored higher for submissiveness than most of the others, but also for independent decision-making and persuasiveness. She was lower scoring on allure, body mass index and problem-solving than almost all the rest. I think he just found her less hard work, and he was tired of dating."

Ellen was musing over her salad with Magda in the coffee room.

"Yes I know what you mean, but I've had the opposite too. Remember that life coach who picked the bloke with the anger management issues? They never stopped fighting, and his PQ was way higher than the others we offered her, but once they got to the three month point, his PQ kept going down. I guess she chose him as a project, and whatever happened, she beat him into shape, which must've been what he secretly wanted. God I'd hate to have such a weak man!" Magda had married a strong silent type in the police.

Ellen always felt that her pairings were based on a particular look in the eye of the candidates, something indefinable which put two people together who belonged together.

When the announcement was made about the cuts, Jade assured Ellen that she was in the top quartile on strike-rate and that it would stand to her when they made their choice. But Ellen knew how little this platitude was worth, given Jade's ultimate self-interest and her protected status.

Matches came up on her screen as pairs of images: women on the left, men on the right. The algorithm's 'preferred' partners were always

in the centre of the screen, and around them, second, third and other choices were arranged down each side of the screen as thumbprint images in descending order of suitability. The AI algorithm had just one objective, which was to maximise the profitability of the policy by charging as much as possible while reducing the cost of claims. The initial screen only contained matches which fell within the scope of 'economically viable'.

Unfortunately, this sometimes led to recommended matches which were less appealing to those involved, and therefore less likely to last. Ellen could choose either to approve the preferred match under consideration, or to select alternatives from either side to replace one or the other half of the match. Going with the computer selection, as some analysts did ninety-nine percent of the time out of fear or laziness, usually led to short-term strike-rates and long-term failure. Ellen had been in the job for three years, and her scores had been consistent, if fairly predictable.

In between the two main candidates' images was a small box containing their combined PQ score. This Probability Quotient was the central plank of Strasbourg's success as the leading insurer in the country, and had been honed over the last ten years from Genomica's original work to a point where it had become a highly sophisticated predictor of two people's suitability as a couple. Suitability was mainly based on a couple's potential to produce healthy offspring, and to ensure that they didn't become dependent on costly healthcare themselves in later life. On top of this, the PQ was an accurate predictor of individuals' aberrant behaviour or non-conformity, so Strasbourg was able to provide services to the security industry as well as the health sector, using the G-Match database.

When Ellen replaced one of the two main images with an alternative from the sidelines, the PQ score in the little box re-calculated, and even if she did nothing but stare at the screen, it also changed continuously, based on what each of the two selected candidates was doing in that moment. A PQ68.7 could become a PQ68.8 simply because someone decided to eat an ice-cream, or to cross the road too close to an M-rail stop, and revert to the lower score when they went to the gym. G-Match was a real-time, live

feed system that took into account whether people were making a positive contribution to their health and longevity by exercising or taking active measures to improve their safety.

Strasbourg had long been offering incremental insurance benefits under its main categories of health and safety. Healthcare optional extras included cover for the provision of personalised medication and catering services, which allowed wealthier people to ensure that the drugs they might need were tailor-made to suit their own genome, and if they needed a particular dietary supplement to better their health, it too could be delivered by Nimbus direct to their fridge-micro in ready meals with personalised labelling.

A popular add-on, which had been generating a strong growth to Strasbourg's bottom line was the menu of medical augmentation services that the company offered through its CRISPR Lab, which restructured customers' RNA. There were more and more people buying augmentation, like night vision implants, bio-engineered body part regeneration, and embryo engineering. Stan's vision had always been to accelerate the Strasbourg biogen programme to try and tip the balance between enhanced individuals and those with no advantages, who would become secondary, marginal and unsupported.

There were also security and safety options for people who could afford the premiums, such as home security bots, private transportation for those concerned about using MPVs, and the increasingly popular Surveil-me Proximity Monitoring, which allowed customers to nominate surveillance targets to be apprehended by Strasbourg's security contractors when they entered a specified exclusion zone. The larger the zone, and the larger the number of nominated targets, the more expensive the premium. But these extras were designed for the top echelon of society, and not the mass middle-market which generated the bread and butter income for Strasbourg. Besides this consumer business, most of Strasbourg's income came from government contracts, such as the UI deal that Stan had done.

Strasbourg had begun to move towards a two-tier service, one for the haves and one for the have nots. Second-tier insurance packages applied to everyone on universal income, of course, which already constituted over four-fifths of the adult population. This massive market had economic value to the company, but only because the claims it could make were so limited. There was no trading up to added benefits from the unemployed sector, and little incentive to improve the health of people who couldn't afford it. The disparity in life expectancy between the employed and the UI populations was growing quickly.

Ellen often felt that she wanted to understand what could be the limit of acceptable change. The problem was that the goalposts moved continuously, and what seemed like a horrific abuse of human rights last month was already being taken for granted or ignored by the media.

Everyone was genome chipped at birth, and the chips were continuously feeding biometric and behavioural data back to Strasbourg Insurance. On top of this were feeds from cameras, social media and v-mail content. Any protests about privacy or disempowerment were long forgotten and now everyone loved the PQ, and wanted to use it rather than having to make up their own minds about other people.

Since Genomica first developed the algorithms, and the media stirred their readers into a frenzy of fear that robots would take over the world, there had been fail-safes built into the AI process. All changes and improvements to the PQ were buffered offline pending human approval by Stan, on behalf of the Board, and the Insights team then got told about the updates at their Monday morning meeting.

"Good morning, team," Jade always started on a positive note, "we've had an approvals update from the Board this morning, and I want to run through them before we agree this week's targets."

Nobody showed much interest in this standard opener, since it was the same every week at their briefing meeting. Jade always got the updates

from the horse's mouth, since her dad was the omnipotent one with oversight of the Software Development Department as well as Insights, and he had final say on each improvement to the software. He probably called her up on Sunday nights to give her the week's updates.

"Update 15.2.27 has added a Rational Persuasiveness PQ to the battery on conformism. It has loads of elements, but in essence, it says that if you are sensible yourself and you score well on persuading others to your point of view, you are more likely to encourage safe, secure and predictable behaviour in your partner, and that's gotta be good, right?"

That was one of Jade's favourite Americanisms, which she probably learned on a motivational training course for middle managers. Ellen was sick of being told what had to be good, and she was sick of finding more and more of the approved adjustments to the PQ revolved around promoting conformism.

"Yes, but what about creativity building people's success, which would lead to greater wealth, allowing us to up the premiums?"

This was from Magda, who was the most commercially driven analyst in the room. This was an old debate in the Insights team. If people could be helped or pressured to make more money, they would be better able to afford higher premiums, allowing for a wider G-Match trawl for lower shared PQs. In Ellen's mind, it would also lead to their being able to afford slightly more reckless behaviour which might militate in favour of a more exciting or exotic lifestyle. Ellen always wanted to see more change, brought about by differences between people and allowing more individualism into society. She hated the drive towards sameness.

"Come on Magda, it's not all about thrills and spills you know. Some of us want to settle down and have a secure future."

Jade would say that, seeing as she was getting engaged to Jasper, the man of her dreams.

"Sorry Jade, I agree with Magda. I'm not against having a secure future. God knows, it's been unsettled enough this year for us all. It's just that I want the playing field to be a bit more level in the game between control and free choice, so we can at least believe that we decided on someone or something. I don't know who's been rating my matches, but they're not giving me anything to raise my heartbeat."

Ellen knew that Jade would be evaluating her ability to separate her personal views from her role in Insights, and that this sort of disagreement would form part of the appraisal process during the upcoming redundancy planning. It had happened before with Insights Analysts who were single and hopeful, when they began to choose potential matches based on their own aspirations, or even began to store candidates' profiles in private files of possible matches for themselves. Jade knew full well that Ellen had such a file, but that alone wasn't an issue, since the analysts often raided their private files for clients, to boost a match score and get it right, so they could make their bonus in a particular month. Ellen regularly used her private file to boost matches, but unlike Magda, she didn't seem to be doing it at critical times to make a bonus. More often it seemed she just wanted to find someone special for an applicant, on romantic grounds. Jade would look down on such a weakness.

In the last few months, with an election in the offing, Strasbourg had been reacting more and more to political pressure, emanating from the Department of Domestic Security, rather than simply trying to minimise insurance claims. The incumbent Tory government was aiming to fight the election using Strasbourg's algorithm as evidence of their commitment to a safe state. Labour was fighting against it on the basis that the government ran at best a nanny state and at worst, a police state. The newer elements of the algorithm ensured a more conformist population, and non-conformism was penalised where it hurts, in people's bank balance. Not that everyone towed the line. The right-wing news media was full of stories about deportations for criminal activities, especially for the wholesale deactivation of people's chips by hackers who charged substantial sums for the service.

Rather than combating crime itself, the DDS just decreased the thresholds on deportable crimes, which drew far more targets into the net, ensuring a new supply of soft targets who would cost less to arrest and deport. Deportations had, in this way, become big business. The Government funded the DDS, and used the figures it generated to spin horror stories about what deportees had done to be arrested, and of their level of criminality, which had a 'positive' effect on most people's level of conformity and caution, subduing them and discouraging individuality.

Last summer, they had raised the level of people's fear with news of riots in city centres, to a point where older people's stress levels were impacting medical costs. They did this, knowing the consequences, to strengthen the lobby for euthanasia. It was hard to know whether any of the riots actually took place, as nobody spent time on the streets unless they were homeless, but it was simple enough for stock footage to be doctored to suit the online bulletins. Then Strasbourg altered its map of safe zones, to remove all city centre areas deemed to be flash-points, whether or not anything had happened in them. The change came after a lot of hype, and consequently was given the rubber stamp by the DDS. Re-zoning meant that they could withdraw any financial support for the private security services policing these areas, and also stop the housing market from overheating, as unsafe zoning pushed home-owners out of cities. The larger the unsafe zones, the fewer areas Strasbourg had to cover for insurance claims.

Unfortunately, those in power were not simply looking for a safety-conscious population which would minimise health and security costs, but were also trying to manipulate the markets, since there was a substantial stock market trade in PQ points. There was also a futures market in deportations, which was driven by strategic changes in the algorithms, and government crackdowns on subversion. The brokers dealt in global risk analysis which formed a central plank of every government's market strategy. The politicians were all in the pockets of the same global conglomerates, accepting favours for rubber-stamping policy changes

which reduced insurance costs and pressurising the insurers to take on new risk which had previously been state funded.

Stan had been negotiating several government contracts on behalf of Strasbourg which would increase its reach, and the Board was behind him every step of the way. They didn't care what methods he used to win contracts, and they had even appointed the Chancellor to the board as a non-executive director to smooth the way for winning tenders.

"Strasbourg Espagna has been tracking their Moroccan immigrant contingent, and despite their unemployability, they have exceptionally low PQs. The Claims department there is reporting benefits of G-Matching mixed race, and reducing claims. They're only two years into the programme, so we're talking a few thousand planned mix-race progeny, but the evidence was already there in the Moroccan data we got from Saham last year on their longer term assessments. I'm not sure why the immigrants are all so healthy, and why they're not scoring more highly on social unrest factors, but I'm checking with their head of R&D to see if this is a particular cohort or just the general migrant population. There are differences in the Strasbourg Espagna algorithm of course. They actually don't weight the social unrest factors as highly as we do. You know, the Spanish are much more of a laissez-faire bunch that the Brits."

Stan was making a short Board presentation as a run-up to outlining the Claims Strategy Department's latest thinking that rather than re-scaling the PQ all the time to make the existing genome problems less of an insurance risk, why not move towards fixing the genome so that everyone would be healthier and less expensive to insure?

"So, Stan, if I understand you right, they're saying that the value of these immigrants to the Spanish gene pool exceeds their deportation price, so they're allowing more integration?" Geoffrey Grainger, the CEO, was always a step ahead, "You're thinking about how we can bring this benefit in here, given the tight controls we've got on immigration. Where would we find the racial mix we might want to integrate? Have you spoken with anyone in the Spanish Government?"

"You've got it Geoff. This is all about relative costs and margin, and so I haven't raised the political implications yet. In my view, the issue is timing. Deportation values on Moroccans are relatively low at the moment because they don't deliver an active resource to the receiving market, and there is little resistance to repatriation. The Spanish didn't have a strong case for sale to the usual accepting nations, and in normal circumstances, they'd be repatriating, despite Morocco's desert conditions. The US hasn't been bidding more than $5 a point. On the other hand, if Spain keeps them and integrates them, as they've been doing, the margins on premiums have been steadily increasing, as claims drop. These guys are strong. There's always the option to deport them once they've become parents too."

The $5 a point rate for deportees would equate to a $750 price on the head of each of the 12 million UK people with high PQs in the list of potential UK deportees which Stan had compiled. It was certainly a substantial bounty to the Government and a healthy commission for whoever won the contract for handling their transfer.

"However, Stan, the return on premiums of bioengineering is a five to ten-year benefit, at least, given the time it takes for a generation to be born, while deportation payments or swaps are immediate." This came from Martin Fuller, the FD. "Right now, Spain has Solar credits to trade and the US is like a bloody black hole when it comes to energy demand. They'll take the Moroccans if the offer is right."

"I know, Martin, but that doesn't mean we always have to go for the quick fix. I know you're going to argue share price, and cashflow, but we may be on the cusp of a series of opportunities in CRISPR which would allow us to remove problems from within the PQ, rather than playing with the premiums and benefits packages so much. What I'm talking about is engineering more healthy, less costly people who behave themselves, eat less, want less. The alternative is we let it all slide and in a few years, we have far fewer people to insure. The birth-rates among the UK cohort are falling far faster than among the top quartile, as you all know."

Stan's focus had been on modelling the likely outcomes of a wide range of potential 'gene fixes' in terms of the population. If one made people less dependent on animal protein in the diet for instance, and farming switched to arable, and if those people were also smaller and less hungry, less active and less likely to travel, the levels of risk, coupled with the reduced cost of living would be good for the bottom line, while the impact on the planet would be far lower.

"That's all very well, Stan, but what about the share price in the meantime? What about the front loading on the cost, and what are the long-term cost implications if people no longer need insurance because they're so healthy and hardy? I can't see this being good for Strasbourg, and if I don't, the shareholders won't, and you just won't get it through."

Martin had a nasal timbre to his voice when he was calm, and when he became excited or enraged, it became more of a whine. Stan hated Martin's tendency to threaten shareholder revolt, as though he was some sort of independent voice. Right now he was whining for England. Stan wasn't going to have some narrow-minded, jumped-up fucking accountant dictate to him how he should operate.

"We need to see past the end of our noses here, guys. Get a bit of blue skies into our thinking and start to leverage the gene pool a bit more. I wonder, Martin, what your motives are in putting up all the objections. It wouldn't have anything to do with Chatelaine Futures, would it?"

Chatelaine was Martin's side venture, a small deportation futures house he ran with his wife. It was obvious to Stan that Martin had a conflict of interest which continually drove Strasbourg towards short term trades rather than investment in R&D, bolstering his brokerage business.

"Oh come on, Stan, that's uncalled for. As you know I'm nothing to do with Chat..."

"Oh, fuck off back to your abacus, will you Martin?"

Stan often bullied Martin in Board meetings in order to get his way, and Geoff didn't object, knowing that Stan was not only far more able and valuable to the company, but that he controlled too many of Strasbourg's inter-woven business development projects to be removed.

Geoffrey Grainger was also conflicted when it came to deportation trading. Before he joined Strasbourg, he had run a leading security contractor, and one of his first moves when he got the Strasbourg job was to set up a deportation processing division, under the code-name Egress. This unit pre-selected potential deportees from the company's PQ databank, and set up pre-shipping documentation and travel approvals on all 'at risk' individuals so that when they did commit a crime, it could undercut competitors on the handling charges associated with their relocation. The Egress List had massive value to the security contractors as a predictive tool to profile potential offenders, and he'd sold it into his previous security firm even before Egress was fully developed.

Egress was one of the most secure divisions of Strasbourg, with blockchain encryption on all its files. It was regularly the object of attempted hacks, both by Strasbourg's competitors and by potential deportees looking to get themselves off the radar. Two months ago, a hacker co-operative, called Gimme, shocked the Board by cracking the Egress encryption, and accessed the profiles of all twelve million people on the list. Within minutes, Gimme was on the Darknet offering to edit it by adding or removing records, depending on the client's requirements. They even posted a rate-card for individual name removal or block deals for tranches of names associated with particular families or gangs. It took two weeks for Strasbourg to repair the breach, by which time the horse had bolted.

Drug gangs operating in close proximity to one another were prepared to pay Gimme to have each other's members added to the Egress list, if they weren't already on it, in order to speed their deportation, and Gimme's members all removed themselves from the list as soon as they gained access to it. Strasbourg's internal security team identified several

potential Gimme members as being connected through work they had done with the US immigration office in Washington, responsible for taking deportees. That implied that Gimme had state backing. The US had been taking so many deportees in exchange for powergen credits, and had been accused of trying to re-rate large numbers of them in order to increase their value. At $5 a point, it was a lucrative process. What better way to raise the price of an accepted deportee than to hack and uplift their PQs?

The PQs in the list were in continuous flux, as potential deportees altered their behaviour, and the list was not a stand-alone product. It fed from and to the master database. Once hacked and altered, all the PQs of the 12 million people on it had to be deleted or re-calibrated. Not surprisingly, a good number of potential deportees were on the list for the very reason that they were themselves hacking and manipulating their chips, or paying for this to be done. In these cases, the culprits would have to be detained and physically re-tested and re-chipped in order to meet with Government protocols on deportation. It was a difficult business, involving a lot of leg-work, tracking people who didn't want to be tracked. It involved the security contractors bringing them into centres for identity checks, re-loading their G-maps to the new generation of harder-to-hack chips, and then taking each person through an intensive physical and psychological review to rebuild their PQ before implanting the replacement chips. It was a time-consuming and costly exercise which would push up everyone's premium.

The industry spent a lot of money letting their customers know about these costs, to justify raising premiums or downgrading PQs, and whole rafts of private security firms or bounty hunters sprang up around the insurers to pick up the work of arresting people on the list. Identifying those who had deleted themselves from the Egress list was not difficult since an offline copy list could be de-duped against the corrupted one, but almost without exception, these deleted people had gone off-grid, as soon as their chips deactivated, so they couldn't be found easily to be brought in. Of the twelve million people on the list, some 2.3 million remained at large two months later, untraceable. The hard format chips which most people

had implanted into their wrists at birth over the last 25 years were not only outdated technology, but physically removable, either through surgery, or more barbaric means. In various bars in the East End, it wasn't uncommon to see groups of men with mutilations and scars on their wrists from home surgeries.

Recent work in the CRISPR Lab had allowed Strasbourg to develop DNA tags which carried the PQ interface, making the chip into a gene marker which could not be removed and could only be altered or hacked using genetic engineering processes. The whole thing was much more secure, but without being able to capture or even track the people still carrying decommissioned old-style chips, it wasn't possible to introduce the new genetic chips. Strasbourg's share price plummeted on the back of media reports that the old chip should have been updated years ago, but Strasbourg hadn't wanted to commit the investment, and Martin Fuller took the full brunt of the blame, quietly re-directed by Stan onto him. The DDS wanted to know whether the list could be reconstructed to restore its value, or whether it was no longer an asset to trust, and the shareholders wanted to know what Strasbourg was going to do to restore their confidence. Martin had to go.

Stan had, for the best part of thirty years, been one of a very small group of powerful men who had their fingers in all the pies, and his accusations of Martin and Geoff's conflicts of interest applied equally to his own side activities. He had, according to Jade, even written a little sub-routine to do his deport trading for him, and he was going to let Jasper make use of it. When Gimme broke in, the sub-routine was altered, in an elegant and unobtrusive amendment to the code, so that the AI which handled Stan's investments in deportation credits started making crazy trades throughout the first night. Stan got up the morning after the hack and turned on his Nimbus over his breakfast to find he was several million out of pocket. It was a slow process to undo these trades, and the embarrassment fuelled his anger. To add insult to injury, the hackers had added his name to the list of deportees, as a little inside joke, and that

made him think that they must be people he'd met before, or possibly failed to satisfy in one of his business arrangements.

Stan was a meticulous man and had always maintained detailed files on everyone he met in the cryptographics business, as well as in programming, analytics, systems architecture, insights, genetic engineering and one or two less relevant areas, such as politics and finance. Being one of the great architects of the Genomica algorithms meant that he could write search routines in his sleep, which could pull people from many lists based on their probability of matching criteria. He used his search and select program to generate a shortlist of no more than a hundred possible members of the Gimme co-operative, of which perhaps ten or fifteen had the skills to crack the Egress security.

Stan remembered one or two of them, from his days at Genomica. Nick Artremis, whose moniker was The Artful Dodger, was well known for his hacking skills, and had been involved in several previous brushes with Stan, both at Genomica and more recently at Strasbourg. His current status was 'off-grid' since he'd disabled his chip two years ago and had been careful since, despite having a high deportation price on his head. Nick had once met Stan, at a mapping conference, and had proposed that Genomica employ him to road-test their firewall. Stan had rejected his offer out of hand, saying that he himself was completely comfortable with that responsibility. Nick had subsequently hacked into Genomicas' internal v-mail, just to prove he could, and left an insulting little note for Stan to the effect that arrogance has a price. Nick was definitely Stan's number one suspect. As he had been off-grid for a long time, the only way to reach him would be to send a taunting v-mail to his last known address, on the assumption that he still tracked it, and hope he was arrogant enough himself to respond. That didn't work. Stan put a permanent alert on the Strasbourg security files for any vid, DNA or fingerprint recognition of his whereabouts.

John Vaunt's name was also on the list, though he was also off-grid. John had at least two aliases which he used, and also a substantial

deportation bounty on his head. Stan had no recollection of him, but his profile as a top graduate in bio-engineering and analytics from Imperial gave him the tools. Stan would undoubtedly have lectured this guy, even if they hadn't been personally introduced, during his period as Visiting Professor at ICL when he gave lectures every year to the final years. He was thinking of stepping down from the job, which had lost its status and appeal over time. In the last couple of years, despite his status, attendance hadn't been anything like it had been at the beginning, when Genomica first sold to Strasbourg and Stan was recruiting as many of the top graduates as he could get his hands on. At that time, he had a certain cache associated with his cool new tracking system, and there was standing room only in the lecture theatre, but now, the whole PQ system was considered authoritarian, establishment and uncool by developers and students alike.

Once everyone began to grasp the enormity of Stan's intention to sell the PQ algorithm to an insurance company, they dropped Stan as their icon. Student forums were littered with abusive comments about Genomica, and then the financial press picked up on his intentions. Once the penny dropped with the mainstream media, stories quickly spread of the totalitarian state he was obviously trying to set up. There were civil rights demonstrations outside Strasbourg's offices, and death threats to Stan and Mary. When it became obvious to Mary's family and friends that Stan was planning a very different future for himself as Svengali, Machiavelli and Mussolini rolled into one, they all put him at arm's length and Mary lost her respect for his work. She had already lost her respect for him on a personal level, because he refused to give up sleeping with half the female staff at Genomica. Jade, then a small child, became the pawn in their fights, which Stan dominated. Jade always supported her father, and he loved her all the more for her loyalty. She was excited by what her father was doing. She was very materialistic, had developed her bullying skills at boarding school, and she was incredibly single-minded about any goal she set herself.

Among Jade's generation, those who weren't inside the fence were building subtle networks, and learning to find chinks in the establishment's

armour. Their benefits were eroded and removed, and they had to fend for themselves. This was the backdrop to the hacker movements and the numerous alternative communities which tried to survive at the edges of society.

Using his sub-routine, Stan was able to find several links between Artremis and Vaunt, who had both provided contract coding and encryption services to the DDS, MoD and one or two security firms. They had both gone off-grid within ten minutes of one another which meant that they were working together at the time. Gimme had not surfaced as a hacker co-operative until two or three months before the Strasbourg breach, so Stan could not be sure that they were key players in the hack, but he thought it likely. At the same time as Vaunt and Artremis went off-grid, there were some eight hundred others doing so nationwide. This was a little above average, and Stan was able to correlate the backgrounds and profiles of all of them to find the ones most likely to be connected. This amounted to over 100 people who could have been working together having some links through previous work, geographically or in terms of demographics. These people became the Gimme Masterfile, and everyone on it was filed for alerts on all biometric data. Within a few weeks, ten had been picked up, and none of this group knew anything about Gimme. All were deported once they'd been interrogated.

Once the Egress repairs had been made, and a contract had been put out on the Gimme masterfile, Stan brought in a specialist firm of bounty hunters, put substantial deportation prices on the top fifteen names, and sent them out to hunt down the hackers. He didn't expect much success in arresting either Artremis or Vaunt, since their stock images and voice prints had been hacked and erased along with the cloud back-ups, and the DNA and biometrics data had all been altered. He ran them against everything he could, but it was like looking for a couple of small needles in a very large haystack. It was not surprising to Stan that both had had the sense to disguise all their biometrics.

Strasbourg's damage limitation PR simply reported on the repair program, the amount of swift justice meted out, and the success of the new genetic marker chip in closing down any future hacking. In truth, the problem was far from dealt with, and for as long as Strasbourg had encrypted information which sought to subjugate people, there would be teams of hackers ready to try and bring it down.

"And update 15.2.28 is a downgrade on the PQ variables associated with a range of immuno-deficiency markers. Strasbourg CRISPR Lab has built another repair patch to take them off FADs, which is good, right?"

Hardly a month had gone by in the last year without a new chromosomal repair patch being developed to remove inherited conditions from the 'fatal and debilitating' list, nicknamed FADs. CRISPR focused on those conditions which cost the most nationally to medicate. The PQ algorithms pushed up premiums dramatically for those who had any congenital defects, and sufferers or their parents were hard sold opt-outs to discourage them from paying to have these conditions covered.

Jade looked around at her team of insights analysts with disdain. Most of them would do whatever she told them to protect their jobs, but Ellen was the least pliable. She was ruled by her heart, more than her head, and Jade was irritated and attracted by this in equal measure. She understood how her father's inexorable drive towards efficiency was at odds with Ellen's view of the world, but Jade knew he was right, even when nobody else saw the future as clearly as he did.

Ellen's problem was that she disagreed with the driving forces behind Jade decisions. The proposed removal of infants with congenital conditions from the tracker would be one more outrageous decision driven by greed. Injustice always incensed Ellen.

"If your incurable congenital defect is now curable, you should benefit from the advance immediately, and not be left waiting for the

adjustment, and penalised for it," she blurted out.

She knew she should really keep her mouth shut, since Jade was not one to get sentimental about people she didn't know, but she couldn't help herself.

After the meeting, Jade called Ellen into her office to have a quick chat. Ellen knew what was coming.

"Look, Ellen, you know I'm a big supporter of your work. I know you have everyone's wellbeing at heart, but this is a cut-throat business and we're in a corner here in Insights. You know we can only keep half the team, and I want you to be here after the cull, as my number two, but in all honesty, I can't recommend you if you keep showing me up in meetings."

Ellen knew she had to suppress the rage she felt. If she wanted to stay in at Strasbourg, this was a red line. You get with the programme and accept the human consequences, or you get dumped into the reject pile, where UI dictates your life and death, and you no longer even have the semblance of choice.

"Yeah, I know. Sorry Jade. I just want to feel that what we're doing is making life better for people, not worse. Sometimes I think we're really helping people find what they want and that we're bringing a unique human aspect to our work. Then along comes another load of decisions which are driven only by the costs. Do you remember that saying "the best things in life are free"? What was that about?"

"There you go again, Ellen. You're the conscience of the whole fucking department, and I respect you for having morals, but frankly, you need to keep them to yourself. It's not just my views that're being taken into account. You know they're picking up on all of it, all the time." Jade pointed to Ellen's wrist, on which her PQ had probably just risen several points.

"Yes, I do try to keep my mouth shut, but when I'm stressed, I just have to say what I'm thinking. I can't see how it's going to get better with half the people, and twice the pressure. I just want something good to think about..." Ellen felt like crying, but Jade didn't like having to handle her staff's problems.

"C'mon, girl. You've got my party to look forward to, which is good, right?"

The lowest PQ Ellen ever matched was a 30, held by an extremely wealthy young man in perfect health, who exhibited careful behaviour, conformist attitudes and 'safe' friends, but who had his own creative and individual style. The perfect man, and she was amazed that he was on G-Match at all, since he was positively beautiful. When he came up on her screen, Ellen was almost drooling.

"Hey, Magda, Jade, look at this one. Enough to make your mouth water. Jade, I bet you'd give up Jasper for this guy. His name is almost as good as his looks and his PQ: Alexander De Vries."

Everyone had gathered around Ellen's screen and was ogling the very handsome, square-jawed, blue-eyed man in the centre, who had a self-assured smirk and serious eye-brow puckering all in the same expression.

"Would you trust him?"

"Would you care?"

"I might have to try him out first, then decide..."

"I wonder if I could hide him behind a big score. You know, slip a one in front of his unbelievably low PQ on the system, and then set a date and time to meet him somewhere classy." Magda was always scheming to match good looking men, even though she'd been married for several years to the Russian policeman, who was a PQ67. She was looking after her age

group, the 35-50s in North London, and probably hankering after some toyboy sex.

The whole day was filled with smart cracks and frivolity around the office. "Alexander The Great"', as he'd been nicknamed, was matched by the algorithm to a stunning model whose great score was still quite a bit higher than his, at 42, primarily because of her weaker financial position, though their combined PQ72 was still lower than Ellen's own, which was currently at 78. That's the sort of pain you don't want when you're single. Needless to say, she couldn't find a more suitable pairing and she approved the algorithm's selection. After he'd accepted the first date, she couldn't help tracking their combined score most days over the next couple of weeks. They dated three or four times in two weeks, and seemed to be getting on well. Alexander clearly had a positive influence on the model's score, which dropped to 38 after he helped her get a better paid job. Then there was a long gap between two dates, and they ended up parting company, despite their seemingly ideal pairing. He subsequently showed a lot of interest in a PQ63, who was also very attractive and ambitious, but whose family included three sets of twins, and an uncle who had been arrested for paedophilia.

"No accounting for taste, eh, Ellen?"

This was Chris, one of the few men in the team. Male Insights analysts were few and far between, since women were statistically much more successful in choosing suitable matches than were men. Chris was gay and handled half the country's gay matches, across a wide age range, though according to Jade, the G-Match algorithm was already outstripping Chris and Anthony's performances. She'd let slip to Ellen that both the men were out at the end of the month.

Ellen tried to focus on the job in front of her, as the clock seemed to have slowed to half-pace. She liked the look of the girl on the left, who reminded her of herself a bit, and the guy that this girl had applied to meet didn't strike her as a bad choice either. He was a 70 and she was a 75. Ellen

copied his code into her personal folder for consideration as a possible G-Match for herself, if this date of his didn't come to anything. The two prospective partners had a combined PQ145, which was quite high, and the dark haired girl with the round face really ought to choose someone with a lower PQ, because her income didn't really support PQ145, but all the guys behind her first choice were higher scoring. Ellen couldn't do a lot to help her, but she had her secret stash in a small sub-folder, called 1NS, short for one-night stands, of men with attractive PQs who liked to play the field. If she were to raid her store and insert one of her PQ50-60 men into the match, they might hit it off, but he'd probably go off after one or two dates looking for a PQ40, who probably wouldn't want him. The footloose low scorers were a bunch of arrogant and greedy lads who cared more about getting their end away, and about lowering their premiums, than the feelings of the girls they dated, and were always boasting on social media about the low scores of their conquests.

Ellen was a romantic at heart. She dreamed of meeting the PQ30 man at a party and him falling for her, despite the scores. She fantasised about men she couldn't get, and even with her job, and all the access it gave her to the G-Match database, she didn't seem able to find mister right. She opened her folder and chose a couple of guys for the dark haired girl, dragging the man in the centre of the screen back to the bench, and then she sent the girl her alternatives to consider. Within a few seconds, one of the shoe-ins had a date with the girl, and Ellen could move on to a new Match screen. The guy on the bench would warrant further study tomorrow, if she didn't meet anyone tonight at the party.

The news, which was continuously streamed on the office v-wall, washed over her:

"......Alistair Prim, Home Secretary, reported increasing numbers of birth cert chips being hacked and deactivated illegally... darknetters... calling for greater deportation powers..."

"Whitecastle Boardroom coup as General Pinders is appointed head of Government Contracts..."

"...Strasbourg announces £50bn rights issue ... investment in Monsanto's CRISPR Development Labs... stem the growing number of immuno-deficient births..."

"... In trading today, shares in the PQ90 Plus Surrogacy Clinic plummet as G-mapping fraud is uncovered..."

Ellen hated the news always being on in the Insights Department offices. Every day it was getting worse. Control of behaviour, control of choice, de-selection of undesirable traits. God knows what it would be like if the Government introduced the more stringent pre-natal assessment measures being talked about. Sure, the average intelligence and health of the nation would improve, but there would be nowhere to hide. It wouldn't be about the no claims bonus any more, more likely about widening the deportation net and, if the hawks got their way, forced terminations for high PQs.

On the dot of five, Ellen approved her last match of the day, without the level of attention she might have applied earlier in the afternoon, logged off and got up to leave. The Head of Department was out and Jade wasn't working late on the night of her party, so for once, it would be OK to be leaving on time. She could see Jade in her little glass office, grabbing her coat.

She and Jade left the office together, and waiting for the lift, side by side, Ellen dwarfed her. When the lift d-panel checked her, the inevitable slim-line ready meal ads began to play, since she was already hungry. Jade's panel was much more interesting.

"I'm sick of only getting dieting ads while you get handbags and holidays. I mean, I go to the gym, I take the medication. Even when I get shown clothes they're never as posh as yours. Still, no disrespect, but with your dad on the Board, and Jasper wanting to marry you, you don't have to put up with anything but the best, do you."

"Now, now. Jealousy will get you nowhere."

Ellen had been over-spending, what with all the help she'd been giving Elsie and Jodie, and her balance seemed permanently low, so she never got presented with upmarket goods or holidays. Surely you should be allowed to see things you can't afford as well as those you can. Isn't aspiration good for morale? But to be fair, that wasn't Jade's fault, it was upstairs that policy was made. Strasbourg's tendrils extended to advertising, and it was intricately entwined with the Nimbus empire too.

"That's the point about having your G-map held by the insurance company." Jade reminded her "They bring you into line, recommend the best way to live and help you to stay with the programme, or get penalised on the policy, which is a good thing, right? I know it's hard for you, but it's best this way."

Ellen caught herself wanting Jade to fall down the stairs, or suddenly become obese or get seduced by a man with congenital abnormalities or something. She seemed to epitomise all that Ellen felt was wrong with the system her dad had created. She was his AI project. Perhaps she was in fact a futuristic robot rather than a human being. Perhaps everyone had fallen asleep and woken up to find that the definition of human being had changed and there was no longer any need for robots, because a new breed of humans had become artificial in their intelligence. Now all people needed to do was learn how to work much faster.

Jade was a fine-boned bird, while Ellen was more of an Elk. Not overweight, but large, and with a strong drive to graze. George and Elsie were both large too.

"You're over 25, and so your parents probably didn't know what they were getting into when they decided to start a family. You were obviously conceived before pre-marital G-mapping came into force, so it's not surprising your PQ is high."

They had had this conversation often. Ellen noticed the undercurrent of pity in Jade's tone. If they weren't supposed to be friends, Ellen would have considered it distain. Jade was only 23, and undoubtedly, Stan would

have chipped himself before it became generally fashionable and then obligatory. Mary would have been chipped when she became pregnant if Stan was in control, or when they were married.

"I know it's sentimental wanting to marry someone for love, and risking everything on chemistry, but why can't natural selection and chance play a bigger part? Who wants the perfect PQ baby with the perfect bore of a man?"

Ellen, ever the romantic, wanted to feel attracted more than she wanted to further improve the human race. Jade just frowned and scrolled through her v-mail from dozens of excited party-goers accepting her invitation. The invitation list was a roll-call of the next generation of leaders, and probably had Stan's fingerprints on it. He was certainly footing the bill for Jade's wedding, which she never seemed to shut up about. Ellen had yet to receive her invitation, and she was certain that this wouldn't arrive unless she made the cut at the end of the month when the redundancies were announced.

"Frankly, Jade, I'm sick of the PQ, and I'm sick of being penalised for my genetic code. I'm happy with my body, actually, and I'm sure there's someone out there who will feel the same. I do hope you've got some interesting men coming to the party I might like."

"Funny you should say that. There's a guy been staying with Janine at my place that might appeal. He's spent the last week with her, but he doesn't seem bothered about her, and I've invited them both to the party. I had already invited her, and when they got together, I had to include him, but then I wondered if he wasn't hitting on me rather than getting into her. You know Janine, though. Always after a good party. Anyway, this guy, whose name is John, is pretty fit. Not sure what he does, but anyway. Might be your type. You should check him out though. I haven't found him on PQ, because apparently he has some top secret clearance and can turn off his chip. He might be a 30 or something, and you wouldn't get a look in then. No disrespect. But perhaps he's got some problems and he's not as

low scoring as he looks. Then again, he might be a Sub for all I know, and you know Janine. She never asks or cares. I have the feeling he dumped her this morning, so if he comes, he'll be on his own. Frankly I'll be glad to see the back of him, because Janine isn't the quietest in bed, when she's got company. But he is easy on the eye, and clearly knows how to handle her. If I see you there, I'll point him out. I'm going to be there early, and most people aren't coming till nine."

Jade didn't want to say too much to put Ellen off, because it would suit her purposes if Ellen took John away. She'd been uncomfortable having him staying at the flat, because she didn't know him and didn't trust him, and he'd seemed very nosey. She'd checked his PQ, but it told her very little. His name was John Valance, and he worked for the MoD. He seemed innocuous enough according to his scores, with no skeletons in his cupboard and a PQ of 62, not too high and not especially low. He probably earned well, and could afford Ellen's 78 if he wanted. Up till now, Janine had only really had one-night stands, and was hopelessly fickle about men. Then this guy turned up and first of all he seemed to spend more time chatting to her than Janine, and asking all sorts of questions about work and her dad. And then he started winding Jasper up, teasing him about being a rich kid, and mouthing off about his lifestyle, which this John seemed to know more about that he should. Jade assumed that Janine has been gossiping with him and made a mental note not to tell her anything. She also decided to check with Jasper whether he wanted to contribute to the rent now that he's practically living at the flat, so she could squeeze Janine out.

The lift emptied into the foyer of the Strasbourg building, and everyone poured out onto the concourse and headed for the M-rail. Jade turned the opposite direction and a private Uber pulled in. She did that most evenings, which made Ellen really annoyed, because she couldn't afford even an MPV lift, and Jade always went private.

"See you later." Jade hopped into the cab and the door closed behind her.

Ellen just made the 5.10 M-Rail east and she got to Tower Hamlets by 5.30, which avoided her having to turn down an invitation to stay for dinner at home. Elsie was no longer interested in her being there, and Jodie was on the "happies", so she barely noticed anything, but she knew that George waited all week for her to visit, and he always got quite maudlin if she didn't give him enough attention. If she arrived after about 6.30, he always offered her dinner, and she felt embarrassed saying 'no' when they had so little. If she planned to stay, she always took food to supplement their provisions, but usually she aimed to go straight from work, and to leave before they were due to eat, because it depressed her too much to eat the porridge they had for dinner.

The room was cramped and overheated. The air was stale and moist with the sweat from the three occupants who had no way to open the windows or turn down the heating. It was a square room, with a low ceiling, and old aluminium framed windows, which faced North. The walls had been Magnolia, but now seemed more like a tobacco yellow, though nobody had smoked in there for ten years, and the carpet was a beige nylon pile, with stains and scuff marks around the doorway to the kitchenette. The room was cluttered with basic furniture: two armchairs and four uprights, a cheap melamine dining table standing in front of an old Screen Wall which was rarely turned on. Elsie had stopped watching NetCast, and George only caught the news first thing in the morning, before the others were up. His Nimbus had no credit and the screen wall hurt his eyes.

The windows looked out onto the nearest tower block in the massive estate, barely visible through the grime on the outside of the panes, and the smog-like atmosphere which hung over the area. Nothing was very clean, and nothing was new. The flat was on the 20th storey of an unexceptional council tower block in Tower Hamlets. It was one of fifty seven 24-storey blocks on this estate, built to house newly retired and redundant families who didn't have private means. All of George and Elsie's bills were paid at source, from their UI, and all the services to the thousands of occupants

on the estate were regulated centrally. Those included the heating, lighting, broadband, surveillance, deliveries, maintenance of the communal areas, and lifts. Nobody managed these services, which were all fully automated, and the residents had long since given up trying to complain online about faults or poor standards, since they had no control over payment or supply, and nobody to complain to.

In many ways, this was a care home for the economically inactive. Before, when they were both working, Elsie had been the one who held the purse strings. George had his full-time job at Fords, building gearboxes for diesel cars but he had always been hopeless with money, and had she not taken his pay packet into the housekeeping, George would have spent it on useless things. He was never a big drinker, and didn't set out to waste money, but he just couldn't help shopping for car parts and tools online. Once he and Elsie were on UI, she didn't need to worry about protecting their income, since it was all taken at source, and even George couldn't go out to buy things at will.

Now, with all the service charges taken centrally, and their food paid for and delivered without choice, there was nothing left in the bank each week to make discretionary purchases with, so Elsie simply gave up on her role as housekeeper.

The voices of the people in adjoining flats could always be heard clearly through the walls, and the ceiling in the sitting room, but you got used to that background to your life very quickly. Though the views from so high up should have been panoramic, encompassing the South Bank, Big Ben, the Wheel, Westminster Abbey and back to the City and Docklands, there was so much dust on the outside of the windows that it was impossible to see anything clearly. Ellen couldn't make out individual apartments opposite, and if she stood with her head on the window, and looked down, she could only make out the movement of the traffic below at night, when the moving lights were visible. The hoped-for clean air may have come, or it may be on its way, but it wasn't possible to tell from inside the flat, because the windows were etched with a fine frosting after years of acid rain.

Since the loss of fossil fuels, there had been a dramatic reduction in vehicles on the road, and nobody burned coal any more, which should have cleared the air, but nobody noticed. Nobody went out more than they had to during the day, in the heat. UV protection cost money that nobody in Tower Hamlets could afford.

Once autonomous vehicles proliferated, private motoring had become prohibitively expensive, and the old petrol and diesel cars that George had built had all been converted or scrapped. Multi-lane roads gave way to single lane streams of driverless electric vehicles which never stopped for more than a few seconds to drop off and collect passengers. MPVs carried between four and twenty passengers, and only the wealthiest people had their own cars as most people had given up their privacy in favour of economy. Car parks had all but disappeared, and the MPVs worked day and night. Nevertheless, across the city, more apartment blocks had taken over the spaces left by the carparks and green areas, and the little sky visible before had been supplanted with grey windows and concrete pillars.

George bemoaned the demise of the motor car, and of the internal combustion engine, but only because he could build one with his eyes shut and had never been retrained for making electric vehicles. The MPVs were entirely built by robots, and were designed to travel over a million miles between services, which were conducted by autonomous repair vehicles at the roadside. Once the new MPVs and journey micro-billing services had been introduced, the industry changed almost overnight. Fuel stations all closed down and the network of charge docking stations was replaced by road surface charging panels. Manual driver insurance quickly became an impossible luxury as driverless was many times safer than human controlled driving. As soon as critical mass was reached, the employers in city centres built travel time into their work schedules, and passengers were expected to treat their journeys as office time. Many of the largest corporations actually provided fleets of MPVs to collect and deliver the staff, in order to ensure private terminal connection in each. Meetings were held on the road, and one could even book a two-person vehicle for important staff or

for a private one-to-one chat. In a larger vehicle, as many as a dozen people could be on separate calls, v-mailing, scanning the news, ordering their shopping and arranging their social lives. Some sole traders and freelance consultants even chose to spend their whole working day in an MPV, going wherever it was needed, and paying the charges for mobile office services while on the move, rather than the cost of transportation and office rental.

George gave up watching what other people did in their apartments in the surrounding blocks, as it was clear that they did just what he, Elsie and Jodie did: nothing. He'd even stopped complaining about the noise his neighbours made while rowing or partying, because it was at least the sound of human interaction, and proved they hadn't all hanged themselves out of desperation. He gave up going out once the streets became too dangerous, especially as his Strasbourg UI policy didn't operate in Tower Hamlets, which had been completely re-zoned as unsafe. The green parks which used to surround the estate became scorched and brown long before they were built on, and the last few trees were removed to prevent the bed-rollers from building fires, so even if he'd gone out for a walk, it wasn't going to be to a green area.

People who lost their jobs and found themselves on UI had been herded into this estate and others like it, and there was a long waiting list for flats, but George and Elsie had been lucky that Ford let go enough people in one tranche that they were able to jump the queue. It was a local cause celebre that the firm was about to lose 10,000 employees and none of them would be able to afford their existing accommodation once they were on UI. The Department of Social Housing dealt with the media rumbles by removing single apartment occupants in Tower Hamlets in favour of families. George and Elsie found themselves quickly evicted in Dagenham and transferred to high rise living. Single occupants, who were all on UI, were transferred into dormitory blocks, or left to fend for themselves on the streets, and the local disenfranchised soon established Bed-roller Village under the arches on Ackroyd Drive.

The low-rise apartment blocks all over the city became vacant when more and more people were transferred, and fitters were employed to divide them up into smaller bedsit units for singles and for hotels. London didn't shrink with the reduction in employment, and nobody was prepared to spend money building UI accommodation in the countryside or commuter belt.

George had kept a lock-up on Ackroyd Drive for years, which he used to store car parts he'd filched from Fords, or bought online, before the money ran out. He'd spend hours on end under the storm lamp, oiling and tapping, listening to Heart FM and smoking rollies. It was his escape from the misery of the tower block which seemed like prison after Dagenham. Here he could tinker with his gearboxes, rebuilding them again and again, making believe that he was still on the production line and still had to prove he could do it right. But the lock-up had been broken into and occupied by squatters looking for warmth, and it was ransacked for anything saleable. Luckily, George had expected this to happen sooner or later, as the Village filled up and all the toe-rags in Tower Hamlets began to descend on the arches, so he'd moved all his tools to the flat before the break-in. He hardly ever visited the arches any more, since he'd been beaten up there and robbed of his shoes a couple of years ago.

Elsie hadn't worked in several years, and had just turned sixty, though she might have been mistaken as much older. She was so unfit that she couldn't walk any distance beyond the confines of the apartment, and her skin had a grey-green hue, for lack of exposure to UV light. She sat in her worn armchair day and night, and slept fitfully between her virtual reality gaming sessions. When Ellen arrived, she was slumped over, as though unconscious, but she was clearly not. Her loose flesh was trembling slightly as her bare flabby arms flailed slowly in mid-air. She was wearing a full-face VR mask, headphones and data gloves, which made her look like some latter-day Darth Vader, and she seemed to have no awareness of the room or its occupants. She didn't register her daughter's arrival at all. In her reality, she was fighting her way through an overgrown thicket in a verdant

rainforest to find her one true love. All around her, covered in creepers and vines, lay larva blocks, the ruins of some ancient Inca temple. On the remains of carved statues, sat macaques, and tarantulas crawled over the stones. The sounds of parakeets and shrieking monkeys overwhelmed her and she felt slightly nauseated by the smell of exotic fruit rotting underfoot, and the smoke from the fires in the clearing she could see up ahead.

Tauro, the object of her mission, wearing nothing but his lion-skin thong and the leather straps around his upper arms, was tied to a stake in the centre of the Mayan village she had visited many times before, right beside a boiling caldron. Last time she was there, he was tied face down on the beheading stone in front of the chief's hut, his taut arse in the air, and the time before, he fought two leopards in a small wooden cage, armed only with the long laces from his sandals, while the villagers looked on and cheered. Tauro could be saved only by Elsie, and he was otherwise doomed to be beheaded, torn to shreds or boiled alive, only to re-emerge in another life-threatening tale of heroism.

This time, she had no spear or machine gun to help her rescue plan. When she reached the weapons cache, and despite having accrued points for saving Tauro from execution, there were none to be had. She had progressed to a level of martial arts skill where she was equipped with only her machete to defend herself, and she had to free him from his bindings, while the guards slept.

Elsie's pale blue acrylic shell suit was stained down the front, from the times that she had tried to feed herself whilst playing, and failed to connect the spoon with her mouth. She was indifferent to food when she was playing, and the porridge which George made every day was completely tasteless anyway, as he had never understood how to use the seasoning sachets provided. Elsie's trousers were stretched taut over her sanitary nappy, which Ellen recommended last time she was home. The chair had seen one too many accidents, and George finally gave up trying to unplug her so he could clean up.

"Fuck it, Ellen, she don't care anymore. I can't manage to lift her and if I switch it off to get her to eat or go to the toilet, she starts that fucking howling like a dying cat. I can't stand the sound of it, so I don't never want to switch her off in the middle of a game. If I wait till she's finished, I'm too late. I gave up talking to her 'cos she never listens any more. I haven't had more than a few words out of her in weeks you know. Nothing you could call conversation, anyways."

Elsie had no objection to the nappies, as soon as she realised she could play for hours without getting up. She'd go without food as well, if the VR deal wasn't time limited. George had increased the basic four-hour deal to ten hours a day a few months ago, when Ellen started topping up his account from her own income. It was simply to keep the peace that he upped it, and ever since she'd become so vegetative, he'd tried to cut it down again, but she just couldn't sit still without the mask on.

"I've even had to spoon-feed her while she drifts into another fantasy or she'll starve. Maybe you should save your money and we'll let her go cold turkey, down on the street, where she can howl as much as she likes. Last time I ventured out, it was like one of those fucking war games out there so maybe she wouldn't get bored at all. Once she's better, she might actually make the effort to talk to me, or we could drop her at that new day centre to make sleeping bags for the no hopers."

"Dad, you know she's not going to cope with less hours. And they're not no hopers, they're people who didn't have jobs to lose when you got your UI deal. Besides, you've got your thing and she's got hers. It's that or the "happies", and you know how much they cost. Jodie should cut down on them, you know. She won't want to get out of bed, and they're really expensive too. I can't afford to cover them as well as mum's contract. If I don't keep my job, she'll be going cold turkey without any alternative."

"Yeah, don't tell me. Jodie wouldn't need them if she had something to look forward to though. She always used to be so cheerful when she was at Tescos. I was thinking that if we could get her back to studying, she

could get some extra exams and get a job, like you did. We could spend the money that Elsie's wasting on VR and buy some educredit for her. It'd be a good investment, if she could get through them analytics exams like you did. She could earn her keep, instead of lounging around doing fuck all. We could get some real food and maybe sometimes get an M-rail into Oxford street or Camden, just for a walk around with some other people where there's police protection."

"There's no jobs, dad, even if she had the exams done. I might not have one soon, and that'll be it then. I'll have to move in with you and share Jodie's room and give up my flat."

"You hang on in there, Ellen love. You was always the bright one and you know there ain't nothing else once that's gone. Jodie'll be OK. I'll see if she might help me with the engines when she's bored."

Ellen had been visiting less since Jodie moved home, after she was made redundant when Tesco closed down all the high street outlets. A few months before they let her go, they moved her off the tills when the trolley scanners were installed and sales became fully automated. For a while, she was made to stand in a little booth near the exit, to make sure everyone was happy they'd been charged correctly and were happy to be scanned again as they left. That customer service role didn't last long, once people got used to talking to the app instead. Then Nimbus bought Tesco for its delivery service and that put paid to high street food shops altogether. Everything was being delivered from the farms and processing plants direct to Nimbus, to be packed centrally and delivered to peoples' fridge-micros. She'd applied for the warehouse, but they only had a handful of staff left on order management, with fully automated picking, packing and delivery, and she didn't have the programming qualifications for that. When she first lost the job, she started working on her analytics certificate at night, but pretty quickly, she lost the will to keep going, even with George and Ellen pushing her. Elsie had long since lost interest.

It had only been six months and already Jodie was climbing the walls with boredom. George wanted to keep her in all the time, after his

recovery from the mugging. The streets in Tower Hamlets became no-go zones for the police, and besides workers getting in and out of Ubers, only the M-rail slid silently towards the city, taking the eligible to work. Ellen was the only one left in the family with a job, and that looked set to change within a few months, if not in the next round of cuts. She was always the smart one, though. She earned well and George thought that if she could make a good match, it would mean they might get out of the block and into a low-rise somewhere with a bit of greenery to look out on. Jodie resented her, and George, who'd always protected her, had become hopelessly dependent on her to advise him on how to look after Elsie and to cajole Jodie to help around the flat.

"How's work love?"

George loved having Ellen round. It was his only real conversation of the week.

"Oh you know, dad. It's hard and fast. They keep upgrading the algorithms, and introducing new thresholds and premiums, so I'm run off my feet. Did you see on the NetCast News that Strasbourg let another hundred staff go last week? The thing is, they've got a new package which does my job, the G-Match applicant interface, without oversight. It's still being assessed, but the signs are that it's much more effective than people are at the same task. Even though they've got nearly half the population on G-Match, they're still cutting staff. Someone's making a fortune, but it isn't me. It's getting more technical every day, even though we see less of the code nowadays. They want us to be more creative and come up with off-the-wall ideas to pull in the insurance switchers, but I was trained to be an analyst, not an artist, or a con-artist either."

"So how are you meant to beat the computers? By being more illogical or something? What do they want you to do?"

"Oh you know. Come up with some way of increasing the premiums without people switching. They're busy cutting the benefits without telling people too. My department is trying to choose people for matches who

will stay together after the first three months, 'cos the biggest problem is break-ups. Everyone needs to feel part of some bloody club, and it's all about dating now, so I spend all day trying to check that the computers make the best matches."

"You're working on that dating app? I thought you were doing analytics. Some sort of clever way of looking at how people end up making insurance claims, not some dating app. So what's the applicant interface when it's at home? Sounds like a computer programme. Do people have to apply for permission to date? What a lot of bollocks! In my day, dating agencies showed people videos of each other and then they chose who to go out with, if they liked what they saw. Are you saying that it's all automated now? I s'pose they don't need someone to make a decision, since it's all numbers. Have you tried it? What sort of fellas does it offer you?"

"Yeah, everyone uses G-Match now, Dad. Even people like you, if they wake up and find their partner is, you know, living in a different universe."

Ellen smiled sweetly at George, trying to make a joke out of Elsie's problem, though he knew she meant it. She hated the way Elsie had effectively deserted the ship since she became addicted to VR. Sometimes she sneaked a look on the system at who it would pair George with, if he joined, but nobody came up who she could imagine as a step-mother, and besides, she knew he'd never give up on Elsie. Despite where Elsie had landed, George never doubted he'd stay.

Besides, George wouldn't be targeted by Strasbourg for potential custom, since he and Elsie were on UI, and also, they were still registered as a couple on the system. UI matching was a whole different department, fully automated, and with the sole objective of minimising costs to the system. The birth rate for UIs was dropping every year, which helped. Ellen had wondered, when she heard that, whether UIs didn't want children because they didn't have space or spare income, or whether something else

was suppressing the rates. Maybe they were putting something in the UI food boxes.

Ellen could still run a trial match sub-routine for anyone without overstepping her authority, and when it was quiet at work, or she needed a break from the real work, she picked friends at random and had a look. Jade had twice had a go at her for wasting time doing this, especially when she put her own name into the system several times in one week.

"I've been on it for a while, but all I've had is crap so far, dad. You know I'm on PQ restrictions, and they keep tightening up the scores, so I only seem to get the dregs offered to me. My score isn't that high, but it's becoming worth less every month. BMI points are up, and the cholesterol match is being re-graded. You'd wonder whether they're interested in people being healthier, or just in cutting healthcare costs to a point where nobody gets any."

"Rich people must be living longer than poor people nowadays, 'cos we ain't got the cover they can afford. I suppose the rich kids get a better selection of dates do they?

Then again, when I met your mum, it was just down to fancying her in the Mecca Dancing. I couldn't've cared less what her cholesterol level was. We was both drinkers and smokers, but then people died of heart attacks all the time at fifty or whatever."

"Yeah, I know, dad. That's why I'm paying for it now. If you and mum had been a better match, I'd be fine. Still, you never even had your G-map done till I was born, did you?"

"I didn't have to, and I wasn't going to waste my money on getting chipped back then when it was optional, 'cos there was no incentive. If I'd been single, maybe, but we was happily married and healthy too. Then your mum went into the system when she got pregnant and I had no choice, and we got scored down, and even when I was at Fords, I couldn't afford their healthcare plan. Not that it matters any more. The basic package is all we

get on Universal Income, and that's no fucking use to man nor beast. So you only get offered matches with men that are good for your health, and not the ones who you might fancy the most? That sounds crazy."

"Yeah I know, and it's not my health they care about, but only if I'm going to have children. The last guy they set me up with was a PQ75, and I'm a 78 at the moment. If he'd been even slightly, you know, attractive, I'd have been OK, because we'd have been about 150, and the premium would still be manageable, but he was thick as two short planks and weedy looking. Any man with a bit of something about him is way lower on PQ, and then he'd be looking at my PQ and thinking he couldn't pay the premium, or he wouldn't fancy someone with a higher PQ than he had. I would be fine without health insurance, as I'm fit as a fiddle, but then I couldn't get Jodie's pills, and I couldn't sign up to G-Match, and I'd be on loads of blacklists which would make life miserable. They don't give staff the gold or platinum packages, you know, even if you work in the insights department like I do. I have to get a promotion to be offered gold, and there's not a lot of chance of that when they're replacing so many people with new computer upgrades. My boss, Jade, is on platinum, but that's because her dad invented the whole system."

The insurance industry became concentrated in the hands of fewer and fewer companies, and through acquisition, Strasbourg built a UI insurance business second to none, because of the marginal savings they could make on volume. They took over ageing hospitals and clinics with minimal investment, using second-hand stripped-back outdated technology which was being replaced in the premium clinics servicing employed people. Robotic surgery was one of the few areas which were cost-justified, and day-care hospital facilities predominated, alongside automated home health.

Last winter, George was down in his workshop, putting the finishing touches to a gearbox which he'd stripped down and re-built several times. There was a knock at the door, and when he opened it, there was a spotty young fella there with a lopsided grin.

"Hey mate, You got a spanner I can use for my mum? Her wheelchair's got a wonky wheel an' she keeps going round in circles." He looked pretty shifty and George wasn't about to invite him in.

"Where're you living son? I can come round 'n' give it a butchers"

"I'm in the flats. Block 12. She's a bit funny about stranger's mate. No disrespect. Look, If you've got an adjustable wrench, that'll do. Let me have a look at the tools and I'll tell you the size."

Against his better judgement, George turned to look over his shoulder into the workshop, and as he did so, he was hit on the back of the head by an iron bar. As he went down, he felt the young one's boot in his ribs, and then a fist to his face.

He lost consciousness with the second blow to his head, but before it struck, he could hear the sirens.

When he was taken into Mile End Hospital A&E, it was like the Marie Celeste. Because of his chip, he was tracked continuously by Strasbourg, and when he was mugged, its early warning system could respond quickly. His medical requirements were logged as soon as he received the first blow to his head. The ambulance was scheduled and despatched while the mugger and his mates kicked him in the chest and face, and stabbed him twice. It arrived before they'd left the lock-up, laden down with car parts, and George lay in a pool of his own blood. With nobody on board, the ambulance sent vids to security services of the three retreating bed-rollers who were picked up minutes later, arrested and deported within a week. George's vitals were all monitored throughout the assault, via his chip, and fed to the admissions unit at the hospital while the driverless ambulance was on its way to the lock-up. He was lucky that these were amateurs. Professional attackers would have smashed his wrist first to disable the chip so that they would not be filmed leaving the scene.

George was lifted carefully but unceremoniously onto the trolley by its robotic hoist, and shovelled into the back of the vehicle while the

soothing trolley audio instructed him to lie still, and the morphine injection was administered by the trolley arm. By the time he was wheeled into Mile End A&E, the system had his surgical requirements set up on the ancient Da Vinci operating robot in Theatre 4. The trolley slid out of the side of the ambulance and followed the magnetic floor track to the surgical wing, where it lined him up on the conveyor which fed four operating theatres in rotation. Despite the morphine, George was still conscious, and found himself between a jumper with two broken legs, who cried continuously, and an unconscious burn victim whose story he never found out, as the hospital worked its way through the evening list. In each theatre, Da Vinci surgical robots worked quietly and efficiently, while robotic orderlies cleaned and replenished supplies. Nobody attended the operation, because there was no need for human intervention, and he was left alone with his fear, despite the painkillers. There was no general anaesthetic available on the UI policy. That was reserved for platinum policy holders who might be eligible for a day in the recovery room. George's broken bones were re-set and pinned, and his stab wounds stitched in fifteen minutes and as his trolley followed the tracks back towards the ambulance bay, he was signed off by the only person on duty, a first year medical intern slouched in the control room, fifteen hours into his shift, without a personal examination. The surgical tools made their report, matched it to George's chip feed, and established adequate recovery scores. The data on the four screens arrayed before the intern allowed him to say 'yes' to each of the four release forms generated from the throughput of all four theatres simultaneously. It was an outdated formality. The intern would not have known what to do if George's recovery scores were low, given his lack of additional cover for hospital care, and post-operative medication had already been provided, so now it was up to home care.

From the theatre, he was delivered back into the ambulance for the short drive home. By the time Jodie reached the front entrance, to take him up in the lift, he was regaining consciousness and could help himself off the trolley and into his and Elsie's bed without the hoist. The trolley took itself back to the ambulance as soon as he was offloaded.

He'd been supplied with slow-release medication, controlled by Mile End in response to his chip feedback, and for six weeks, he was on pain killers and antibiotics. As they ran out, George's auto check-up results were fed back to him through his v-mail by Strasbourg, reporting acceptable bone growth and tissue healing. The v-mail wasn't a courtesy. It instructed him in no uncertain terms to get off his arse and do some exercise, or have his premium penalised and his emergency care package frozen for six months.

All the v-mails he received about the incident, ostensibly issued by the hospital, but actually from Strasbourg, were clearly circulars, compiled and personalised to his case, and containing the usual friendly CGI characters. George wasn't bothered that he'd spoken to no one in the whole process, from the beginning of the assault until Jodie came into his bedroom five days later with his breakfast porridge. What was the point of listening to a real doctor tell you what the machines already knew and why make the painful journey back to Mile End for a check-up when the chip reported exactly how his recovery was going moment by moment. All in all, it was faultless. His PQ was like a roller coaster of course, and had he had a job, his premium would have cleaned out his bank account, but on UI, you don't have to pay for care, when you can get it. The smooth talking CGI 'doctor' in the white coat in the v-mail, which had never studied medicine, told him how much exercise he must take, and showed him YouTubes of how to go about it. Another v-mail arrived shortly afterwards from a smart young CGI 'executive' in her navy suit and white blouse, seated behind a large polished desk, warning him not to enter any unsafe zoned outdoor areas or he would forfeit his emergency care rights under the policy. Fair enough.

As a Strasbourg employee, Ellen's Silver Policy premium was paid at source, and she had no choice as to her level of cover. She had never claimed on it, and had never been told how she could do so. Likewise, George, Elsie and Jodie received their UI after deduction of insurance contributions, and they had no idea how to claim against their policy. All their medical costs were sent direct to Strasbourg, as were their contributions to local policing. Other private contractors received payment direct from the UI

system for running schools and managing the UI housing. Nimbus took payment from the government for their food supply, plus their limited access to phone and TV, leaving the family with a book of vouchers each week which could be redeemed against laundry costs, cosmetics and toiletries, 'happies', VR and other small luxuries. There was a black market in vouchers of course, but there was very little contraband to be had, and it was all at exorbitant prices. Mostly the dealers supplied watered down alcohol and various uppers and downers, and took peoples' voucher books off them to sell on to bed-rollers to buy food with, in exchange for dealing.

Jodie was unpacking the weekly food box onto the kitchen table. She was nervy and restless, shuffling about in her grey hoodie and drainpipes and the inconsistent pink fluffy slippers with ears on, which had at some time been Elsie's. Despite a lethargic gait and unkempt appearance, she was methodical and economical in her actions, as she moved between the box and the cupboard, stacking the shelves with packets. Jodie never felt calm, even when she was exhausted and half asleep, despite the higher dose of SSRIs she was taking. She had dark rings under her chocolate brown eyes, and her straggling fringe hung close to her eyebrows, obscuring her frown. She was always beautiful and inscrutable, and she rarely smiled. Now she seemed to Ellen to be even more withdrawn and unhappy, which she was. She was only 23 but she looked older. Her skin had been the colour of honey, but had begun to show a grey green tinge, like Elsie's, since she wasn't going out. Ever since George's incident down at the arches the whole family had been on lock-down, and besides, Jodie was no longer interested in going out, or in meeting her friends. She started to age more quickly once she went on the pills, and she was losing weight. A year ago, she'd have been called lithe, or fit, by half the lads in Tesco, and now she'd be called scrawny, though she wouldn't, because the lads in Tesco were all gone, along with the store.

Even George had started to see the change, though she was always the apple of George's eye, the baby of the family and gorgeous as a teenager. He always thought she could have had her pick of the boys in the old

days, if she'd been out at dances, like George used to be, every Saturday night. She'd have knocked them out down the Mecca. But when she was G-Mapped at birth, and with George and Elsie's biological quotients, and her personality scores, Strasbourg wasn't going to do her any favours. Elsie and George had a combined PQ of 190, which is pretty bad, though they never really cared, since they were settled and Elsie was already seven months gone with Ellen when they found out. George was always overweight, and Elsie was big boned. She was such a strong woman when she was young, and never a day's sickness, even though she turned out to have high blood pressure and had to spend half her pregnancy in hospital. That was in the days when they'd take you in for rest without killing you on the premium. Wouldn't happen anymore. Even with Jodie, Elsie had to rest up at home, which was hard, since it came off her mat leave and Fords were cutting overtime after they lost the Uber Autocab contract.

Ellen was born with a PQ79, which George thought was pretty good, in his naivety. Nobody really understood the implications of the new PQ scores then, and the Strasbourg FAQs told him they could re-test her at sixteen to see if any of the personality or academic scores had dropped. Two years later, before he'd seen the impact on his premiums, Jodie was born a 95, and straight away the monthly charges went up. She had the same Biological Quotients as Ellen, more or less, but her personality scores were much higher. She was always a restless, irritable baby. She was colicky, always whinging and prone to screaming fits when she didn't get what she wanted. She was so different from Ellen, who'd been docile as a toddler. George used to tease Elsie that she must've had a quickie with Billy the caretaker while he was at work. And she might've. Billy was built like a whippet and laughed like a hyena at Elsie's jokes. Always helping her into the lift with the buggy and her shopping, so it wasn't so far-fetched. But George and Elsie had always been monogamous and neither doubted the other. Jodie was diagnosed with ADHD, and the methylphenidate was way outside their budget, so she suffered from a short attention span, anger management problems and anxiety. She found school hard and failed most of her GCSEs. She was always breaking house rules as a teenager

and staying out late, hanging out on street corners with a bunch of lads. Needless to say, she was pregnant at sixteen by one of the street kids on the estate. At the time, Strasbourg offered special rates on abortions to children in low income families, because in the long run it saved a lot of claims, so Jodie was marched to the clinic by Elsie, who still held out hopes she'd return to school and go on to college, like her older sister. That was when Elsie was in charge, and George just went along with it, even though he wondered how Jodie would cope with the grief. He'd always treated her like a child and he found it impossible to talk to her as a woman. The abortion was never discussed, but he could see that the light in her eyes just went out after.

Once Elsie lost her job, which was soon after the abortion, Jodie didn't go out much as there was no spare money. She didn't go back to school because she became really depressed and it was only the job at Tesco which saved her from self-harm. She took to the routine, loved the bit of money and started going out again, once a week on a Friday. She mainly went out to avoid the rows with Elsie, who wasn't coping well with losing her job, and clearly begrudged Jodie her nights out, when she and George were settling into the UI rut. That was in the months before Josie tried out the VR. They fought over nothing, and said terrible things to one another. Jodie blamed Elsie for pressurising her to have the abortion, by forcing her to a decision which she'd never felt was hers, and Elsie blamed Jodie for failing to get her act together and go back to school. The atmosphere at home became explosive, and George always took Jodie's side. Elsie was suffering terribly with the withdrawal from work, and her loss of status meant she felt threatened and insecure. George tried to cajole her, while defending Jodie, but he had never been much of a debater or persuader, and usually ended up leaving the women to their sulking and heading to the arches to play with a gearbox.

Elsie's VR obsession started as a bit of fun. It was Ellen who'd bought her the first headset as a Christmas present, and since then, she'd upgrade twice, and added the gloves and stepped up her usage to ten hours a day. Jodie hated seeing her mother slouched in the armchair, and refused

to help George clean her up when she soiled herself, or feed her when she wouldn't switch off the headset at mealtimes.

"She's fuckin' disgustin', dad, and I ain't touchin' her" Jodie wailed. She had developed a street patois since she left Tesco, and laid it on thicker to annoy him.

"Look, love, I can't do it on me own, and she's past caring. If you don't help around the place, we'll end up living like pigs, and Ellen'll stop coming round, and it's not as if we can open the windows to let in some fresh air, is it?"

"I ain't doin' it. You can change 'er fuckin' nappies. I'll do the kitchen stuff but she's your fuckin' wife."

"You watch your language, girl. What's got into you since you lost your job? Who're you trying to impress? Not me, 'cos I know who you are, Jodie. I know you're a sweet an' loving daughter under all that shit."

Once the insurance went up, he and Elsie did what they could to lower the premiums by behaving sensibly, exercising, eating only what they had in the food box, but you can't fight genetics. Once you've got the score, you're stuck with it. Everyone was grappling with the concept of PQ scores and how they affected your life. It was bad enough being forced into behaving sensibly for the good of society, and all the nanny state garbage they were fed by the media, but the PQ crept up on everyone. As soon as they were on UI, George and Elsie dumped their Nimbuses and took no notice of their PQ, though the diet they found themselves on was low fat, unpalatable and unlikely to contribute to obesity. Whatever their scores were was no longer their concern, since the Strasbourg premium was taken out of their UI at source, and they had no control over it. If there wasn't enough to cover the insurance, so be it.

In the early days, when the kids were small, George spent hours online, scanning for alternatives to the PQ. Loads of sites used to offer fixes, though most of that stuff was fraudulent, and Strasbourg and the

others quickly moved to close it all down. Some of the more gullible people George knew at Fords got burned, before they lost their jobs and had no discretionary income any more, paying out their hard-earned savings to crooks who claimed they could hack the chips or the database or whatever and lower your score. George had once been caught like that trying to clock the milometer on his Cortina as a lad, and he'd been up in court then, so he knew it was a bad idea trying to cheat the system. Ellen said it still happened a lot at Strasbourg, and she told him all about the Egress files and the security department and that the whole chip hacking thing had become an epidemic. People who went off the grid were arrested quickly, if possible, because every hour after they cut the connection made it harder to find them. Anyone looking to do it properly pre-planned their escape and used a load of diversionary tactics to confuse the drones and online tracker bots which were sent out to relocate chips as soon as they went down. Anyone who was found, and that was most people who naively thought they only had to demobilise the chip and they'd be left alone, was deported. Deportation had become popular for all white-collar crime, as it was cheaper than prison, and with the universal tracking options, and compulsory chipping, there was very little organised violent crime in the old-fashioned sense anymore. There was no incarceration in the UK for hacking, the most prevalent crime of all, as the prisons were full of no-hopers, living on the streets, who had caused disturbances when off their heads. Jail was more of a drying out facility than a deterrent against crime.

When George had the job at Fords, and they had a good staff healthcare scheme, he thought the high insurance costs for Jodie would only be till she grew out of all the temper tantrums and got over the colic, then he'd have her re-tested and she'd come down in cost. When g-mapping came in first, it was described as a wonderful new way of picking up the minority who had genes with potential problems for their children, like Downs or Spina Bifida or whatever, and that you could ensure a healthier population where healthcare costs were driven down and more could be spent on education and the environment. Everyone bought into G-mapping as a way to make sure their chosen partner didn't

carry genetic problems, before they married or started a family. But then it began to infiltrate daily life in every way. Never a week went by without a new advisory v-mail from Strasbourg:

'Don't eat full fat if you've got a PQ to die for.'

'Drink bottled water, it's points-free.'

'Wear your mask on the M-rail; or the bugs will hit you where it hurts, in the wallet.'

Then the patronising and authoritative v-mails tailed off, and the PQ became fully automated. They didn't tell you how the algorithms worked or what you did that caused the premiums to go up or not. They just penalised inappropriate behaviour with charges, and everyone tracked themselves and worked out how to reduce their scores, like meditating to slow your breath, or exercising your brain to win at the pub quiz or something. It was insidious and threatening. Everything registered on the chip and the chip could be read everywhere you went, from the kharzi to the bedroom. If you were a PQ95, and you were lucky enough to be fucking your neighbour's wife, who was a stunning PQ60, their premiums would rocket, rather than yours dropping. If you ran down the stairs two at a time, because you were late for work and the lift was out of action, your premiums went up, even though the exercise should have been good for you. Broken ankles cost a lot in medical care.

Everyone learned what not to do, and everyone got offered what the insurance companies deemed good for them. George's old habits died hard. First the cigs, then the booze, then the cream in food, the chocolates and chips from the chipper, then the coffee and sliced pan and so it went on. Sure, he could still buy most of his little indulgences, if he had the money, but he couldn't afford the healthcare premiums they carried as well as the purchase price.

Ninety-five turned out to be a high PQ. When it came to Jodie finding boyfriends, it was high enough to negate the benefit of her beauty and

creativity, her fun-loving mischief and the depth of her brown eyes, her perfect sallow skin and the way she smiled when she got what she wanted. Ninety-five made you a bit of a pariah it turned out, and that meant you had to be rich or not at all choosy, and Jodie was always choosy. After the abortion, she stayed in a lot, and only when she settled in with the lads at Tesco did she start dating again, but now all that was gone.

It had been a while since Jodie went out with anyone. She really wanted to meet the right guy, but they were all sub-70s and they couldn't afford, or didn't want, to go out with a 95. There were plenty of men with a PQ80 or above who were stuck on G-Match all the time, hoping for a 50 or a 60, and getting nowhere. Some of them even had good jobs and prospects. It's not that she didn't look great in the video, even though it was made a year ago. She was a lovely young woman with a lousy genotype and an unpredictable personality, and there were no longer places to meet men who didn't pre-check her scores. Everyone had Nimbus contracts, and informagear was a social pre-requisite. If you did go to a club where you were off-grid, you were expected to be up-front with the score. Most people read your PQ even while they were saying hi, or when they entered the room, scanning it on their Nimbus before using their eyes. It was no longer considered intrusive. Meeting someone who wasn't easy to read or who was using a PQ blocker to stop people checking their score was a quick turn-off, so Jodie quickly got used to rejection, and lost confidence, and stopped going anywhere where people 'blind-dated'. G-Match offered everyone a less hurtful introduction, only to those unlikely to reject each other on PQ grounds.

When she first lost the job, and realised she would have almost no discretionary spending under UI, she let her subscription to G-Match go, and went down to the arches a few times to see if there might be some action on the street. She knew that bed-rollers in The Village would ignore her PQ if they themselves were poor enough not to be paying their insurance, and most of them didn't have any means of reading each other's scores anyway. The insurers had very little interest in the G-Match

service for people on UI, because they would never receive more premium than the Government subvention once someone was unemployed, and for almost all these people, finding a new job was impossible. But going on the street hadn't worked out well, and the last time she'd tried to socialise under the arches without pre-arranging it, George had to come down with a crowbar to sort out a bunch of bed-rollers who had her up against the wall. Luckily the surveillance camera there was set so high under the arch, and encased in a wire cage, that nobody had managed to stone it, and luckily the attack happened when George had the wall TV on constantly for Elsie, before she retreated into the VR.

Jodie had suddenly come up on screen, getting into difficulties. He'd opted to have her tracked when she left the building, as a precaution, since she had always been unpredictable and unreliable, and had become more so since she'd lost her job, before they got her onto the 'happies'. George immediately recognised the arches, where his lock-up was, and he was up and out of the flat as fast as he could move. Lucky too that the lift was working, and that he had his tools in the flat. Once he'd waved the crowbar about a bit, and put his seventeen stone body between the three lurching junkies and his daughter, they scattered quickly enough. They were only teenagers, and off their heads, but he knew they'd have had her and then slit her throat, soon as look at her, and this part of Tower Hamlets was justifiably an unsafe zone.

When Ellen arrived, Jodie buzzed her in on the old box by the apartment door. The main door should have opened automatically, since Ellen was family, but George had never registered the family members on the L block database, because he didn't fancy everyone knowing who their visitors might be, and the old estate computers were so insecure, even a five-year-old hacker could pull everyone's data and work out when apartments might be empty or when vulnerable people might be alone. Not that they had many visitors, even then, but he was always funny about privacy.

Jodie was so bored now that she enjoyed sorting out the groceries when they were delivered each week. It reminded her of Tesco. In her empty day, it was one of the few tasks she looked forward to, even though the box contents hardly ever varied. Besides bottled water and the weekly book of washing tokens, there were the usual seven family tubs of microwaveable porridge, full of the required mineral supplements, but not much calorific value. Then there were sachets of curry and Bolognese flavouring, which they rarely used, and enough low-cal drinks sachets for the three of them to have one each a day. Jodie did think about trying to trade the flavour sachets at the barter shop in Q block, until she found that everyone else had the same idea and nobody wanted them.

This week's special was 'the roll of roasting beef', which hadn't seen a cow before but as far as George could remember, was pretty realistic. They had a choice of this or the 'chicken', which was OK, but only lasted two days, compared to three or four with the 'beef'. Jodie had never eaten chicken or beef, and the last natural protein she tasted was some sort of pulverised maggot steak which had been illegitimately reclassified from agri-protein to human food. It was one of those 'real meat' scams, involving Department of Health corruption and importation documents being signed for fees. The product was dumped on the market by a South African conglomerate a couple of years ago, when she still received discretionary food vouchers she could spend in Tesco. That scam had lasted all of six months, until A&E departments started filling up with botulism cases. Since then, and before Tesco closed down, all unprocessed food imports were stopped, and food processing now took place in one of those vast automated factories outside the city.

On principle, let alone the botulism scare, Jodie was not a big fan of animal protein, or synthetic meat, which was almost all grown in laboratories from bacteria. She'd been brought up to kill bacteria with antiseptic sprays, not to eat them for nutrition. If the family was better off, for instance if she'd been made redundant from a government job, there would be dried Krill shavings every week in their B plus box. Jodie's friend,

Carmella, who had lost her job in The Central Bank, and was eligible for an A-plus single person box, occasionally invited her over for a fish curry, even though Jodie could only bring her porridge ration as a contribution. Carmella was a good cook, and ever since the bank let the last of their staff go, she'd been traipsing the city in search of spices to bring her rations to life. The porridge was flavourless, but it mixed well with the Krill and turmeric to bulk up the curry.

Jodie was unpacking their Standard Box B, for three adults, or two adults and two children. The words 'Box B' were printed in giant letters on the side, in case the recipient might pick out the wrong box in a mass delivery, which often happened in the lobby where the boxes were dropped on a Monday for all the apartments in the block. It was barcoded with the family's details, so the truck-bot was sure to dump the same shit on the doorstep every week. It got stacked in the communal hallway, along with four or five other Box B's and several Box A's for the singles, and one or two Box C's for the largest families. This block had no premium boxes delivered. The apartments were smaller and less well furnished than Carmella's, and besides, if an A plus box were delivered, it would be snaffled before you could say 'Krill Curry'.

Bigger families which were allocated a Box C seemed to get slightly less food per person, which was presumably intended as a discouragement from having more children, but it was all the same shit, as Jodie established once when she fancied a change and opened someone else's Box C to check.

When she first started at Tesco, Jodie topped up the larder with whatever she could get from work, which was considered special staff perks. Every night, the branch manager gave out damaged packs and some out of date items to the staff who worked hardest. It was presented as a perk, but really it became a big bone of contention when everyone was competing for leftovers, because they were working for minimum wages. Jodie was always among the top employees when it came to productivity scores, as she'd learned to keep moving all day. She had been told by the

store manager, who had been trying to get his dirty hands into her knickers for months, that the staff productivity algorithm scored distance walked in a day as the number one measure of productivity. Once she knew that, it was easy to fiddle the results. Even if she was taking her lunchbreak, she'd eat while walking up and down the aisles, and she loaded shelves by parking the pallet as far as possible from the display.

Jodie always retrieved the box from the lobby on a Friday, as soon as she saw the delivery on the door cam, ever since the squatters from the basement apartment had raided all the boxes for the tokens, and the family had had to manage on reduced rations all week. George was meant to be the hard man and go downstairs with his crowbar or a baseball bat to sort them out, instead of fucking around in his lock-up, but he was too busy cleaning the carburettor to do his thing. The squatters were from The Village under the arches, and they slept in the basement when it was too cold out on the street. He didn't begrudge them their bit of heat, and even the occasional foray into the lobby to look for scraps.

"What's the point of all the work you do on that engine, dad?" Jodie complained. "Even if you ever get it running, you'll have nothing to put in the tank. What's the point of searching for parts on those sites, when we haven't got any spare cash?"

"That's not the point, love. I only need one or two more parts, and I might get lucky with someone who would swap what I need for some spares I've got. It's a classic. I built them gearboxes for years. I can do it with my eyes shut and one hand tied behind my back. Besides, it's not about finishing. It gives me a reason to get up, and a reason to get out of this prison and feel the weather. I know you don't understand. You should find something that occupies your brain, like me, instead of taking the 'happies' every day."

"That's not fair, dad. You know I didn't want to be made redundant, and I want to work. I hate it in here as much as you do, but there's nothing

to do. I know you want me to get the analytics exams and to get a job with Strasbourg like Ellen, but like she said, there's no new openings, and I can't concentrate on the studying if I take the pills, and I can't get through the day without them either. What am I meant to do?"

George and Jodie had never been on the same wavelength when it came to decision-making. He was much more like Ellen, without the mental acuity, and Jodie was like Elsie used to be, full of emotional intelligence but not prepared to apply any logic to her life.

Jodie's pills were costing a lot, as they were the high dose. They kept her from wanting much though. Nothing at all really. She no longer felt the need to find a partner. She couldn't be bothered cooking so they only ate the prepared microwave mush most days. It all looked the same, smelt the same, tasted the same. She never cleaned the apartment, didn't make any effort with Elsie, and had almost nothing to say for herself. The Educredit they received as part of the UI wasn't getting used, and she knew she would fail the exams if she even went ahead with them. George had given up trying to change her, and Ellen was never around to bring them together or to push Jodie.

"Whatever else you do, you should lay off them pills. They're draining your brain. You need to be sharp if you want to survive. And we could use the tokens for some more Educredit for your analytics exams. If you don't bother even trying, you're fucked." George was like a scratched record.

Jodie was meant to be re-sitting her analytics exams next month even though she'd got no chance, any more than any of the thousands of other hopefuls, to get in to Strasbourg Insights, or any of the other insurance companies.

Ellen collected up Elsie's dirty washing and stuffed it into a carrier bag. She'd been taking her parents' laundry home more often, in an effort to save their tokens, and putting it into her own service. Elsie didn't notice at all, but George was grateful.

"Are you off, love? Careful outside, going to the M-Rail, won't you. It's meant to be unsafe round here, you know. Not that I'm covered for being attacked anyways, since the mugging. I can't go out unless I want to take my chances. That's what the crowbar is for, you know. Maybe I'll walk down with you to the stop, just in case."

"Thanks Dad. I'll be fine. It's early, and people are still going home from work."

"Yeah? Round here? You must be joking. Nobody within five miles has seen a pay packet in years. Come on, let your old dad accompany you to your train."

As they walked out of the block into the heat, George stepped in front of Ellen with his crowbar held like a sleeping baby in the crook of his arm. He looked left and right before he took a pace forward to let her out of the porch of the building, and they walked quickly to the M-rail in silence.

CHAPTER 3

John

John Vaunt had been on the move for weeks, dossing on peoples' couches, renting rooms with other peoples' ID, eating from other peoples' boxes. He travelled light, with a rucksack containing a change of clothing and a small Nimbus Pro he'd adapted. He could've afforded anything he wanted, having found his way into bank vaults and Nimbus Retail order services, but he had no interest in acquisition. He rarely tried to partake of luxuries, even though he could have paid for them from other peoples' accounts, because he found he couldn't stomach the hypocrisy. Many of his associates used their hacking skills to cream off whatever they wanted for themselves, and their families and friends, and some even lived like rich kids, in Hampstead or wherever. Hacking was a way of life which became ingrained when you started out, and most of the hackers had come from one sort of deprivation or another. John had had the opposite experience until his teens, and while he agreed with the socialist view that the wealth of the country needed to be redistributed, he didn't agree with taking whatever you wanted just because you could.

He'd been off-grid for over two years, and had become used to his low-key existence, effectively living hand to mouth and on his wits. Since he joined the hacking community, he'd preferred to view himself as part of a political underground, a fighting force. Of course the image was a bit hackneyed, and he'd come to realise that underground movements suffer from lack of sunlight. Their members become blinkered and one-dimensional in their approach to solving the problems around them. It is, in the eyes of the hacker, about breaking into corporate enclosures to free up resources, and in some way pass them and their benefit out to those who have less.

Gimme was John and Nick Artremis' invention, and they'd been very selective in recruiting its members. They didn't want disaffected terrorists, and they didn't want robber barons or organised crime members. They wanted a crack team of morally reasonable hackers which would respond to their leadership and focus on their strategy, rather than playing pranks, getting greedy or being destructive for its own sake.

This was all part of an endgame for John and the members of Gimme, and playing Robin Hood would be a distraction from the co-operative's stated objective to bring down the establishment which they felt was degrading the quality of everyone's life. In his view, nobody represented the problem more clearly than the great Stanislav Janekowski, and no institution epitomised the establishment more than Strasbourg Insurance PLC.

All the time he'd been hiding in plain sight, in the city, close to the action. He'd been inside the servers of Strasbourg for about a month, every night, with full coder status, which he'd hacked during a fling with Stephanie, a young and ambitious systems architect working for Strasbourg's R&D department whom he met on G-Match. She was happy to boast about her pay grade and clearance level, once she understood him to be working for the MoD in a National Security role. Her Nimbus had given him all her passwords during his first attempt, sitting on the toilet, locked in her bathroom as she slept. It reminded John that weak cybersecurity comes with arrogance, and that Gimme should be reminded all the time that they were underdogs, and not controllers.

Once he was into the servers on that first occasion, he'd headed straight for the G-Match database. Having set up a fake ID with all the right scores in preparation, he was able to replace John Vaunt with John Valance and receive his new PQ, direct to the Nimbus. Once he logged into G-Match, then, he immediately received several invitation v-mails for dates. His own score of 60 gave him his pick of the low PQs, but he wasn't really looking for a partner, so much as someone in Strasbourg with the right pay-grade for access to the more high-level programs.

By the time Stephanie woke up, she saw him sleeping beside her and tried to read him with her Nimbus. She found his profile and PQ were locked because he'd put a block on his status, citing his work as justification. But because she was a systems architect with good clearance, she decided to circumvent protocol and to check him out through facial recognition as he slept. A quick scan revealed his PQ, together with details of his health, family member profiles, home, social media use and travel history. Everything fitted the story he'd told her in the Sombrero the night before and was totally plausible. His PQ made him eminently eligible, and she began to consider the possibility of dating him again. When he woke, they continued where they'd left off the night before, and by the time they were done, and John had had a shower, it was time to leave.

Stephanie had to rush with her preparations for work, for which she'd be two hours late, and John made vague noises about going out again, without enthusiasm. When she tried to reach him later in the day, on the number she'd taken from his profile, there was no reply. After her first incursion, he had put a block on his v-mail that she couldn't circumvent, and within a week, she'd given up trying to find him. For John, she was only a stepping stone to obtaining access to the servers. Once he'd stolen all her passwords from her Nimbus, had a couple of hours' sleep and shared her breakfast, he headed back to his temporary accommodation. He was sharing with Micky, a fellow-hacker who had a flat in Stockwell, in a grubby one-bed which was more than adequate for them both, in John's view. Sitting cross-legged on the floor by the bed, he waded through the staff files, looking for the right person to work on. He wanted a senior person, close to Stan, who worked in either Insights or Security. It should be a woman, because John knew the power of his charms, and it should be someone who liked clubbing, had a broad selection of business friends so that he could build a network through her, and someone he didn't find unattractive.

Once he got into the departmental files, it came down to two or three possibles, and of these, one overwhelmingly appealing target with

the uniquely appealing name; Jade Janekowski: Status Engaged. Jade had the authorisation level, the surname and the right social media profile, but was clearly not in the market for a fling, having become recently engaged to a rich kid called Jasper. John thought of playing a long game and causing their break-up, if he could, by inserting negative messages and images into Jasper's profile for Jade to see, casting doubt on his honesty. But that would take a long time and wasn't guaranteed to succeed. If Jade was going to be any use to Gimme, John would have to get into her Nimbus and pick up her passwords, so that he could use her ID to hack Stan. He didn't want to give up easily on her, because she was so near to his ultimate target, so he did a bit of digging into her profile to see what alternatives there were. Among her contacts were a couple of women who caught John's attention. Both were close to her in different ways, and both were very attractive and single. Ellen Franklin, an Insights Analyst working directly for Jade, was gorgeous and had a really interesting PQ, but she didn't seem to be spending much time with Jade outside work. The other, Janine, was pretty straightforward. She was dating a lot, loved partying, and lived in the same flat as Jade. Janine made more sense than Ellen, even though he knew he would like to meet Ellen and find out how she operated in her work. She had great scores for emotional intelligence and everything in her profile pointed to a conflict between her job and her personality. Ellen might be ripe for winning over, but Janine offered a much more logical back door to Jade's life. John had often slept with attractive women simply to have somewhere to stay, and had he bumped into Janine at a party; she would have been his sort of target for a one-night stand. The fact that she was sharing a place with Jade was ideal, and he decided that he could kill two birds with one stone. He wasn't keen on sleeping on Micky's floor much longer, and the flat in Islington which Jade appeared to own, was very smart. Janine was a rich kid, and connected through her father to Stan.

John lounged in his boxer shorts and tee-shirt on the bed in Janine's room, in the two-bedroomed apartment she shared with Jade. It was the smartest place he'd stayed in months, taking up the whole of the first

floor in an Edwardian double-fronted mansion in the heart of Islington. Despite the mess of Janine's clothing, ashtrays full of reefer butts and empty champagne bottles, it had period charm, high ceilings, disused Edwardian fireplaces and plenty of new tech devices. Must've cost a bucket-load of shares in Strasbourg for Stan. The road was quiet and safe, without being too suburban, and Islington still had some lovely restaurants and pubs which were not kitted out with all the personalised menu screens or scanners, and therefore less intrusive than the new places in the West End where you couldn't get in without the right PQ, and blocking was not an option. Unlike many of the amateur chip hackers who all tended to get caught pretty quickly, John had worked hard to establish his alias, and while his anonymity was not really at risk, because of the time he'd been off-grid, he saw no point in walking too close to the electric fence and being detected. It was unlikely that he would put a foot wrong in the way he presented himself, but more likely that he'd be noticed as being too low-key, and be identified, like some black hole, for not being there.

Having a fake profile replete with PQ meant he didn't have to block access, or to explain himself in the majority of situations. He had secured himself a VIP option with the PQ database at Strasbourg, only available to a few dozen people, all mainly senior defence staff and politicians, which allowed him to switch off his PQ tracking completely. He didn't like to make use of this, because it drew more attention than it avoided, but at least it was an option in a tight situation. Most clubs had a door policy demanding visible PQ, and some had set maximum scores for entry, to maintain some spurious exclusivity. Needless to say, one could bribe a doorman to bypass the scanner, and lots of places let girls with higher PQs in before 10 pm, if they looked pretty. Islington was more bohemian, and most of the pubs and restaurants didn't operate door policies. Menus were still printed on paper in some places, and once you got in, it was even considered uncool to scan someone with your Nimbus to check their scores. Needless to say, the toilets were always full of singles scrolling through their Nimbuses which had been set to proximity monitor all the people in a bar and store their locations in the room. They'd go into a

cubicle, have a quick look at the PQs they'd identified and try to memorise their positions in the room, then come out, pre-armed with enough data to help choose or avoid potential partners. John enjoyed the unpredictability of not knowing anyone's PQ. For him it was all about instinct and impulse. Without the usual constraint of insurance premiums to fund, he had no reason to select people based on their PQ. For him, if he liked someone, that was enough, while they might be checking out his PQ60 before they reciprocated.

There were few tracker drones patrolling Islington, which was not a typical hiding place for off-grid subs, so when he left the flat to go to the local shop, or over to The King's Head for a beer, John could be left in peace and no questions asked or reports made by shopkeepers or barmen.

He and Janine had returned late last night from the West End, and she was buzzed in as soon as the door-cam scanned her, despite being draped on the arm of an off-grid chip hacker, because John's chosen identity was faultless. Janine was happy to have John in her bed because he had what it takes. She didn't need to worry about his PQ, even though she thought she knew what it was. She didn't bother to check him when he hit on her in the Sombrero, which was old-fashioned enough that it was uncool to turn up in informagear. It was a retro place with cubicles and dark corners where people picked one another up by chatting and touching, rather than whipping out their Nimbuses at the drop of a hat to check each other's scores.

Janine was one of the lucky ones who could have what she wanted for breakfast, lunch or dinner and could date whoever took her fancy, because her dad was on the board of Barclays, and paid her premiums. He was also a friend of Jade's dad, and consequently a non-Exec at Strasbourg, and a shareholder in Stan's Canterbury Security business, which specialised in processing deportations.

Janine didn't understand what they actually did in Strasbourg, other than providing private health insurance, because her privileged upbringing

had taught her that she didn't really need to listen to people. She would have asked Jade all about it, but she was just not that interested. In the end, it was easier not to know. It was easy to go from pub to club, and dinner party to rave, taking whatever she could get her hands on, human and chemical. It was easier to ignore the morass of people in the high rise apartments on their universal income, living on the pap they got given, and to avoid unsafe zones in favour of the right parts of town. She had all the basics bubbling quietly in her subconscious, but she just didn't see the point in engaging with something which she found grubby and unattractive, and which she had no power to alter. To that extent, Janine was the antithesis of John and everything he cared about, and had they spent any time trying to find common ground in their views of the world, they would have failed miserably.

She didn't ask John whether he cared, because in her vacuous world, it was considered in poor taste to discuss politics, social issues or the news. She met him in the Sombrero, allowed herself to be picked, and concentrated on taking her pleasure. She took him at face value for what he presented himself to be: the laid-back rich boy with the sardonic wit and the great put-down lines. She didn't understand even the most basic aspects of her father's wealth, which was the only thing John seemed to want her to talk about, besides Jade and what she did for a living. She had no concept of how healthcare was funded, or how its costs could be minimised by pre-selection and behavioural controls. John tried having that conversation on their first evening together, and quickly gave up. Janine didn't know that, and she had nothing to say in response, since she'd stopped hearing what he was saying and was letting the music wash over her.

John rarely shared his views in face to face conversations because he came up against this sort of callous disinterest all the time. He rarely had any face to face conversations any more, since more and more of his time was spent behind a screen, mainly at night, manipulating the systems he hated. Some of the Gimme co-operative members were 'Politicos' who spent their time in smoky rooms arguing with each other and their followers about the way the world should be, and others, like John, just

got on and tried to change it. It wasn't that he had no interest in sharing his views, and in hearing what the others thought should happen. In many ways, he didn't trust online profiling, since he'd learned to miss-use it, and he preferred to hear someone talk passionately about their view of the world than read about it in the forums he kept abreast of. He had debated so much at Imperial with lecturers and students, and he'd read everything he could get his hands on about the alternatives that were set up by large numbers of deportees trying to resist their fates.

There had been several attempts to establish independent communities in unpopulated parts of the world, places where equality and fairness were cornerstones, and where people were given freedom to live their lives the way they wanted. In some of these, there wasn't the critical mass necessary for survival, and the small groups who set them up couldn't provide for the basic requirements of a viable commune. In others, the anger of the members erupted and they went out to find the enemy, rather than live in isolated peace. This was particularly a problem where the communes supported the opposers of oppression, where guerrilla warfare against authority drove the majority. Forays into local cities for armed violence, or concerted digital insurgence didn't end well, since automated weapons, especially armed drones were inexpensive and highly effective against any enemy hiding out in forests or mountains. In these cases, the attention they drew on themselves resulted in a military intervention, and depending on the regime, either mass executions, or rapid arrests and imprisonment.

John had read about one large colony of some five hundred people in the desert wastes of Southern Spain which had drawn subversives from across Europe together to live in an isolated valley in the Sierra Nevada, where there was hunting and fishing, and bearably cool weather. The colony had managed to survive untouched for almost three years, despite being on the radar of the Spanish security forces. At first, it seemed to have the ideal mix of pacifist environmentalists living in tee-pees, and tech nerds using solar-powered equipment for hacking, who understood how to bleed the banks without detection. Despite everyone in the commune being off-grid, the group was being tracked by the Spanish authorities using

heat mapping drones because of the amount of produce brought into the valley and the comings and goings of local black market traders. When eventually someone in the Ministerio de Defensa identified the source of its funding, and the Catalunya Caixa got to hear about the amount that had leaked from its accounts, it was time to shut down the colony. Rather than sending in a large army unit, or infiltrating the group with spies, a lethal virus was introduced to the water supply and all five hundred people who had been living in the valley and dependent on the well they'd dug were quietly exterminated, before fumigation bots were sent in to remove the evidence. John hacked the Spanish MdD server when rumours of the attack leaked, and found video evidence of the effects of the virus, prior to the clean-up. He was the one who had leaked the footage anonymously to the media.

John and Nick were somewhat different from the other members of Gimme, in that they were strategic thinkers with some understanding of the likely effects of what they could do to undermine the status quo. Nick had a good grasp of economics and sociology, and had a lot of interest in the development of small communities.

John was a highly skilled hacker with an axe to grind about the ownership of software, and the way in which corporations' drive to make money had become or was always far more important to the shareholders than anyone's wellbeing. The wealth of corporations had for fifty years outstripped that of smaller countries, and their global reach, since the invention of the internet, had ensured that they could avoid tax. As AI began to take hold in most manufacturing and distribution businesses, so the profit margins grew exponentially. Vast swathes of the working population lost their jobs, and the shareholders became god-like in their power. The global AI corporations could purchase anything they needed. They could bribe governments to alter legislation and to adopt practices which would not pass muster with the voters. He was fascinated by the way in which AI was changing the power dynamics of western civilisation, and it was obvious to him that unless control of AI was taken out of the hands of monomaniacal tech billionaires and profit motivated Boards, it

would threaten the future of mankind. The profit motive which prevailed meant that harnessing AI would lead to goals being set which overrode the welfare of ordinary people. It was a creeping and insidious process which had been developing for a generation, without the need for Strong AI. Everyone's fear of singularity, the moment where the AI would take control of its own development, and teach itself to be far more intelligent than its developers, was distracting them. The older algorithms which monitored people's behaviour were doing more than enough to change society, and were completely in the control of small numbers of people.

These same people were spending vast sums of money in pushing the AI boundaries, in a race to be the first to launch a Strong AI. When switching on an AI to teach itself, and potentially outstrip human abilities, these were the same people who would set its goals and guiding principles. These autocrats were obsessed with their visions of the future. They were surrounded by yes men who supported their views, and they were prepared to operate alone in setting the goals for their AI.

John knew that there should be fail-safes in the system, so that it could be switched off or re-directed. It was an accepted principle that a self-learning AI should not be connected to the internet at any point, on the grounds that it would learn to access other AI and because there would be no control of the information it could access online. Many people questioned whether computer intelligence could develop in harmony with humans, or whether it would ultimately replace them, as the next 'life form'. John had no issue with the concept of the long term evolution of cybernetic life forms, any more than he did with the development of a superintelligence which could benefit the world. His problem was with dictators or business moguls taking it into their heads that AI would give them global domination and untold wealth if it could be harnessed as a weapon.

So far, the world's leading AI developers had worked together to build security and to adhere to a set of principles which ensured beneficial outcomes, but now he, and the others in Gimme who really got AI, feared

that one or another of the owners and their backers would decide to 'go it alone' with their research and break the cardinal rules. Already, automated weapons were deployed all over the world, and some of these had a level of intelligence in terms of making snap decisions on strikes. The algorithms which operated the PQ were undoubtedly intelligent, making choices between people based on probabilities rather than absolutes. The trend with intelligent software was to gamble more and more on what was likely to happen, by taking into account more and more variables collected from more and more touch-points. AI was becoming better at predicting human activity than humans themselves, and in doing so, was becoming better at performing many of the functions humans performed. If this continued and accelerated as it was doing, soon AI might just select the logical option of marginalising or removing humans.

Nick had been a lecturer at Imperial when John was completing his degree, and was himself a leader in the field of coding algorithms for AI who had applied his knowledge to the processes of developing Strong AI. He'd spoken at all the main conferences of the time on directing full AI to benefit humanity, not to undermine it. He'd left his job when it became clear that the education system was no longer interested in instilling students with a set of guiding principles for developing computer power. Stan, a close friend of Nick's professor, felt that it was not in the interests of commercial outfits like Genomica and Strasbourg to have people like Nick in charge of AI development. Stan directed the professor to deal with Nick. He offered substantial funding through Strasbourg on condition that Nick was not part of the research programme they wanted to commission, and so Nick lost his job. Nick knew that Strong AI research had become a 'wild west' of overly ambitious developers competing to win a race which they had no understanding of, driven by the money provided by corporations like Strasbourg. In the early days, Dr Janekowski had been his hero, as he had been to many of his generation, but now Nick had become completely disillusioned by Stan's transformation from scientific explorer to greedy manipulator of peoples' lives. The AI which Strasbourg employed in the PQ programme stopped short of full AI, and yet Nick knew that Stan

had always wanted to reach the winning line first. By the early forties, it was clear that only two or three corporations had the skills and resources to achieve Strong AI, and they were each looking for different outcomes. Stan's eggs were all in the basket of controlling social welfare. The Israeli Defence Forces, through several specialist contractors, was more interested in autonomous weapon systems and had cornered the drone market with its new generation of armed space drones. Monsanto's bio-engineering programme had led the corporation towards Strong AI in the agricultural development process which led to aerial farming and phytoplankton processing. All three were converging on the same goal for different purposes, and the AI R&D world was watching the race with trepidation.

When John and Nick came together to form Gimme, they had a shared concern about Stan's activities because he seemed to be closer to Strong AI than the others. They knew Gimme had the skills and resources to damage the infrastructure of the G-Mapping and PQ programmes, and potentially to affect the results of the full AI race, but could foresee the turmoil this would generate. Also, as Strong AI took control of its own security, they could envisage a situation where no human would be smart enough to access the source code and alter it. The lock-out would effectively spell the end of human control, unless the whole AI could be destroyed by physical means.

The established order on which the government relied, comprised of the profit-making enterprises which supplied state services to ordinary people, was vulnerable when shaken. Failure of a large infrastructure business like Strasbourg wouldn't just hurt the shareholders, but would undermine every service it provided. Nevertheless, they knew that this was the seat of power in several western economies, and that breaking the hold which Strasbourg and one or two other companies had on the population would potentially bring down the walls between the haves and the have nots. But it would leave people in a no-mans-land, where vast numbers of UI recipients were no longer provided with their food boxes and basic

medical support and at the same time these washed-up people had lost the means or skills to produce anything. Blocking the PQ databases would leave large numbers of defenceless people, who no longer had the ability to make independent decisions, exposed, and that could prove dangerous.

Taking down Stan and his power base would leave a huge hole in the corporate structure and behind the scenes decision-making process of government. The assets of a few people and their businesses would need to be managed in a handover which might take years. Pre-AI industries couldn't and in most cases shouldn't be resurrected, and after all, AI provided vastly more efficient wealth generation than human muscle.

It was 3 am and John sat hunched over his Nimbus, dictating coding commands. His V-Mail flashed 'Artremis' and he said 'yes'.

"Hi Nick, How's it going? You're up late. Something on your mind?"

"So, John, bit of a surprise this morning. I heard from Stan. Turns out he has is an old v-mail address of mine, and he was using it to goad me into responding. God he looked awful. It's a while since I last met him and he's lost the rest of his hair, and he's got fat and deranged-looking... But maybe he always looked mad, I forget. Anyway, he wants to meet to talk about how I got into Egress of course."

"No shit! I presume you didn't reply yet."

"Nope, but I think we need to decide whether to engage with him, rather than simply trying to take him down. It's not that I want him to keep his position and power, but perhaps we could get him over a barrel in some way, and then we wouldn't have to blow holes in the boat, and try and sink it, to remove the captain. We'd just have to try and control him."

"So what are you thinking? Do you think he's close to being able to push the button on Strong AI? The full works?"

"Well, the PQ algorithm, coupled with some of the other security programs we've both worked on are already running on deep learning principles and self-improving with every iteration. But none of them is autonomous. Stan has, sensibly, built in fail-safes on all the Strasbourg algorithms, with human approval processes for all upgrades. Even if the AI is generating the developments now, he's the guy signing off on them all."

"But as these are self-learning algorithms, aren't they likely to teach themselves how to circumvent his controls?"

"You'd think that, but of course these are not artificial general intelligence programs with multiple skills. By and large, they're specific to one task. The PQ algorithm may be the closest to a general intelligence, and we're only really informed about the version which is in the public domain. I'd hazard a guess that Stan may already have far more advanced versions stashed away in his Genomica Labs."

"So if he's setting the objectives for AGI, what are they?"

"Well in my own view, his objective has always been to maximise profits for Stan and Strasbourg, but to get there, he has not yet been prepared to crush all obstacles. It's arguable whether the damage which the PQ is inflicting on everyone's lives and the healthcare and security squeeze he's been applying for years, is the equivalent of crushing obstacles."

"OK, Nick, you're preaching to the converted here you know. So let's say he took the brakes off on the AI. Would it iterate rapidly and become AGI overnight, and then would it take over control of the Strasbourg enterprise, and Stan's coders?"

"I don't see why not. If it became connected to the Net, it would have pretty much infinite information resources to draw on. It would be the seminal moment. Though it's always seemed simplistic to me that one day AI is under human control and the next it's taken complete control away from people and is operating without support."

"And how can we know which direction it might go? I mean, even back when you were my lecturer, you told us that beneficial AI was in the hands of humans and that computers don't make moral judgements. If Stan launches an AGI, will it decide that the best way to optimise healthcare and security is to remove the need for both? I mean, by removing the target market?"

"Not necessarily. Both are services to people, so why remove the people and the service rather than improving it? It all depends on the goal-setting. I do think that computer intelligence can be pointed in the right direction, and if it achieves superintelligence quickly, and concludes that some sort of new technological race should replace humans, who are weak and stupid, that will happen. There again, it might want to augment human intelligence because we are already pretty sophisticated computers."

"And do you think Stan wants to risk being taken over, or taken out, but his own AI?"

"No I don't. It isn't in his nature to give up control."

John was silent for a while. He'd been thinking about the alternatives to destroying Stan's work, because he knew somewhere inside it, and in Stan perhaps as well, there were good ideas, positively beneficial developments. If Stan could be brought to the table and persuaded or forced to share a more positive outcome for everyone, it would be much less risky. Maybe they could put together an irresistible case for the right way forward by modelling the outcomes.

Clearly, small independent communities would not be allowed to co-exist with the monoliths, especially if they were feeding from the same teat. And a computer simulation model wouldn't be enough to change the status quo. Making a practical demonstration of a successful alternative was one thing, but getting millions of disenfranchised and depressed people to buy into it was quite another. A positive movement with its own drivers and attractions would be essential. Setting Gimme up as a

destructive force to remove the likes of Stan and his ilk was all well and good, if you wanted to become state enemy number one, but the danger of removing Stan's power structure without a workable alternative was much greater. As things stood, everyone was fed and warm. They had a degree of protection from disease and security from attack. They may not be fulfilled, but they had some sort of stability and a set of rules to live by. If the walls were taken down, there would be plenty of criminal groups ready to storm in and raid what they could.

"The key to this succeeding is to find a way to destroy Stan without removing the best aspects of the infrastructure. We need healthcare and security, but we need people to begin to think for themselves and to stop relying on the PQ."

"OK, let's try and find his weakness and exploit it. Let's present him with a better alternative, and make him an offer he can't refuse. I think it'll only work if we can demonstrate our ability to take control of his software in some way, to send him a message. I also think he needs to have a really attractive offer, rather than just a threat."

"We need to come up with our own alternative model which generates enough wealth for everyone without the manipulation and subjugation everyone has become used to. There's no point in dismantling everything. It needs to be economically viable, and needs to reward the organisations driving it, without necessarily making them richer."

Nick always summed everything up in a way that sounded plausible, manageable and straightforward, even when it was none of these things.

"I'm working on some patches which would effectively take over the authorisation process for systems upgrades at Strasbourg. Every week, and sometimes several times a day, Stan manually authorises changes to the programs. If he woke up and found that job taken off him and some upgrades he wasn't expecting had been authorised, it might get his attention."

"That sounds like a good weapon. I'm working on communities modelling to see how it might all look in the future. But we should have both ready before we contact Stan, or else he'll annihilate us. The alternative has to be more attractive to the mass market than what we have now – that should be easy enough given what seventeen in twenty people have to put up with on Universal Income. It should appeal to politicians, and that'll only happen if Labour is going to have a chance at the elections, because you can sure bet the Tories won't be interested in a more egalitarian society where they have to sacrifice standards for the greater good. And it has to appeal to Stan, even though I can't see him making money out of our future in the way he has made money out of Genomica." John was always inspired by Nick's calm decision-making.

"John, I think you may have Stan wrong if you think that's what'll drive him. He's actually come from similar roots to ours. He's a computer scientist who was a hacker, albeit for the Russian Government, and he's a man who hates to toe the line. If we can separate him from the corporate role he has, and offer him a place on the fringe, where he can play with computers and have some fun at the expense of people he hates, we might excite him."

"You mean invite him to join Gimme?"

"In a way, yes. Gimme can't continue forever as an illegal hacking co-operative with subversive objectives. We need to become more legitimate, and we need to influence society from within. That's where I came from, John, when we met, and that's where I want to go back to. Once Stan is out of our way, or at least batting for the right side, we have some chance of getting back to normality. Frankly, I'm sick of hiding and sick of living like a vagrant."

Nick was sitting in the corner of The King's Head with a pint, and John was eating a pork pie he'd ordered, because it was reputed to contain the real thing and certainly tasted great. He was trying to get his strength

back after a night with Janine, and trying to concentrate. They rarely met, because Nick was fairly paranoid about being scanned, and tended to hide away in borrowed apartments or when he could get out of town, in a tiny village on the Suffolk coast which he reckoned was off grid.

"It's just a few old fisherman's cottages, one pub and a grocery shop where they still sell tins and packets of real food to people who pay with real money. I know a few of the people who live in the village to say hello to, and I'd swear that between them there isn't one drawing UI and there isn't one earning more than a basic wage. They fish and farm, they barter and share, and it's almost self-sufficient, except for commodities and powergen that they buy as a community. They're a friendly bunch, even if they are a bit of a throwback. They all help one another, they care about each other's children and they have real relationships. They even have a parish council for fuck's sake. They're all registered and chipped of course, but I've never once been asked what my PQ is, or been scanned as far as I can tell."

Nick had a romantic view of the old world, and he'd clearly found somewhere to live out his fantasy. He had been a research fellow and lecturer at Imperial, specialising in Political theory and AI modelling. He was well known in legal circles for having set up the protocols for robo-judges in the UK, which had dealt with the legal waiting lists, introduced immediate judgement without trial in certain cases and removed any hint of human bias from justice.

John and he had shared a passion for understanding the implications of AI for society, and a predilection for going where they weren't allowed. Nick was more of a strategist than John, with a far deeper understanding of the upper echelons of politics.

Together they had burned a lot of midnight oil discussing and researching the latest work produced by Stan and his competitors, as far as they were able to track it, and trying to find ways of getting up to speed, or even ahead, on a shoestring. Imperial had access to reasonable amounts of storage and processing power, which Nick still made use of when he

could, but nothing compared to the US, Japanese and Russian teams. ICL also had offers of funding from several conglomerates, including Genomica and then Strasbourg, because Nick and Professor Keanes were well regarded and the college attracted some of the best students in the subject. The problem had been that Strasbourg's funding and Stan's excellent resources were offered with lots of strings attached. Stan wanted to own and have ultimate control of all IP, and to set the goals for any Strong AI. This, in Nick's view, effectively put the whole development on a footing with the Israeli autonomous weapons programmes or maybe the eugenics schemes initiated in concentration camps. Stan, not surprisingly didn't agree, and they had some blazing rows in front of Prof Keanes before any agreements could be reached on funding.

Those disagreements had been enough to have Nick pushed out. It wasn't a dismissal, but he'd been excluded from all discussions about the Strasbourg requirements in the contract, so he was effectively emasculated in the department and left teaching undergraduates without being able to show them what their own university was doing, and what they might be involved with as postgrads. His job became untenable and his view of Stan and his methods became even more jaundiced than it had been.

"So why don't you just walk away from Gimme and the work we've been doing to try and take down Stan and his merry men? You could learn to catch cod or whatever is still swimming in the North Sea, and leave the rest of us to stew."

"What, and miss all the fun of seeing Stan fall to pieces? Come on John, we go back long enough for you to know I can't walk away now, any more than you can. Besides, the village is kind of quaint, but there's no one to really talk to about what you and I do."

"If they've got Teraband, you can still keep in touch. But I know what you mean about being where the action is. So what are we going to do?"

"I might not want to disappear into a film set for The Quiet Man, but I don't want to live like a fucking zombie in London either. I don't want to accept all the gross things which people here have come to accept. I hate the M-Rail, and the Ubers, and I feel scared more often than I feel safe on the street. I hate the designation of unsafe zones, which only serves to make them more so, and the food boxes, which have destroyed people's love of food. Most of all, I hate the powerlessness of it all. And I can't believe anyone else wants to have to accept it all either."

Nick always came to John with his anger, because John understood him and what he was saying. It wasn't enough to have John listen to his rants. He needed rescuing from his depression, and John somehow had a way of bringing him back from the darkness of his thoughts.

"I know what you don't want, Nick, and you're not wrong, but isn't it better to know what you do want, to test it out as a possibility before making any moves, and then finding out if other people also want it? I expect half of Tower Hamlets would love to move to your fishing village. Fuck it, half of Islington would too, if they knew they could buy their illicit tequila and the latest fucking informagear fashions there. Oh yeah, and they'd need to bring their autobutlers with them."

John was more angry about class. His life had been blighted by people like Stan who was instrumental in creating the two-tier society. In Stan's world, there were the haves and the have nots, and somehow Stan didn't seem to care that the one group was shrinking while the other grew, so long as he was in the one that had what it wanted.

"You say that, but if you told them about the place, they wouldn't have the mental capacity to imagine it. Most people can't see past the end of their noses any more. They daren't even think about life without their Nimbus and their PQ. They're going to have to learn to live without all that shit if we get our way, and that means looking back to a time when they weren't plugged into technology all the time. It's like we're already some sort of cyborgs. We've got to go backwards to go forwards, John, and I'm

scared that there's a big fucking hole in the archives. You can bet that Stan has worked tirelessly to expunge the memories of those better times."

"OK, but that hole can be filled, and if we can get the future right, people will come to drink the water. We've got to know where we want to get to before we ask Stan to take apart what we have. So let's try and set out what exactly we want to keep, and then we've got some foundations."

"Fair enough."

"If we could get rid of Strasbourg's centralised control, and shut off most of the PQ tracking, so we only collect information needed to help people regain control of their own lives, we'd be better off. We'd need some way of harnessing AI without giving it too much to play with, which would mean getting people to make more decisions on a case by case basis, rather than using algorithms which depend on probability quotients."

"That's fine, but it takes AI back to the dark ages if it isn't self-learning and people need to authorise access to personal data. Can control be wrested from the hands of the likes of Strasbourg so that the AI objectives shift to maximising the benefit to the individual rather than maximising profit to the corporate shareholders? It might result in more costly healthcare or security, but at least it would be in the hands of the users."

"My worry is that we'd be creating hurdles to success, and not simplifying things. Most people wouldn't be able to authorise access to their data in a meaningful way any more than they used to when they signed away their rights in the T&Cs box."

"You know about my work on the justice system and the development of AI judiciary services. That has been one of the most cost-effective and fair alternatives to human management I can think of. It isn't beyond us now to set up AI systems which are better placed to choose what is accessible and what isn't, without miss-using it."

"Don't you think that everything we hate about the way it's developed is rooted in the centralisation of information and the power held in it by too few organisations? The whole Big Data thing gave them control, but only because it wasn't shared. The more they had, the more they could manage and manipulate us. We are more predictable than we realised, and once they had the predictions right, it's been like Strasbourg betting on races with the results in front of them. Of course the actual model for using Big Data to predict behaviour and attitudes isn't the problem. The problem is who uses it and for what ends."

"You sound like the NRA used to sound in America, when everyone used to have the right to own a gun: 'It's not guns which are the problem, it's the people who hold them'. If we give people guns, they're sure going to point them at each other and pull the trigger. We have to be prepared to restrict the access to big data in order to block its misuse."

"Yes, you're right. We've got to take down these monolithic data hoarders, and remove the links which feed the algorithms. But we need an alternative which works. It seems to me that one fail-safe would be to reduce the amount of data collected at any one place or by any one institution by limiting the size of each data pool. Centralisation means eighty million records in each of the main European markets, and globally, ten billion. I think we need to be building a structure of much smaller units, smaller communities, where everyone could actually relate to one another on a personal basis, and the data they generate could be fed into a modular AI which served them locally rather than centrally. It would engender trust and it would have to be open enough to show people that it was benevolent. The local AI's could be linked into networks, without a central controlling hierarchy, and run on co-operative principles."

"Like my fishing village?"

"Yeah, in a way. But that sounds like it's a bit too small. The communities would have to be bigger to be self- sustaining, and diverse enough to embrace a spread of people, to cope with everyone's foibles

and shortcomings. They'd need referenda and all those other democratic processes we used to have. Hell, maybe they could even begin to protect the weak."

"It all sounds so warm and wholesome John. But if there is an AGI, it will want to globalise, and then it'll look to colonise the universe, because that's more efficient. It'll be like the brain, a neural net, with a central guide and local infrastructure. You know when someone gets localised brain damage, and other parts of the brain effectively compensate…"

"Yeah, well I guess a central hub would work, so long as Stan the man isn't sitting in the middle and Strasbourg isn't charging people to breathe."

John got up to buy them each another pint and they sat silently for a while, mulling over the implications of this radical deconstruction. Nobody had come into the pub in the last hour, and it felt safe. John wondered how many places in Britain were still safe from the prying cameras and live feeds.

"Let's assume we can design some sort of community simulation that takes into account the basics, like production and consumption, decision-making, education, health and entrepreneurial activity. Let's work up some definitions and criteria for success. Let's write some rules."

"Yeah, and we need to base it all on having enough money to bail all those people out of their miserable subsistence lifestyles, get them all off the 'happies', and out of their shitty tower blocks and back into productive work. We need to make a simulation which stands up under different structures. Bigger and smaller communities, urban and rural. We need each to be heterogeneous, when it comes to personality, race, religion, genotype, class and anything else which has divided people up till now."

"It sounds a bit like Noah building his ark to survive the floods which destroyed Sodom and Gomorrah. I'm not ready to play God, but we've got to be the ones to turn on the rain which causes the floods which wipe

away the evil. And when the rain stops, and the floods recede, it may be that there isn't much to go around when it's spread across everyone, but that's got to be better than the inequality we have now with UI for nine in ten and greed for the rest."

Conversations like this reminded John why he liked Nick, and why they needed to meet face to face more often. It wasn't enough to work in parallel, sharing their sub-routines, digging holes in the wall around Strasbourg. They needed a shared vision which they could articulate to one another and then find ways to spread the word.

CHAPTER 4

Preparing for the Flood

If Janine was disinterested, Jade was positively paranoid. When John got back from the King's Head and Janine let him into the flat, he went into the kitchen where Jade was having her lunch and catching up with her v-mail. He made himself a coffee and tried to engage her in conversation.

"Hi Jade, I'm John. Janine and I are... going out, or something. She mentioned that you share."

Jade looked up, but said nothing and returned to her v-mail.

"Are you related to the great Stanislav Janekowski? I saw your surname when I was friending Janine." That was easier than telling her he'd checked through her HR files at Strasbourg weeks ago, and only found Janine through her.

"Yes, he's my dad. Why do you ask?" She sounded annoyed.

"It's just that he's been one of my heroes since I was a first-year at Imperial. He came to talk to us about cryptography and genetic engineering, and I was so inspired by him. I ended up doing my dissertation on some of his work."

"Not my area, I'm afraid. What's your surname? He might remember meeting you. How long have you known Janine?"

John didn't feel like answering either question, though he could have given her the Valance surname, which was pretty watertight. He'd even substituted it for his own surname in the ICL records in case someone should check back on him. Janine came into the room in John's shirt and nothing else, which saved him having to answer.

"I met this beautiful man at my birthday party, didn't I darling? You know, that night you and Jaspar were too busy to come along. Not that I can remember much about the meeting part."

Janine was always half-conscious until mid-day, when she decamped to the nearby greasy spoon for her brunch, and then to a pub for afternoon refreshments, then back to get ready for her evening out.

"What was the name of that cocktail you bought me, John?"

"That looks like my shirt, Janine. How about putting your own clothes on and I'll buy you a late lunch?"

He wanted to get back to Jade, and Janine seemed happy to drift off to the bathroom.

"Do you work at Strasbourg, Jade? I think I heard of you from Stephanie Morgan in the Systems Development Department. You're the deputy head of Insights, aren't you?"

John knew exactly where Jade worked, what her job was and even what she'd said in her emails to her boss and to her father in the last 24 hours. He just wanted to feel his way to see if she might be a sharer or a hoarder of secrets. She looked annoyed at his knowledge.

"Yes, I do work at Strasbourg, but I hardly know Stephanie. How do you know her?"

"Oh, we went out once, a while back. That's all," he smiled.

"So what do you do, John? Are you a cryptographer, or a genetics specialist, or did you give up after your studies?"

"Oh I do a bit of coding, but it's all, you know, a closed book as they say. MoD. So, Jade, do you like The Sombrero? I haven't seen you in there ... Pity."

He decided to test the waters and change the subject. She looked annoyed again, but then her Nimbus rang and she said, "sorry, will you excuse me, it's my fiancé. I should take this," and she left the room, before opening the screen. John made a mental note to quiz Janine about the fiancé over lunch.

After their meeting, he felt that he and Nick had a clearer view of where they were trying to get to, but he didn't think it would be easy to get all the members of Gimme onto the same page. Some of them were bent on destruction and others were more interested in hacking for its own sake. All the members wanted Stan brought down a peg or two, even though some admired his skills and power, and all of them had expertise, but they weren't a cohesive team.

What he needed was an engaging story or game to educate them and test out his theories. Like so many coders, he'd learned to write algorithms which were iterative, in that the coder could input variables in the form of data streams and the algorithm would take them into account in formulating its output. If John provided all the Gimme members with the tools to build their own community in a simulation game, they could all throw spanners at it and test its resilience. A simulated community could work out how to deal with scenarios which might undermine the utopic vision he had. They could find out how to deal with a greedy criminal in its midst, or handle an environmental threat like a drought, or could cope with birth defects and viruses. A computer model could iterate instantaneously, and demonstrate the probabilities of various outcomes, allowing it to evolve as fast as those playing with it could input new variables.

Pulling data streams from Strasbourg's files which could be used to feed the simulation should be well within the reach of the hackers in Gimme, and the players could choose which ones to use and what weightings to give them in their future worlds. And if it was successful enough to result in population growth or new inventions, that too could

be played out on screen. Their generation, and even that of some of their parents had been exposed to endless gaming apps which drew on scenarios, and allowed players to set goals. Most of them involved violence and destruction, rather than communities living in peace, but he'd played some which were quite similar to what he had in mind. It turned out that there were several off-the-shelf products which were easy to adapt, so he chose the most open and generalised package he could find and started work. John could code for twelve or fifteen hours straight, once he had good music in his earbuds.

He worked for three nights on the game, with Nick's help, and then distributed it to Gimme, and let everyone know that they should play it to destruction or to a point where all the likely and unlikely outcomes were tested. The sim-community began as a simple village, and evolved into a small town, an ethical company, a national government and various other structures worth evaluating. The data-streams John added initially included the staples: food, heat, powergen, physical infrastructure, population, birth rates, land access, transportation and quickly grew to include healthcare, security, social communication, religion, environmental feeds and emotional drivers. All the data was culled from real-life tracking systems developed for the PQ algorithm, and stripped from Strasbourg's own databases. Gimme tested the models John and Nick provided, based on various population types and sizes, using fresh data from local and overseas people. Within a few days, the 'book of rules' for success was being refined, along with sets of boundaries which should not be crossed if the equilibrium were to be maintained in the sim-community. These became the cornerstone variables on which the goals were based. John and Nick set out the goals as targets or laws limiting the game. Wealth accumulation, ownership and power were the most difficult elements to set boundaries on, given that so many institutions and communities had always been driven by greed and hunger for power. It wouldn't be enough to set out for utopia when any of these could destroy a society. But without some sort of totalitarian rule, how should the free market be controlled?

John had been involved in high level hacking for several years, and had never set out to make money from his skills, unless it was needed to further his political objectives. He was sure that he could undermine Strasbourg's business model through the algorithms which drove it, in order to send panic through its shareholders and customers, and bring it down. If that only served to drive the customers to Strasbourg's competitors, he would have failed, and he knew that he'd need to find a way to topple the house of cards which the whole insurance industry was founded on. This would be a high risk game, played against Strasbourg's software developers, or perhaps Stan's own team at Genomica Labs, the private research facility he maintained. Rather than trying to fight his opponent head-on, John wanted to find his weaknesses and present him with alternative ways to win.

John would have moved on from his not very satisfactory fling with Janine, once he found out that Jade wasn't personally available to him, only there were a lot of people looking for him and his colleagues in Gimme and his activities on the Strasbourg servers hadn't gone unnoticed. He'd set off alarms only two days earlier, by trying to access the secure keys of Jade's boss, and it was only that he was working through Jade's home terminal without her knowledge, that he managed to back out of the corner he was stuck in, and drop down a couple of levels to avoid being followed. It was unlikely that the attempt on the citadel had not been brought to Stan's attention by his firewall.

The hacker's life is only half about breaking encryption and exporting data. The other half is about creating mirrors and false trails to avoid being followed. Even when it came to Janine, he had to edit her social media feed to stop her posting any images of him, or identifying information. She clearly had a big mouth, and she was pretty cock-a-hoop about having John on her arm, so he waited until she was asleep one night to take over her Nimbus and re-wrote her history, subtly so she wouldn't be asked awkward questions by her friends. He had spent years building John Valance into an alter-ego in three dimensions. Valance was a systems architect in the

Ministry of Defence, and so it would be next to impossible for even the most diligent nosey flatmate to find out much about him that he didn't choose to share. Janine was very turned on by the implication that he might be a spy, and his prior knowledge of her secrets, such as they were, went a long way to establishing his bona fides.

He seemed like a lot of her rich male friends who didn't work, even though he wouldn't tell her where he lived, or what he actually did at the MoD. They'd been out a few times for dinner, and always somewhere nice, though he didn't seem to be given VIP privileges wherever they went, in the way that Marcus and Jaspar were. John seemed to go unnoticed, and yet he managed to get them tables even in Los Alamos and Beaver, which everyone knew were both completely booked out for months to come. He paid for them wherever they went too, though never at the table. He booked them into places which had old-fashioned paper menus, and wouldn't be seen dead in the sort of places which have ad-screens and digital menus that serve up personalised choices based on the PQs of those at the table.

John and Janine had a lot of sex, since that's what she expected of him, and he was happy enough to oblige, because she was good looking, experienced and proactive. She seemed pretty satisfied with his performance, though he found himself quickly bored by her predictable moves. Once Janine had been through the motions, loudly proclaiming her satisfaction, and she'd taken her 'happies', she was out for the count till morning and John could get on with his work. 'Happies' were not generally used for recreational purposes by people who could afford coke, but Janine had always found it hard to be optimistic, since she had nothing to strive for. She'd stolen the 'happies' from her mum, last time she crashed out of a relationship. Her mum used them all the time, since her dad had introduced her to them. He was never home and clearly played away, and her mum was drinking a lot, and her PQ shot up as a result. It was becoming a joke around the Board of Strasbourg, so he had to get her off the booze and back on the straight and narrow with the SSRIs. The family didn't spend much time together, so there was rarely an opportunity to discuss why they

made each other so unhappy or to try and rectify things. Janine was kept in the style to which she'd become accustomed and Jade didn't mind having her around as a distraction from the intensity of her work.

John picked up Janine because he wanted to get closer to Jade. He fancied her more than Janine, and she obviously had a lot more about her, only he realised that she wasn't going to be separated from Jaspar. The guy had a PQ of 106, but could afford whoever he wanted, so John figured it'd be better to hang around with Janine and put Jade at her ease. That way, he could work through her Nimbus at any time without her knowing, and operate inside Strasbourg as though he was her. If they got on to him, he'd be close to them, and he'd know well in advance that he had to get out. Jade was in the right job, and her authority level was high enough to give him the right access to Stan.

John grew up in Tooting, and Jade's regional responsibilities in G-Match meant that her database had his whole family covered. She had responsibility for their premiums and G-Matches in her team, so if she discovered he was John Vaunt, she would know he was blacklisted. But John Vaunt wasn't on Strasbourg's G-map data files anymore. He'd expunged himself during the Egress hack, along with many others, and he'd tweaked the PQs of all his family members while he was at it. He was one of several thousand 'off-grid cases' in the region, a number of whom he had worked with either legitimately as contractors or co-operatively as hackers, though he generally preferred to plough his own furrow. He'd been through Jade's profile with a fine tooth comb as soon as he'd dumped Janine, and now he wanted to do the same with Stan's file, but it turned out to be definitely beyond his reach for now.

Jade was profiled as ambitious, intelligent, well qualified and well connected. In fact, it surprised him that she was not in a more powerful position, given her connections, but then she had very strong work ethic and diligence scores in her PQ, and she'd been steadily promoted every year in Strasbourg, having been recruited straight from college. She was at Imperial almost ten years after he was, though by then the whole AI

department had been effectively subsumed by Strasbourg for Stan's researches.

Jade was well paid at Strasbourg, even though she had started at the bottom on very little. She was independently well off, after Dr Stan had sold Genomica, because she'd had shares in her name as birthday gifts every year until she was a teenager. Stan had also set up a trust fund for her and bought her the apartment.

Gimme had a strategy, and were lining up the chess pieces for a game with Stan. John and Nick had decided how to move forward, and now John felt it was important to plot his moves. It was worth looking again at the constituents of the new PQ, in order to establish whether it had simply become more sophisticated than need be. He figured that the basic requirements of tracking peoples' health and monitoring their wellbeing so that welfare services could be brought in when needed were wholly appropriate. In his future community model, he'd assumed that the current level of support would be a minimum and no one would want to return to the days when you had to go to the doctor, phone the ambulance, or hope for the hospital bed. If Stan was focussed on reaching AGI soon, then Gimme needed to have control over public opinion. Stan might be an autocrat and potentially a tyrant, but Britain was still a democracy of sorts, and its public sentiment still held sway over government decisions. Launching an all-embracing AGI could either be with a fanfare, or done under the radar, for reasons of 'national security'. The framework for control of AI had been creaking for years, and endless policy committees had failed to keep up with technological advances. Nick had at one time been considered part of the inner circle, on the moral high ground when it came to defining the goals of AI, but as with so many other government initiatives, the governance had been subsumed. The committee places had been given to those in power, and not the academics. The decisions which were made became less public and the media showed less and less interest in explaining the complexities and risks of AI to an ignorant

audience, especially when most of them had lost their interest in objective journalism.

In fact, the original objectives of Stan's AI research at Genomica had been wholly focussed on benefits to society. The tracking and reporting ability of the chip was what attracted John to Stan's ambitions all those years ago when he had stood up in front of the Imperial College class and explained Genomica's model. Perhaps Stan's idealism had been overtaken by his greed and the pressure exerted by profit at Strasbourg, but that didn't mean what he'd invented should be destroyed. John sent an update to Nick.

'I'm thinking the chip needs trimming but the AI is fundamentally good. What would happen if we cut it loose with clear goals for good? Would it re-calibrate? Are we talking about super-intelligence with a heart of gold, or some logic which makes us a distraction and overdue for extinction?'

'That's the $64K question. Perhaps we could clone their algorithm without Stan knowing and then I could run some tests on a stand-alone computer to see what happens.'

'Can you ensure it remains stand-alone and doesn't iterate its way to a jailbreak? I know you're clever by human standards but...'

'If Stan is about to let the genie out of the bottle, we have to assume he's already considered that issue. I'm not going to fuck with a monster, you know. If it looks unstable, or further advanced than we expect, I'll leave it alone. But I'd really like to study what he's been doing. Wouldn't you?'

"OK, Nick. I'll go in and see if I can copy it."

Nick had been mapping conurbations against the sim-community model to try and establish where larger, unwieldy population groups might be divided. He couldn't see this being imposed, but like the old boroughs and parishes, there might be administrative units which could sub-divide a city. It seemed more logical to sub-divide communities based on their proclivities, so that people could effectively move in and out of

them based on what they offered, what rules they needed to impose and what the 'costs' were. If some people wanted to live like peasants in an old-fashioned world where AI didn't exist, they should be able to do so, and if others wanted to be controlled by an AGI in a paternalistic society which helped them co-exist with robots, that should be possible too. In the future, there would be others who might want to travel to, and inhabit other planets, and those who would welcome integrating with AI in some sort of cyborg development, but right now, it was all about definitions, limitations and freedoms. He knew that this was, of course, no more than an academic exercise until they could work with the agencies involved in governing and planning. It wasn't something that a couple of guys in a hacking co-operative could take on, unless they could delegate it to an AGI of course.

'So what are you thinking of trimming, John?'

'Well, we work backwards from here to a point where it had all its value but none of the eugenics shit, for a start. I can't see much point in G-Match once we take away the super-human race idea.'

'But what about eradicating diseases and abnormalities which cause suffering?'

'Yeah, I don't think we should remove anything which is positive, but we can remove the financial goals and see how it affects insurance costs.'

'So if you can take a copy of the program without detection, and we can play with it, we can strip out what we don't like and build in some new security which is hard to crack, and then replace the original with the new version at Strasbourg. That should scare the shit out of Stan, and buy us enough time to give him the sim-community model and rule book to look at. Frankly I'd rather work with almost anyone else in a position to implement a grand plan, but I have a feeling that Stan is in fact the man. Do you think that would be enough of a carrot and stick for him?'

Nick was not as attuned to Stan's process as John, because he had never made any study of the man.

'No, I don't think it would be enough stick, which means we'd need to offer him a lot of carrot. I don't think he'd be bothered enough about threats to his business, since he has his fingers in so many pies. I also think he's hardly given us any attention since they repaired the Egress lists, and I think he'd be coming after us much harder if he felt cornered. Let's find his weakness and then we'll know how to get him over the barrel.'

The Party

Everything went like clockwork once the M-rail arrived, which made Ellen feel optimistic about the evening ahead. The carriage was not too packed, and the short walk from the Stockwell stop to the apartment was without its usual threats and unease. The door clicked open as soon as she looked into the screen and the lift was waiting at ground level, as she'd Nimbused ahead, even though it rarely delivered on its promise.

The dry cleaning was waiting in the shute, her linguine was piping hot in the fridge-micro, if lacking cream, and she was in and out of the apartment in minutes. She'd have preferred to have a shower, to wash away the film of Tower Hamlets grime which clung to her skin after every visit, but there wasn't time. M-rail timetables had been curtailed twice since the line ran through Balham and Tooting unsafe zones and the trains were often stopped by no-hopers throwing concrete blocks onto the line. If you missed the eight o'clock train, you might have to Uber it into central London and Ellen's bank balance couldn't take any more battering.

Now she was in the thick of the party, at the bar, and getting to know a tall slender man with long black hair, stubble and a steady gaze, who gave his name as John. She'd barely sat down and ordered her drink when he was standing close to her. So close, she could feel his body heat through their clothes. She knew she wanted him, the moment she set eyes on him, without being told by her Nimbus what he scored. She couldn't check him in the subterranean bar, but she just knew. So that is how animal instinct feels, she thought. Beats G-match hands down! She'd already forgotten whether he'd started the conversation or whether she'd bitten the bullet. Who cared now. But later she realised that he had approached her and he already knew her name.

They talked and drank and danced together all evening, though before they got drunk enough not to care, she tried and failed to glean some background. John didn't share like most people. He just wanted to dance, and oh could he dance. He was slim but strong, good looking. He had piercing blue eyes and a gentle smile. He moved like a swimming seal, and touched like a nuzzling cat. God, his scores must be sub-zero!

At about midnight, the party began to quieten down as some people left to catch the late M-Rail, and others subsided into sleepy corners. Ellen and John had been moving closer, touching one another in a dreamy, controled way, like ballet dancers. Their lips had brushed, and her fingers had combed through his long locks. She'd felt the heat of his hand on her back. But for once, she was really trying to pace herself. This wouldn't be a quickie. This had real potential, and she was determined not to blow it by pushing too hard.

"So, if you hate your job, and you're not chasing money, what do you want to do?" he asked as they lounged across the padded bench seat in the vintage train carriage permanently parked at the platform.

"You mean now, or generally?"

"Let's get to 'now' in a minute.... What about life?"

"Well I'm young, single, hot as hell, and I want to start a family."

She'd had a lot to drink.

"Yeah? Not interested in changing the world? You work in the right place."

Ellen vaguely remembered mouthing off about work, ranting about the algorithms controlling the people, the pre-determination of everything, but she couldn't remember talking about where she worked.

"Yeah, I am, and I really want to believe there's an alternative, but you know, I'm tired of all the shit that keeps happening. I'm sooo tired of

fighting with people who think there's only one way to win, and that's by doing other people down. I just want to run out of it. Right now, I can't be arsed changing the world. I want to live for the present."

She was swaying slightly from the drink, and trying hard to focus on the question, so she wouldn't come over as a complete airhead, but also because this guy seemed to see through the dressing up and the personal sales pitch and he seemed to know her heart in some way. If she could only trust him, she could really tell him how she felt, and he might like her more for knowing. He seemed to be the sort of man who would hate what she hated. But there was no way of knowing that. Above ground, she could have spotted his tendencies in his PQ. She was quick at reading the signs, once she'd checked someone. But down here, in the switched off world they were cuddling in, he could be anyone. He could work for the police. He could be one of Jade's dad's special team that vetted the staff, looking for weaknesses. He could be a subversive with a price on his head. How could she just trust him without some sort of proof?

"Which takes us nicely into what you want to do now," he grinned.

He slipped a finger into the back of her top and stroked her warm shoulderblade, which made her arch her back and push her chest out. He bent his head and kissed her nape, open-mouthed, as his hair fell across her. She leant back against the bench and closed her eyes, almost purring. The sensations mixed with her alcoholic haze and she could have pulled him into her there in the dark, but some part of her held onto consciousness. She opened her eyes, took a handful of his hair and drew his head back until they were looking into one another's eyes.

"Mmm, that felt good, and I'm, you know, feeling pretty hot down here right now. Feeling sort of ready to maybe find an uber home, if you are, but we only just met and you've been pretty backward in coming forward about stuff. Maybe we should get to know one another better before I lose what's left of my self respect."

"What, you're not asking about my scores are you? Don't you like what you see?"

"Well, as I say, it's getting harder to be objective, but you know, a girl's gotta think about these things before she jumps into bed with a horny stranger."

"Is that what you usually do? Check a guy's scores before you get their v-mail? Just as well we're out of range. I hate that stuff."

John bent to kiss her neck again, but Ellen still had a hold on his long hair.

"Yeah, me too, but how do I know you won't take what you want and then leave me ravaged and lonely? I want someone who wants more than that. I want to feel it's right, if you know what I mean."

"I like instinct too. I've given up on using numbers to decide what I do and who with. I'm looking for something more too. More than you know. I'm interested in changing things, and I'm not going to feed the system, even for someone who is, honestly, the first real person I've met in ages."

"Wow! That's a nice thing to say. I think you're the hottest guy I've seen in ... ever... and I spend all day every day checking out men for a living. It's just that everyone relies on PQs all the time, and it's hard to trust your instincts when it's all presented for you, you know. I know what you mean about feeding the system. We're not the customers, are we? We're the currency."

"Yeah, we are. And whenever someone meets someone, they feed the system. So when you meet guys, and you check their PQs, do you trust the numbers more than your own intuition?"

"Everyone does. You know that. But I'm employed choosing people to match, based on my intuition, rather than being a slave to the numbers, and up to now, I'm beating the AI for successful matches, so I have to say

I trust my own judgement better. But then again, I'm still single, which isn't a great ad for my skills, is it? I'm on G-match, and honestly, I've found nobody even vaguely fanciable with a score of 75 or more, and I can't afford anyone with less. I suppose you're a 25 or something, and as soon as you know what mine is, you'll disappear."

Ellen was on the brink of telling him about her 78, but just in case he wasn't being honest about not caring, she thought she'd hold back a little longer, and enjoy a little more of his body, before she blew it by letting him know her PQ.

John just laughed and watched the couple snogging across the isle. They didn't seem to be having problems.

"I don't give a fuck if you've got a score of 78. And I honestly don't know what mine is anyway. Don't you want to manage without being told what to buy, without having your daily needs pre-empted? Don't you just want to choose? Really choose? Get to do what you want when you want? Spend time with who you want, and trust your instincts? Have children with who you want, not who they say is right for you?"

John was really animated, and serious. He was a little disconcerting, but Ellen was excited. He said what she thought. She bent closer to his ear and began to whisper.

"That's the sort of talk that gets people penalised on their premium, you know. But it's true. I want all that. I want you and I want all that. Hey, did I tell you my score or did you guess..."

She knew that whispering didn't circumvent the listening devices in the office, or on your Nimbus, but down here in the depths of the earth, nobody was being listened to. It was just that everyone else at the party was probably a dedicated follower of scores. It was a Strasbourg Insights party, after all. Jade would have her out of her job as soon as you could say 'subversive' for what they were saying, and it was already probably grounds for deportation.

And then he was back at her neck and her thoughts parted company with the sensations running through her body, and she knew that tonight there was no future made of scores.

"Its fine for Jade. She's my boss over by the bar in the black dress. Her dad's loaded, and when she met Jaspar, the one with the white shirt, it turned out he had a big score, but apparently he's rich, and great in bed, so they went ahead anyway. She can eat what she wants, even meat, because her dad pays her premium, and she's got, like, a non-existent obesity PQ. All right for some!"

John continued to nuzzle into her neck.

"You know that stuff isn't all there is, don't you?"

G-match had been sending her profiles for compatible partners for the last month, and so far she'd met three, starting with the best match – which would mean the lowest cost insurance for offspring – and working downwards. She hoped there'd be that spark, given the compatability scores, averaged across over 200 factors, but there wasn't. Funny really. You'd think that well-matched people would be attracted to one another.

And here she had all the sexual attraction she could want, and not the first idea what John's PQs looked like. What did he mean about it not being all there is? Ellen got up, swayed to the ladies, collected her coat and followed John to the lift. As it rose to the street, she leaned back against his firm warmth, and he wrapped his arms around her. The Uber was waiting for them, and John held his Nimbus on the pad to accept the charges, while Ellen selected the address on hers. She could have checked him then, if she hadn't seen his glance and realised that he would walk away the moment she did.

It was just getting light, as she woke, and stretched languidly. It could have been a dream which she was waking from, a dream of the best sex she'd ever had, only there was a naked man in her bed, and she could feel the real effects of her night in every pore of her skin. John slept peacefully beside her. She felt amazing, but she knew there would be repercussions. If everything she remembered of their conversation had been said, John was bound to score high on subversion. Not that their conversation had been scanned, down in that subterranean secret cavern. But he was speaking his mind, and that had to be a reflection of his PQ, and vice versa. He had to be a risk. A high scoring non-conformist. But he had to be worth a risk.

Ellen lay still for some minutes, trying to luxuriate in the warmth and smoothness of his body. But she knew she wouldn't be able to let it lie. She knew herself well enough. Like walking past the bakery every morning, she knew she'd have to go in sooner or later for a croissant. Slipping out of the bed, she retrieved her glasses, thinking to find out more about him without waking him. But nothing registered in the corner of the screen. He wasn't registering as blocked, but he didn't seem to have a PQ. She knew that a few people in high places were walking around without having their chips switched on, but this guy, John, didn't seem to be one of them. He was off the grid, a ghost. He had to be a hacker, or he had to have paid a king's ransom to have his chip deactivated.

When he woke, Ellen was already showered and dressed. She was keen to get breakfast, but not her usual low fat yoghurt and fresh fruit tub which Nimbus had delivered to the shute while they slept. For once, she felt entitled to sustenance after their night. She stood at the end of the bed and contemplated the hugely exciting feeling she'd had in the shower when she realised how illicit they were being. John just kicked off the sheets and lay naked in front of her, forcing her to run her eyes down his body. He knew what he was doing, and grinned at Ellen's blush.

"Any thoughts on what you'd like to do this morning?" he said.

"Oh I can think of a couple of things, but I'm hungry."

"How about Umberto's for breakfast?" he suggested

"How did you know that's my favourite cafe? Have you been checking me?"

"I just guessed...."

He lay back, putting his hands behind his head, and looked down at his erection. He made no move, but looked again at Ellen's gaze, transfixed as it was.

"Maybe we can spend the day getting to know each other better," he said.

"I really think we should give ourselves plenty of time to explore each other... and find out how we feel about life. But I'm starving, so let's get some food first. Give me ten minutes and we'll go."

While John showered, Ellen watched her v-mails. Jade had already been on asking how she and John had got on. Maybe Jade had checked him at the door, which would mean she knew he was hard to pin down. Ellen replied "Great! How did Janine meet him? Is he a friend of Jaspar?" She hoped that Jade would reply before John was out of the shower, but realised Jade's v-mail had been sent in the early hours and she was probably still unconscious.

The sun shone on the empty street. Ellen stood in front of the ad-wall at the M-rail stop and saw herself walk by in Karen Millen. They entered the quaint cafe with its plate glass window piled with delicatessen, and sat at her favourite table. Ellen viewed the table screen as it scanned her and instantly changed to her own menu of favourites, but only low fat options, as usual, even though she fancied pancakes with maple syrup. There were some recommendations, themed on what she liked to eat. She decided, reluctantly, on the muesli and low fat natural yoghurt, thinking of her premium. She touched her order and the menu deducted the price from her Strasbourg account, and the screen switched to clips of the new

e-book by Morrison, since she'd nearly finished his last one, plus cinema listings for the omniplex in Clapham, where she'd taken her mum last year for her birthday. It was coming up soon, and she'd forgotten.

She turned to John, waiting for the table screen to scan him and for the menu to offer him whatever he was allowed. Nothing. Instead, the screen saver faded to a red and orange gingham tablecloth – in keeping with her mood, her heightened expectation. The light dimmed slightly, to suit her sensitive blue eyes, and the air cooled as her chair reported her weight and body temperature.

He looked at her, then down at the table screen. No menu appeared, no change of advertising. She watched him smile, unconcerned. He seemed so at ease, which was more than she could say for herself. He seemed to know so much more about her than she did about him, which was not meant to be part of her normal first date strategy. Now she sat back with a strange sense of excitement, realising that she'd been right earlier. He must have hacked his chip and deactivated himself, which meant he was probably on the Egress list and wanted to get off, or he was in some gang and had bought his way to anonymity

"Why aren't you getting the menu? You must be..."

"Off grid. Yes. I'm able to switch off my chip from my Nimbus."

"That means you're either a VIP, or a Sub."

"Yes, and yes. I'm a VIP Sub! You OK with that?"

So there it was, no ceremony or evasion. She felt the warm glow of being trusted, quickly followed by bitter disappointment. That ruled him out as a prospect. Strasbourg would cancel her policy if she showed any evidence of consorting with him.

"You know what penalties that means for you, and I'm sure you know what it would mean for me, if they know I'm with you. Especially

working for Strasbourg. Did you buy your deactivation, or are you some kind of hacker?"

"No, and yes. And I know a lot more about Strasbourg and Stan's algorithms than most people. I'm sure it's a shock, that you might have spent the night with a Sub. You probably haven't met one before, have you? And you might just want to get up and walk out of here and pretend nothing happened. I won't stand in your way. You can sleep soundly in the knowledge that I'm so far off grid, you won't have been tracked for it. Your precious PQ is intact, even if it isn't exactly single digits."

John had tensed and was looking away. He seemed so irritated by Ellen's fear that she thought he would be the first to leave.

"Hold on. It's just... I need some time to... You're right, you are the first off-grid man I've met, and definitely the first Sub I've slept with. I'm trying to get my head round the idea that you're deactivated, but you're sitting here in the middle of London, completely visible. You've spent the night, and yet my PQ hasn't shifted a point. I'm just not used to it."

"So, how does it feel?"

"Scary. Thrilling. It feels OK though... better than that, if I'm honest. But how come you haven't been picked up, taken for re-activation or deportation? I thought there were whole teams of contractors rounding up the hackers and deporting them. We are talking about Egress aren't we?"

"I trust you Ellen. More than that, I think you and I are kindred spirits, so I want to tell you everything about who I am, why I am doing what I'm doing and where you might want to get involved. It's a lot to take in, and I honestly don't know if you are either ready for it all, or whether you're prepared to step off the conveyor belt. But I'm looking for someone I can share all this with, and I think I just may have found her."

"OK, slow down. What is 'all this' when it's at home?"

"Well, for starters, I'm not a lone wolf. I'm part of a small team. We're called Gimme, and we're all specialists. Stanislav Janekowski, as you know, is Jade's dad. Yes, don't look surprised. I know a lot about Jade and Stan. Stan is a Director of Strasbourg and he used to be the founder of Genomica, which was the company that invented the chip, and later the PQ. My dad worked for Stan at the beginning. In fact, he wrote some of the code for the chip, before Stan had him squeezed out."

"Can I ask something? Take a step back? Did we just meet at a party because we fancied one another or did you know about me before we met? If you know about Jade, I assume you know about other people in Insights, because you must have hacked our files. If you knew, and you picked me out at the party, why?"

"Why What?"

"Why did you select me and why did you seduce me, and why the fuck am I still sitting here when I'm pretty sure I've been used?"

"OK, fair questions. I did know about you, and Magda and Rachel and Denise and Martin and Stephen and the others. I didn't exactly pick you out, but I did pick out Jade's housemate, Janine, and I did seducce her because I wanted to get close to Jade, and it was Jade who invited me to the party last night, which is where I saw you. As to whether you've been used, all I can tell you is that I didn't need to meet you. I don't think you have any more access to Stan than I do. I chose to spend time with you because, frankly, I liked what I saw. Oh yes, and as I'm being completely honest, I already looked at your PQ and I liked what I saw there too. Not that I care about your score, but I like your psychological profile."

"Hmmm. I'm not sure I believe you, but I'll give you the benefit of the doubt for now. What is it about my psychological profile that you like? And I'm not fishing for compliments here."

"Well, I think you are intuitive, independent, slightly nonconformist, but a realist. You're not a subversive, but you are on the edge of the circle,

and for me, you might just represent the sort of person who can look out as well as she can look in."

"And what is this edge of the circle all about?"

"In my mind, the circle in which most people reside is becoming smaller, more claustrophobic, and definitely it's an unhealthy place to spend one's life. From some of the stuff you said last night, if you can remember it, I got the distinct impression you hate a lot of the restrictions it imposes. That circle is like a noose, and it's controled by Stan and Strasbourg and others in positions of power. I'm not ready to call them evil, but I do know that their strangle-hold has evolved because they love power, they love money, and they have the tools to tighten the noose, using AI."

"I'm not a coder, as I'm sure you know. I'm just a glorified clerk with a skill for spotting good matches. But even I recognise what you're talking about. I don't really understand how artificial intelligence works, or how much power it has in Strasbourg. I do know that everything which comes out of the computer is approved by the Board, and nothing changes unless it suits them. I also know that I've a better than average chance of losing my job to AI within a month."

"So whether you recognise the circle as a fence or a noose, how do you feel about stepping out of it?"

Ellen was used to being monitored everywhere she went, and measured in everything she did. She hadn't experienced the freedom of hiding, ever. Here was someone hiding in plain sight. Someone she had known to be real, who wasn't measured or scored. Her waste bins tracked the packaging she threw away, her clothes reported their wear and tear to her bank, and her spending choices were dictated by upcoming bills. Her v-mail was 'cleaned' for antisocial content, and her conversations analysed for meaning and inference.

"I think we need to talk about all this, but I'm sure this isn't the place to do that. Can we go somewhere that is safe? Back to the Bond Street station or somewhere?"

"Yeah, that's a good idea. I know a few places that are out of range, but first we need to eat."

She should have noticed outside that the ad wall hadn't changed as it normally would, when he passed. He might have appeared in a Boss suit, striding elegantly, or on board his yacht, in Lacoste. She'd been delighted with how she looked in the red Karen Millen, and she'd paused long enough to check online that she couldn't quite afford it, but that they'd offer her terms... but now she remembered how the wall had stayed green when he passed, like a vampire passing a mirror.

"I'll have what you're having," he said quietly. "Would you mind ordering for me, as I'm not very popular with these devices. "

She felt scared, but her heart was racing and she wanted to go with it. She touched the tablecloth which reverted to the menu.

"OK I'm having low fat yoghurt and muesli, and I expect you'd like a fry, but I'm pretty sure it won't let me go again without penalties."

He smiled and took out his Nimbus. The same model as hers, but it had an extra small box attached, unlike any upgrade she'd ever been offered. He held her hand across the table, palm up, and scanned the chip in her wrist. He made a few quick slides across his screen and pocketed the device.

"There we go, I've deleted the charges for your breakfast, so now you can order the pancakes you fancy without any penalties, and the same for me."

"How do you do that?"

"I could tell you, but we don't want to waste the time it would take, and besides, you might want to take this one step at a time."

He moved closer, feeling the cool air in her space. He lent in close and whispered "I could just remove you from the files, and you could join me

off grid. Contrary to popular belief, it's not all mafiosi and pornographers on the Darknet. It's really liberating, and much safer than Googlenet. We could start by deleting you from G-Match – it's not a dating site you know, just a spying portal. Or we could change your status to 'dating' without any problem. I do have a couple of suitable aliases you could match."

John sat back waiting for the pancakes. Ellen sat silently contemplating another life. It would mean giving up her job over the road, and once she was off the system, she'd have to cut connections with everyone she knew, like Jade and her friends. What would happen then? What would she live on, and where? How would they treat her parents once they found she'd deactivated? There must be another way of living. There had to be thousands of off-grid people, and they couldn't all be bad. John seemed genuine and safe, even if he wasn't in the system.

As the waiter brought their breakfast, her eye was drawn to the window, and over the tower of scones displayed for passers-by, she caught sight of a man in the street in a dark suit, coming towards Umberto's. She turned back to her strange new friend, but he has gone. She pulled out her Nimbus, which was buzzing, and the screen showed him, standing in a doorway across the road, in shadow. He whispered "well?"

CHAPTER SIX

The Rains

"Hey Nick, how are you? You alright for a pint?"

John and Ellen had taken the M-rail from Stockwell to Islington to meet Nick in The King's Head. While John greeted Nick in their usual corner of the old bar, Ellen hung back, reading the list of plays on the noticeboard to be performed downstairs. John had given her some background on Nick. She'd read a couple of his papers from his days at Imperial, and she'd seen his vid at Strasbourg from before he went off-grid. She had the impression of a healthy if slightly drawn man in his late forties, so she wasn't ready for the crumpled-looking old man in the corner. His last vid on the Strasbourg files made him look like the respectable academic he had been at the time, in a linen jacket and with short hair. Ellen had gone in to G-Match to look for him, even though she knew it would be flagged up on the security system, given Nick's current status as a wanted man. Luckily, John had been tracking every click from the terminals in Insights, and was alerted to her indiscretion. He was able to remove the evidence of her search before it was inserted into the standard weekly security update automatically generated from each department and analysed by the security team. He had to warn her about using the office to do any background reading, and uploaded another patch to her personal Nimbus to ensure that all her searches were untraceable. He'd given her a load of people to research, so that she would be busy enough herself to let him spend the late evening doing his own work, rather than talking to him or distracting him by fondling him. Much that he liked the attention, John was trying to focus on getting everything ready.

Nick was dressed in black jeans and an old hoodie, with straggling grey hair and bags under his eyes. She wondered if he was living on the

street, but from what John had told her, Nick had money and a couple of perfectly adequate bolt-holes, one in Tottenham somewhere and another out in a village in Suffolk. She hadn't been far outside London since she was a small child, when George still had a car, and before the M-rail was built, so the idea of travelling to Suffolk seemed like an international adventure. Nowadays, getting to the countryside was almost impossible on public transport, and she couldn't afford to use a personal vehicle, even if she could book one to go that far. She had a romantic notion of country villages from childhood memories and NetCast, and she thought maybe when things felt more secure around John... if they did, she would suggest they went to visit Nick in the country. That was if John's skills would allow him access to transport and if Nick was OK with intruders.

She'd viewed some film of Bungay, the nearest tiny village on the coast, several kilometres walk from his cottage, and it seemed unimaginably quaint and old world. John had actually come up with the idea of a weekend away, but the unspoken truth was that he didn't feel able to get away while Gimme was working so hard. Besides, Nick was in London, working nights on creating a clone of the PQ algorithm which he could edit and test. He'd been working in isolation, in a home-made Faraday cage to ensure that whatever he set in motion with the AI wouldn't get out. The cage would stop the AI taking over other computers to achieve a goal, provided it didn't manage to persuade him to let it out, which was always assumed to be the biggest threat from an isolated super-intelligent machine.

Once he'd pulled a copy of the PQ, John was able to see that it was not yet at a Strong AI level which would enable it to self-improve beyond basic sub-routine iterations, and that it had been limited in its decision-making, not only by authorisation protocols but also by the fairly tight definitions of its goals and activities. While it was highly sophisticated, it was only really a set of inter-related subroutines, which didn't have a central 'brain' function. John knew that this copy was not Stan's latest, but was the fully operational version being run by Strasbourg.

Stan had agreed as part of the takeover by Strasbourg that he would have the right to maintain an independent R&D facility under the original Genomica brand. After the merger, Stan had so little time to spare that it was impossible to give the development of the new Genomica any thought, and it languished for two years until he began to feel the weight of working in a multinational corporation. After trying to get the CEO, Geoff Grainger, and two non-Execs, Malcolm McBride and Jaspar's father, to support some of his more 'progressive' ideas for developing the PQ, Stan finally made time to re-invigorate Genomica Labs to begin work on developing a much more sophisticated AI than Strasbourg was ready for. He saw Genomica as his guilty secret, something he could slip away to when he couldn't stand the office politics any longer at Strasbourg, or when the politicians he had to spend time with drove him to escape.

He brought in a team of AI specialists, working in a highly secure facility he set up in Wapping, to move the PQ forward to a point where full AGI was possible. It was an arms race which he was prepared to sink a lot of his money into, and the Wapping office was designed to carry the latest quantum computers, a full Faraday cage setup and enough top-level AI coders to compete with the Israelis, Russians and anyone else with ambition to finally find the holy grail. He oversaw strategy and drove the team hard, but they were way ahead of him when it came to coding.

It was only by chance that Nick found out about the continuation of Genomica Labs, when an ex-student asked him for advice on whether to work there. Despite his best efforts, John had been unable to find a way in to the Genomica servers to copy the latest version of the PQ algorithm, and this was mainly because they were not connected with the outside world at all. The company was clearly not a marketing outlet, and had no online presence he could find. Through Nick's ex-student's v-mail, who had decided to take the job at Genomica Labs, he was able to hack the v-mail server, but found a pretty innocuous range of mail. Clearly Stan had made it an absolute rule for his staff never to communicate in writing or video about the AI.

"This is Ellen. I told you I'd met someone, and this is she."

John smiled encouragingly at Ellen who was standing back, looking awkward. She sidled up to the corner table and now shook Nick's hand, which was cold. She could feel his tension and see the suspicion in his eyes.

"Hello Ellen. John tells me you work in Strasbourg Insights on G-Match."

"Yes, though perhaps not for much longer. They're making half of the team redundant this month."

"Yes, well, the march of AI will not be stopped until everyone is redundant, or extinct. So you work for Dr. Janekowski? Do you like him?"

"I've never met him, and I doubt I would be invited to. Insights reports to him, so he's two levels above me, though his daughter is my boss. Jade said he's never even visited the flat that he bought her, which is near here, isn't it John? He has a reputation for being distant and unsociable."

Since she and John had been spending time together, the subject of Janine had come up once or twice, inevitably. Ellen had to work hard to avoid asking him personal questions about his previous affairs, but she couldn't help asking about what he thought of Jade, and as she'd never been to Jade's place, she was keen to get John's description of it.

"Ah yes, the meteoric Jade Janekowski. How does someone live with such a surname? She must be carrying a lot of baggage, not to mention the Prince of Darkness' DNA. You'd think she would have changed her name long ago, just so she could be seen as her own person. And come to think of it, she might've taken advantage of Strasbourg's CRISPR Labs to make some changes to that DNA while she was about it."

Nick's face held a sort of smirking frown, as he looked at Ellen from beneath his hoodie, with a fixed gaze. Unlike John, who also tended to stare, Nick's look felt penetrating and uncomfortable.

"So you met John at Jade's engagement party last week. By all accounts it was quite a bash. The guest list looked more like the Insights payroll, plus a few little rich kids like Janine. Jaspar's the lucky man, isn't he? His father's a banker, and he's on the Board of Strasbourg. Nasty piece of work by all accounts, and Jaspar's a bit thick, judging by his PQ. I wonder what Stan thinks of him fucking the precious Jade."

Ellen tried to fight her intuitive dislike of Nick. She'd heard from John about his ignominious ousting from Imperial at the professor's behest, with Stan pulling the strings, and how he had joined Gimme soon after John set it in motion, to help with the Egress hack. Somehow she couldn't see him as a Sub. He had a sanctimonious air about him. Nick hadn't been looking for anonymity, but one condition of his joining Gimme had been that he go off-grid and keep a low profile in order that he didn't lead anyone to the co-operative. For John, Nick's recruitment was a huge boost to the group, not just because of his reputation and contacts, but because Nick had been in the forefront of AI coding only three years ago, and that was where all the action seemed to be for Gimme. Three years was a long time, and it was likely that nobody in Gimme had kept up to date with AI developments recently, since only a few very shadowy enterprises were receiving enough funding to compete in the race to full AGI, and they were pretty impenetrable.

"Jaspar seems OK, though I've only met him a couple of times. I wouldn't like to speculate about his intelligence, but he's loaded alright. Has his own car and a house in St John's Wood, which he inherited apparently."

Ellen realised that she was giving much more information than she was getting from Nick, which was against one of her first rules of meeting people.

"You certainly know a lot about people involved with Strasbourg. How come?" she asked.

"In my position, it's unavoidable. And not just those in Strasbourg. George and Elsie, and your little sister Jodie, for instance. Looks like they've

had a tough few years. They're on basic UI, living in Tower Hamlets on that god-awful estate. George was made redundant from Ford in 2022, when they lost the contract to build autonomous MPVs for Uber. You were three and Jodie was only one. Must've been traumatic for him to find himself on UI. Elsie is hooked on VR, and you're contributing to the cost of her package, as well as Jodie's 'happies', as you're the only wage-earner. Jodie lost her job in Tesco two years ago. I could go on, but you know it all."

Ellen felt shocked, and the blood drained from her face. Of course she should have assumed that John and his friends in Gimme could find out anything they needed to know once they'd entered the Strasbourg servers, but having it presented starkly to her by this dishevelled stranger was still shocking.

"Yeah, I do. And so do you. What do you think of my PQ by the way? Am I thick too? And the guys I've been dating through G-Match? Bunch of losers? And what I had for breakfast this morning and what route I take to work and what time I get there? You set yourselves against the people who made all that information possible, and here you are, using it to spy on people. Who the fuck do you think you are?"

She was red in the face and speaking quickly. John put his hand on her arm and she became silent. Nick saw that he'd pushed too hard, and he began to relax, realising that Ellen was not a threat just because of where she worked. His voice softened.

"You're right, I'm sorry for that. We are trying to stop all that and we shouldn't be using it. Look, Ellen, I'm telling you, so that you'll understand that John and I are in a very dangerous game, and we can't afford to take any chances with people who find out anything about us. So we have certain skills which allow us to change peoples' circumstances, for better or worse and ..."

"OK, Nick, enough."

John was very aware of how freaked Ellen had been ever since the morning after the party, and he could see her eyes clouding over and tears beginning to form. They'd talked a lot about what she could do if she stayed on-grid to ensure he was not discovered. Both knew that sooner or later, his connection to her would raise suspicion with Jade, and some image match would be made with an old John Vaunt file, and Stan's security department would send out the bounty hunters to pick him up. It could already have happened, at Umberto's, but John assured her there were always roving security guys following up on anyone who was registered entering places but who didn't show up on the system. He'd been switched off, but if he'd been registering as John Valance, he wouldn't have been followed.

Alternatively, she could go off-grid, but that would entail making a clean break with her family, and her social life. She could re-connect with the family in due course, using a new identity, but only once they had been 'moved' in the system, since all connections to Subs were tracked to try and pin them down once they went off-grid. Neither seemed like a solution at this early stage, and she felt somehow in limbo. John had proposed bringing her to meet Nick as a way of helping her decide how far in she wanted to be with Gimme. She had little to offer the co-operative except her access to Strasbourg, and even then, she was not senior enough or technically literate enough to be very useful. If she was kicked out in the next round of cuts, she'd be literally no use to them.

"Just to be clear, Nick. Ellen knows a little of Gimme's objectives, and she's considering her options. If she's dumped out of Strasbourg next month, the future is pretty grim, in that shit-hole in Tower Hamlets. As it is, I have already looked into what we could do for her parents and sister, and she is thinking about whether we should upgrade their package, and maybe re-route some small disposable funds their way. Nothing big or obvious. And Ellen is considering dropping off the grid too, but I'm not pushing that. You and I both know the downside. Micky and Jojo are the only couple in Gimme, and Jojo is a coder too, so it's not the same."

"Yeah, well, you be careful John. The last thing we need right now is any sort of trail. So, Ellen, what do you think of John's point of view? I assume you're not 100% in favour of the direction that Strasbourg is taking the country, and if you're 'dating' a Sub, I assume you're getting your head around alternative lifestyles."

Nick smiled reassuringly, and Ellen felt she'd calmed down enough to try again, for John's sake if not her own.

"I'm not sure what the right way forward is, and I don't really understand the ins and outs of the technology which is taking over, other than it is artificial intelligence and it seems as able to make decisions as I am, or better. I've been asking John lots of questions in the last week, about other ways of living. He said you'd been working on some simulations for communities, which sound really positive."

"Yes, they are, but it's one thing to generate simulations and another to institute them in real life. We have to enlist the help of the government and big business, and at the moment, those are the institutions who see us as pariahs and terrorists. We think that somehow we have to win over people in Strasbourg, since they really hold all the cards now."

"So how can you introduce people to your ideas?"

"We think that if there's a backlash against the current system, which is centrally controlled, and if we can present the best alternatives in a non-threatening way, ideally with the backing of some part of the establishment, we have some chance. It's not that someone in Stan's circle actually believes that the world is better as it is now than it was before the PQ. It's just that they set out on a path to maximise profits from AI and this is where it's taken them. If we can convince them that this is not the best way to use AI, and that short-term financial gain is at the expense of longevity, we might be able to pave the way for our alternatives to be considered."

"But first you need to remove the power which Dr Janekowski and Strasbourg have over everything to get to that I suppose. As you know, I'm

just a G-match Insights Analyst, which means I spend my time working in the dating business. We're in the persuasion game really, and we spend our time encouraging people to do something which they're interested in anyway. Perhaps you could talk to people through G-Match. I think people see it as non-threatening, and sort of fun, even though they know it's not just about match-making. Most people get it that G-Match is all about healthcare and security and cost saving, and not some sort of romantic thing, but it has a pretty good press. I'm not really sure what would happen if you take it away from people."

"We're not sure either, but as you know, the cornerstone of the whole Strasbourg operation is the PQ and how it integrates with every aspect of Stan's control over everyone. We know a lot about it, how it works and we have some concerns about what will happen if they take it much further, as a full AGI. In fact, I'm pretty sure that Stan's trying to get there, ahead of everyone else. Worldwide. AGI is a self-improving algorithm with generalised capabilities which would generate super-human intelligence, and potentially would take control of Strasbourg, and then all its tendrils in order to achieve its goals. I'm not alone in the AI world in fearing that once the cat is out of the bag, there'll be no stopping it."

Ellen had heard some of this from John and hadn't really processed it. Nick, an inspiring lecturer in his time, had a simple and succinct approach to telling the story, while John had been more convoluted, paranoid even, about the existential threat.

"What do you think those goals might be? If Strasbourg set them, they must be about making money, don't you think?" she asked.

"Typically, AI runs against a set of objectives set by humans, such as maximising profits, winning games, selecting the most efficient path to a given success, and so on. The goals set for AI to date have been fairly simple, and Stan has always built in a caveat 'only achieve this goal if it doesn't undermine the humans, and only if I tell you to.' You get the upgrades which the Board of Strasbourg authorises as part of your

job, don't you? That's all well and good, but it means the AI is effectively acting as the slave, and it isn't advancing as much as it could. But in future, it'll have the ability to adapt its objectives independently to take into account steps it has achieved, without recourse to someone like Stan to approve them. In other words, the AI would take things into its own hands and become self-driven, autonomous. It's easy to see AI as some sort of machine enemy or Machiavellian opponent, so I'm not going to be anthropomorphic about it. There's no cognitive process, and no irrational decision-making. Lots of people think machines will have personalities, and will become aggressive to subjugate humans, in the way that we have done with pet dogs or something. I don't buy that. We have things to offer which make us useful."

"You mean we can live alongside super-intelligent machines that can work a million times faster than humans and make better decisions, and we won't become redundant?"

"Not for a while, by which time we might have integrated with AI in some sort of cyborg society or we might be given our own space to inhabit, a bit like a wildlife park."

"Oh, great. I've always wanted to pace back and forth along a fence, waiting to have food thrown at me. How long is 'a while' do you think?"

"The speed with which a Full AGI could become much cleverer than you or me, or Stan, means that within days or hours or minutes, it could harness computer power worldwide to build a robust, networked, intelligent machine that could circumvent any attempts to stop it."

"Yeah, I thought it might be something like that. We all saw those ridiculous sci-fi films when we were kids. You know, the Terminator ones and stuff. Why wouldn't robots just get rid of people?"

"Well, in my view, it all depends on what direction people point them in to start with. The original goals will affect the direction they take, and the direction will result in evolved futures. John and I have been working

on community simulations that could be guided by a super-intelligent system without being dominated by it. A sort of guardian angel which we can trust. We believe that with the right initial goals, the AI would integrate with human communities. We're running some tests on the PQ algorithm, which has been given more coding hours than perhaps any other AI product in history, and so it has a lot of great features. We think that Dr. Stan may have taken it a lot further too, in his own private empire. The big unknown is whether he is setting beneficial or sacrificial goals."

"You probably know a lot more about him than I do, but if Jade is anything to go by, what could be worse than someone like him having control? I mean we're already putting up with some terrible things because of Strasbourg's rules which everyone just has to accept. My family is being turned into zombies or caged animals by UI. The people I get offered through G-Match to date... at least the people I was considering before I met John... weren't my own choice. I can't go anywhere without being tracked, and I'm made to avoid so many places and things like foods and activities because they're considered by someone else to be unsafe for me. I don't seem to have the right to choose anything. How would AI decisions be worse?"

Nick smiled at Ellen and this time it wasn't at all disconcerting. He looked at John and Ellen, and said, "let's make a move. You were right, she is one of us."

The pub was filling up. John and Ellen were going to eat down the road, and Nick was going back to Tottenham to continue coding in the cage. They left together and strolled slowly along Upper Street towards Highbury. Nick felt safer talking on the street.

"John, I think I've cracked the problem we had with removing the PQ reporting, without disabling the chips. I think we can do that, and at the same time we need to block entry from Stan and blast out our message through Nimbus so it'll become universal quick enough. Everyone who relies on PQ to make decisions about themselves and each other will

quickly have to get used to managing without it, and that could cause a lot of unease. Obviously we need to reassure people that it won't undermine their medical and security needs, but we can turn off the G-Match and stop everyone receiving premium penalties every time they do something non-conformist, and we can cut down on the security feedback systems if we want to. My worry is that if we do, we'd be throwing the baby out with the bathwater, and it'd leave the door open to any trouble-maker to take advantage. It'd be like turning off the alarms in a shopping centre and expecting it not to be looted."

"OK, I'm with you on that, but once we start, we've got to move beyond disruption, haven't we? How long will we get?" John had been worried that Strasbourg's defences were too resilient to be held back long enough for the whole breach to make any real difference.

"It should hold for a while, till Stan's team finds an alternative route round our block. In that window, we need to pin Stan down and put enough doubts in everyone's minds about his motivation. That means getting to all the opposition politicians, the media, even Strasbourg's Board."

"Great. When will we be ready?"

"Well, the reason I wanted to meet today was to ramp it up. I think they know you've been in to copy the PQ. I'm not sure, but I saw a v-mail from internal security to Stan highlighting our breach of the system, and he hasn't responded, which is either because he's too busy, or more likely because he no longer trusts the channel."

"So we need to strike soon. How long do you need to have it all ready?

"A day or two should do it. Meanwhile, I had a look through some of the stuff that Fitz downloaded, and I think we can create a big enough diversion with some of that to keep Stan on his toes. Might even be enough to get him stopped for a while."

John had moved into Ellen's flat straight after that first night, because he was being thrown out by Janine, and since the party Jade was treating him like something she'd stepped in. Ellen couldn't work out Jade's reaction to him, seeing as she'd been so keen to put the two of them together, but during the week after the party, she began to suspect that Jade had been checking John out. Jade didn't say anything, but nor did she ask how they had got on, even though she was usually pretty nosy about any man in Ellen's life. Ellen assumed she had failed to find anything other than the fairly innocuous profile of John Valance, Systems Architect at the MoD. John was tracking Jade's activity online most of the time, and could see her following the trail, and he knew it wouldn't be a case of letting sleeping dogs lie. Something about his profile and the man she'd met didn't ring true, and she wanted him out of the apartment. She'd already given Janine notice to quit so that Jasper could move in, and once she told Janine that John had spent the night with Ellen after the party, it was straightforward to get Janine to eject him. John didn't seem bothered and had packed his backpack and said thanks to Jade on his way out.

Ellen had made no secret at work about having got off with the extremely handsome man everyone had seen her with at the party, and though she knew much more about John now, she was happy to play along with his alias. Magda quizzed her, and one of two of the others, but Jade said almost nothing. John could see that Jade was compiling information on his alias, John Valance, presumably to have him checked out by security. Even the MoD was accessible through the right channels.

Everything had moved on very fast after John and Ellen's breakfast together. She'd slipped out of the patisserie, walked straight past him where he was standing in the shadow of a doorway across the street, avoiding the man in the dark suit, and up to her apartment, leaving the door open. He followed minutes later, once the coast was clear, and found her lying naked on the bed. They'd spent the whole weekend making love, ordering full-fat foods to be delivered, and talking for hours. John's conversation wasn't all

about being a hacker and a political activist. Ellen wanted to know about his upbringing with a single mother on UI, how his father had died and what he'd been like growing up. It resonated with her family's predicament, and John really seemed to understand the downward pressure that people felt when they became economically worthless. Despite what had happened to his father, he didn't seem especially bitter, though his hatred for Stan was there in the background all the time.

John was a good listener, and even though she knew he'd been checking out her history online, he clearly wanted more connection than her vid archives would provide. She described the apartment in Tower Hamlets, and how her father had tried so hard to maintain their old lifestyle after he was made redundant. She told him about Elsie before she was on UI, and how strong and resourceful she'd been, and she talked about Jodie's vivacity and daring before she started on the 'happies'. She got the feeling that John knew everything about it before she'd finished. The flat in the tower block was almost identical to his mother's place, and his mother had struggled with her unemployment too.

He showed her how he could help George, Elsie and Jodie to some better living standards with very little work, if she wanted. She was tempted but felt that such power seemed inappropriate, and she decided not to become indebted to John now or ever, even though she dearly wanted him to help her family. Perhaps when it was safe, she could bring him to meet them, and he could talk directly to George, so it would be her dad's decision whether to take advantage.

"I know it's not stealing from someone, and it's a great offer, Robin Hood, but George hates charity, and I don't think better food or some spending money will stop Elsie's habit, or Jodie's. They need a reason to get up in the morning. They need something to believe in, to fight for. You can't give them that, can you?"

"Not until we bring down Strasbourg, but maybe in the future, they'd consider belonging to a new community."

She did accept his offer to install some code on her Nimbus which would let her turn off her chip at will, without setting off alarms at Strasbourg. When he suggested it, she thought it'd be something she'd use when she fancied eating fattening food that was bad for her, or if she wanted to spend time in an unsafe zone. The freedom of not being checked out all the time wherever she went had a delicious appeal, and she fantasised about what people in a bar would think when they realised she wasn't readable. Then she began to appreciate the import of what he was giving her. It wasn't something to play with, or a way of circumventing the insurance premium. It was the opportunity to go off-grid permanently, if she needed to.

"Look, it's simply a back door. If you're with me, then you need one," he said. "I'm not saying that by us being connected, you're in danger. I wouldn't put you at risk. It's simply that if I'm picked up for something I plan to do, and if I'm tracked back through Jade to you, which could happen, then you can drop out of sight on the spot."

"And what if I wanted to share more with you than this?" Ellen stroked his thigh. "Would it be possible to remove me from the records, and help me to slip away and for us to exist outside the system? I'm not sure I know enough about being off-grid. Is it hard? Are there lots of people doing it? Where are they?"

"That is possible, and I'm hoping it might become attractive to you. It already seems to me to be worth considering. But yes, it is tough enough. There are tens of thousands of people off-grid, even in this country, and there's loads more overseas. Some have become exiled and others have found places to live where the rules are different, and they can get on with each other in a traditional way. From what I've read about these places, most of them don't last because they're too small and don't have enough resources, or they depend on stealing from the establishment to survive. If people don't find like-minded communities, they become loners, hiding out and not daring to interact with on-grid people. That's where I've been for the last two years. I don't have anywhere I can call home, and I can

only watch over my mum from a distance, without contacting her. I have to cover my trail wherever I go and whatever I do. I avoid being logged on vid, and I've had my fingerprints altered. You saw what happened down at Umberto's. That guy. That's a regular occurrence. If it wasn't for Gimme and feeling a bond with the others, albeit an electronic one, I'd go mad."

"So what's going to happen? You've been clever enough, or lucky enough, not to have been captured and deported. Surely sooner or later they'll catch you? Is it possible that what you and Nick are planning could change the way they treat people who're off grid? I mean, you're probably wanted for all sorts of hacking stuff, but maybe you could get some sort of amnesty."

"Maybe. The future is completely unpredictable, and things will change very fast once we begin to act. I'd like to think that your life could be much better even within the world you've got set up, so that you won't need to step out to be with me. For me, it might be hard to get back in without a lot of power, and I'm just not about to try and take power when I'm trying to remove it from others. An amnesty is a nice idea, but I don't think Stan would consider it if he remains in control."

One of the Gimme hackers, Fitzgerald, with the apt moniker 'If-the-cap Fitz' had been looking for ways into Stan's personal life, chinks in his armour, because he specialised in identity theft and generating fake profiles. John had passed the mantle to Fitz because he was up to his ears in algorithms, and this called for a ferret with history in social media. Fitz had spent his life wrapped up in VR games development and had also worked for several specialist agencies which manipulated personal data for political and financial clients, on contract, before joining Gimme. His feeds to John and Nick, who were viewed by everyone in the co-op as its de facto leaders, took some disentangling.

'Stan's been a naughty boy with at least fifteen girls in the office, and a couple of parliamentary researchers, all crowing enough about his

antics for her indoors to keep track. She's following them and guess who's following her?'

'Mary J? Oh, I'd say half of the People of Quality in London.'

'Quality? Half the Labour Party more like. She been the subject of Morgan Edwards' trouser snake for long enough and he's getting more than his end away.'

"What're we talking?'

In response, John got a dump of all the more factual v-mails between Mary and Morgan about Stan's business, which he skimmed through to check they were not fiction. It was all credible, fascinating and mostly compromising to one or another participant. And what struck him was the quantity of information she'd managed to glean about the future of the PQ, and how much she was prepared to share with the shadow Home Secretary.

John had never spent time studying Mary, but now he trawled through her history on Strasbourg's servers, in case she was a contender for leverage against her husband. He could see that she'd not only been one of the first tranche of recruits to Genomica once it had moved to London, and had been involved in the initial stages of the G-Map programme, but she had a Masters in computer engineering and quite a lot of experience with algorithms. He was fascinated by her decision to leak Stan's content to Morgan. From what John knew of him from his public persona at least, he wasn't the sort of slippery bastard who would blackmail her into stealing information. If it had been Alistair Prim, that would have been a reasonable supposition. In this case, he had to assume that Mary had made her own decision to leak it. He v-mailed Fitz.

What's she looking to do? Can you follow the trail from Morgan to see where it's all been going? I'm interested in what Morgan did with these and what his cronies think of them. I'm considering using her. She seems to be ready to undermine Stan, and we can use that. Also where's she getting this stuff. We haven't managed to get this close.'

'Last time I checked you weren't married to him…'

'I saw in one or two of her msgs ref to security video feed. Can you check for back doors?'

Fitz could crack most personal v-mail and use his hacks to collect connected material stored in non-proprietary cloud servers. If Mary had access to security video, he could pull it. An hour later, John received links to a large number of videos from Stan's house in St John's Wood and from the Strasbourg offices. He hadn't time to watch many, but scanning through a few, he came across the discussion between Stan and the Home Secretary, Alistair Prim, about the Tories awarding the UI healthcare programme to Strasbourg, and the obvious bribery which it included. There were loads of different people who had had meetings in Stan's study, or had been recorded at various parties, chatting. It was a treasure trove of useful content. That would be the sort of pressure which Gimme needed to help tie Stan to the barrel. He messaged Fitz.

'Any chance you could search this lot for compromising material, especially involving politicians, and do what you can to provide me with contact details for each one? And also, I'm interested what Genomica Labs has up their sleeves for future upgrades to the PQ. I've scanned their v-mail server, but it hasn't got any reference to their work. Could you work your way through their coders' personal accounts and see if any of them has a lover who has access to titbits? Sorry it's a lot of work, but there's only twenty or so people working there.'

'Are you thinking smear campaign in run up to election?'

'Thinking threat of one…'

Nick v-mailed that night, which was a Thursday, to say he'd be ready by the end of the working day on Friday to launch the PQ blocker. The patch he'd written would not disable the software, but would switch off certain aspects of it, and allow others to continue to feed Strasbourg with data. He planned to initiate auto-messaging to all Nimbus devices and v-mail accounts simultaneously with the news that until further

notice, G-Match would be off-air, that the PQ would continue to support healthcare and security requirements, but would not feed directly into Strasbourg's insurance premiums. This, he said, would come as though from Stan himself, having been routed through the Strasbourg External Communications account to all policy holders. It would go live after the stock markets closed for the weekend, and once most Strasbourg staff had left work. That would not only slow the response time down, but would also keep the change as low-key as possible, even though it would undoubtedly send shock-waves through every channel. As to how Strasbourg's insurance model would change as a result, that wouldn't be Gimme's problem. Undoubtedly, the insurance industry wouldn't run at a loss, and the old way of calculating actuarial probabilities and feeding those through to premiums had been dropped long ago. Nevertheless, Strasbourg already had such a detailed profile for everyone, there should be little problem in predicting demand and appropriate cover. The quality of healthcare to those on Universal Income was already terrible, and they were no longer covered outside their front doors, so it couldn't be worse for them.

'This patch is locked up pretty tight in a quantum AES block cipher, but I've no doubt that the team at Strasbourg or the Genomica Labs guys could crack it in time. Let's assume they'll be called back in over the weekend to do that as soon as the alarms go off. If we're going to have any permanent effect, it's got to be negotiated this weekend. Are you ready for Stan?'

In truth, John was far from confident that he could undermine Stan's position enough through leaks and threats, which would be water off a duck's back to him and no more than a diversion. This guy was supremely confident of his status, and believed that he had the market over a barrel. The question was whether he was over-confident and assailable or whether he couldn't be touched. His position looked secure as long as his algorithms made money for Strasbourg, and as long as nobody else offered an attractive alternative for managing welfare services. But John thought that perhaps there would be a moral backlash against him, if he could be presented as

beyond the pale. Would Strasbourg and the government hang Stan out to dry? Could they manage without him? Nobody is indispensable, surely?

The problem was that Stan could retaliate, as could the government. Gimme could quickly become public enemy number one, and the establishment's spin would be that a bunch of hacker Subs wanted to take away law and order, decimate the healthcare supports which Strasbourg had in place, and worse, block payment of the UI. This last story could be backed up by disruption in the UI payments, instigated by Stan, but attributed to Gimme. Perhaps John should pre-empt this with some sort of interference between the UI control program and the payment system, clearly attributed to Strasbourg. But nobody in Gimme wanted to cause any suffering to the very groups they were trying to help. They should consider how to pre-empt the negative spin. It should be possible to communicate with a large majority of UI recipients through the news media, and Nimbus, warning them that Strasbourg was likely to mess about with their payments to hide its problems.

But in the end, almost anything Gimme did to disrupt the current status quo could be undone within a week or two. It was essential that nobody in the co-operative believed they were the best. If they could break into and alter software, so there would always be someone else who could reverse their work, crack their security. The only way to use this breach was to create a hiatus, a calm space in the eye of the storm, to engage directly with Stan in the process and hope to use his temporary difficulties to persuade him of the other options. It would be worth finding a way to have a live v-mail conversation with him without breaking cover.

'I am worried about him, but we can't have one man getting in the way of everything. We have to bring him to his knees somehow, and perhaps then we can offer him a role in our alternative future. After all, he is more interested in science than money, isn't he?'

'It'd certainly be great to have him inside pissing out rather than standing over us pissing down on Gimme from a great height. Imagine if Stan brought his resources to

bear on our proposals and backed them. But let's not get carried away with positivity, Nick. It's best to concentrate on the next few days. Are you worried about the public's over-reaction to blocking aspects of PQ?'

'Yeah, aren't you? Who knows how people will react. Will the dating business become a mess? Yeah, but who cares? It's about time we started choosing our own partners. Will the security contractors withdraw from their duties? Not unless we cut their feed from the chips, which isn't something I've included in the patch. Will Strasbourg suffer massive problems trying to re-calibrate the insurance premiums? I really hope so. Will Stan lose his job? I doubt it.'

'Well, there's no point throwing everything up in the air unless we're ready to accept how it all falls to ground. Have you included any other disruption in the plan?'

'Yes, I've written a worm to insert into the deportation data, which should bring the whole thing to a grinding halt, and I'm planning to make some substantial donations from Strasbourg's accounts to various groups in need. Those won't undermine the company financially, but a crash in their share price will. We should make sure that the financial markets have access to all the information they need to put manners on Strasbourg. We don't want the company to collapse yet though. It has to maintain the basic levels of service while all the overarching powers it wields are cut back. I do feel we should also hurt Stan through his wallet. Fitz could give him the full credit blacklisting treatment – no cards, no direct debits, overdraw his accounts, freeze his assets. You know the sort of thing. Obviously, unless someone in Strasbourg wants to hang him out to dry, that won't stick, but it might distract him. I think you should dump a load of the Stan files into the mix, too.'

'Let's get Fitz to set that up, but let's hang fire to see how he reacts to the shit storm. I'll go through those vids from Mary and see which ones are best for undermining Stan. We might need some carrot and stick with Stan. OK, better get back to work. Let's talk before the end of tomorrow. Ellen can bring your patch in to her office with her on her Nimbus, which will ensure no interruption in uploading.'

Nick's mail pointed John to a file he'd uploaded to their secure storage which was labelled QP. John liked the joke – PQ backwards – that

this was the patch which would be distributed from Strasbourg's server to everyone's chip, making it hard to reverse centrally, once the chips no longer performed the same functions.

Friday was frenetic for everyone in Gimme. V-mail flew between Fitz and John and between Nick and another Gimme operative, Micky March. Ellen helped John work his way through Strasbourg's servers to identify key people to receive information in the correct order. John set up the v-mails carefully in preparation for the timed launch. Everything was tagged with launch times to coincide, even though it took hours to make sure it was all ready. The rest of the Gimme team were drafted in to deliver Stan's files and vids to individual politicians and to various media contacts at suitable intervals to ensure that the news would be running when the patch was distributed. Victims of the vid leak were given five minutes to view their material before it went public. Just long enough to digest the impact of it but not long enough to make calls to stop its use. The public would see what an absolute mess Strasbourg was in, and how corrupt and dangerous Stan was, at the same time as they were being released from the chains of the PQ. All the material would be delivered to the victims through anonymous routers, and all signed by Gimme, in the name of democratic freedom and equality, while all the public communications would be addressed from Stanislav Janekowski, Director of Research at Strasbourg, 'In the Name of Profit, Subjugation and Greed'.

John wrote anonymously to Mary Janekowski at lunchtime.

'You don't know me, but we, the Gimme Co-Operative, have a shared interest in some of the meetings your husband holds in his study. Morgan's got quite a following for his blogs, as you know. We want you to know, and to tell your 'good friend' Morgan and his followers, that there will be a closed user webinar tomorrow morning. By then, you'll know why. Please avoid sharing this inappropriately.'

He sent it to her Nimbus from an untraceable IP, with details on how to access the webinar, and monitored her activity. She did as asked and immediately sent it to Morgan who was in his office in The Commons. He

did as she requested and prepared a simplified version removing the 'good friend' reference, though both knew that their affair was pretty common knowledge. He marked the v-mail confidential and not for distribution, and sent it to some of his shadow Cabinet colleagues and one or two back-benchers with the webinar details. Nobody abused the confidence, but several in the circular v-mail met in the corridors to whisper about what might be going down. Private meetings with Stan had been attended by several Labour MPs over the last three years, and others knew of them. Everyone was intrigued about why they were being referred to by a hacking co-operative. Everyone cancelled other meetings and family outings to be free on Saturday morning for the webinar. Several agreed to meet in Morgan's office to share the experience.

Micky March had joined the Gimme co-operative a year earlier. He'd been an investigative journalist at NetCast before he was ousted for digging into Stan's role at the GRU in Moscow. He'd been called in by his editor and told that there was no longer a job for him, that he'd get a lump sum to leave and that he should abide by the confidentiality clause in his contract which ran for 12 months post-employment with NetCast. The Editor had had a call from the publisher, who'd been called by the CEO, who had been called by Strasbourg's head of Communications who had been told by Stan that people were asking questions he didn't like and to deal with the problem.

While Micky lacked hacking skills or even much technological understanding, he knew how to manoeuvre his way around the media, how to conduct interviews and how to present information. Micky met Jojo at a party and she turned out to be a coder with anti-establishment views, and once they were together, they made a formidable team within Gimme.

A week earlier, after the first King's Head meeting with Nick, John had delegated Micky to create content for these webinars on the proposals for curtailing the reach of Strasbourg, limiting the use of the PQ and outlining alternative community structures which Gimme would like people to consider. They would all be pre-recorded and distributed from

untraceable IP addresses. John and Nick's voice-overs were altered enough to be impossible to match to records, and scripted by Micky. Most of the vid footage was cut from the security videos that Stan had generated in his study, which added plenty of spice to the topic. Micky pulled together news footage of the brutal mistreatment of British citizens during the deportation process, raids on alternative communities in Spain and elsewhere, and lots of the material he had collated on Stan and taken from NetCast when he left. The last section of the webinar was presented in a different light. Having delivered its blows to the current regime, it went on to offer a brighter future, but took care not to over-sell or proselytise about alternative communities. It drew on diagrams and charts about the simulated communities, and integrated existing healthcare and security service offerings in the mix. Each ran to almost an hour, but with Micky's expertise, they became watchable documentaries, and Nick pulled out all the stops on his persuasive voice over.

The message was clear: 'look what we have now, look who runs it and how, and now look at what we could have.' Those attending each were invited at the end to watch further webinars which would be available soon, that would introduce practical steps for change. Nick planned to recruit individuals from each audience to participate in the second tranche of vids, with a view to having legitimate hosts run conferences, workshops, think-tanks and chat forums in future. The whole concept had to be legitimised, and that had to happen quickly, before Strasbourg could re-apply the screws, or the Tories, in an effort to win the election, began to ramp up the propaganda machine for maintaining the status quo. Once these forward looking events were set up, Nick and the other members of Gimme could then attend incognito. Micky selected journalists from the more liberal media, and especially those who had previously attacked Stan's work. John and Nick felt that with these two influencer groups on board with Gimme's objectives, a lot of work could be done by legitimate opposition, rather than being seen as subversive games.

CHAPTER SEVEN

The Ark and the Flood

It was late on Friday afternoon and Stan had been having yet another disagreement with Geoff Grainger about his recommendation to remove health cover for everyone over the age of ninety who was on UI. It had long been his view that when the Potential Support Ratio, which compares the number of workers to that of retirees, reaches one to one, then the economic model for UI is unsustainable. With more nonagenarians and centenarians than under 16s in the UK population, dramatic rises in unemployment, and reduced per capita allowances in the UI, the model for PSR was breaking down, and Stan wanted to do something about it. Geoff agreed that it would require a different funding structure, but was in favour of tax increases to fund healthcare, rather than curtailment of services. He'd been lobbying Malcolm McBride, the Chancellor, about this, as the budget was due. The Tories favoured a softer approach in the run-up to the election, and squeezing those on UI still harder would not win them votes. Malcolm was a non-Exec on the Strasbourg Board, despite it being contrary to government policy for individuals to hold directorships while in office. He'd been given a special dispensation, to represent the government on the Board because of the pivotal role Strasbourg played in the welfare system and the amount of taxpayers' money which was going through the insurance companies.

Stan knew that the inactive over nineties, exclusively dependent, particularly on healthcare services, were draining the economy. In fact, he felt this to be true of most of the whole population on UI, but he had yet to voice that view. Strasbourg's Healthcare for the Elderly contractors had an army of carer bots which were continuously called out to the vast customer base in response to chip feedback from people who'd fallen or

166

who were sick, or had arrhythmia or whatever. These contractors were already at or beyond capacity.

His model advocated incentives to carers and children of elderly parents to reduce or remove policy options offering supports for this age group, rather than bolstering them. It advocated appealing to their wallets rather than making the carers feel oppressed by simply cutting services.

In fact, it wasn't simply a PR initiative. Stan had been thinking for a long time that the chip should perhaps be upgraded to deliver direct 'instructions' to the body, rather than simply relying on feedback in the form of PQ, premium adjustment and liaison with support services. It would mean replacing everyone's chip with a more complex implant, rather than a software patch. It sounded like an impossible challenge, to reach eighty million people in a reasonable amount of time, but that could be handled quickly through mobile units and autonomous equipment. Everyone would comply and attend the units, under threat of deportation, and it could all be effected within about six months, starting with the elderly, those on UI and all street dwellers. The chips needed to perform more remote functions, such as releasing medication and providing pacemaker and defibrillation functions, and he knew that there was no allocation in Strasbourg's budgets for the upgrade, since there was no profit in it.

His idea was to make changes to the chip which would allow it to deliver an electronic pulse, like an electric shock, that would stop the heart, either momentarily to restrict someone in the process of violent or illegal acts, or permanently. He'd presented this as part of a package of changes to Geoff and the Board, but had come up against a wall of moderation from the majority, resisting what they considered a step too far. What Stan didn't tell them was that the idea had actually been generated by the new PQ algorithm which Genomica Labs had developed. It was presented during an iterative analysis process, in the form of a recommended solution to the problem. Stan knew that had this new PQ software been uploaded to the population's chips, it would already have implemented the change as part of its own decision-making powers to 'solve the crisis in healthcare for the

elderly'. At this stage, the new PQ was safely locked away in a Faraday cage, like a dangerous beast, and Stan had spent some time wondering what to do about the new power that his algorithm was exhibiting.

Geoff had warned Stan that he could not expect Board support for what amounted to capital punishment and euthanasia rolled into one, and he should stop trying to steamroller his policies through. Profit was not enough reason for such extreme measures.

"Frankly, Stanislav, I feel that your approach to this business is not in keeping with the ethos we at Strasbourg espouse. In fact, I think it is not in keeping with the British way of life. You might have gotten away with it in Moscow, but not here. I don't know where you're coming from on this, but I will not allow you to put such draconian, not to say evil ideas out under the Strasbourg name."

"I put this company where it is, Geoffrey. I put you where you are. I put the whole fucking establishment in the comfortable position it is in, and you know it. If you can't see the future clearly, it is you who shouldn't be part of Strasbourg, because you are being left behind. Genomica's work has underwritten progress for fifteen years, and without the PQ, we'd still be in the dark ages. All I'm proposing is a logical response to a massive problem coming down the tracks – what to do about the cost of aging. If you think that whinging about liberal values will stop the rot, good luck to you. If Strasbourg doesn't like my methods, so be it. I'll move right along, because it will be left behind whether I'm driving change or someone else is."

"I should remind you, Stan, that Strasbourg owns the IP, and if you plan to resign, you will walk away with nothing."

Stan turned and left Geoff's office. He knew nobody at Strasbourg had the ability to manage without him, and he knew that Genomica Labs had enough new IP to move elsewhere. The new PQ algorithm, once released online, would find its own way to the top and might not need some monolithic dinosaur of a corporation behind it. But he'd go in his

own sweet time, or he'd take down Geoff Grainger and step into his shoes. It was only three years since Genomica had been acquired, and it had become claustrophobic. Stan knew he was never going to be a good bureaucrat and nor did he profess to being a team player. If they didn't like his modus operandi, that was their problem, not his. The Nimbus buzzed.

"Dr Janekowski, we've been through the logs and there's no doubt that the PQ algorithm source code was downloaded remotely two days ago. It was an exceptionally clever piece of hacking, which we only spotted by chance. We've never seen a blockchain hack of this type. They re-wrote the genesis block and bypassed the Solidity stack. Amazing, in fact. If we can find out who it was, they'd be a great hire. We traced the geolocation of the IP through a raft of servers worldwide, to North London, but it was a dead end with no owner details. It appears that the full source code was copied and at the same time, attempts were made from another IP in West London to hack your Strasbourg v-mail, home server and Genomica Labs v-mail, although this was a less sophisticated attempt and it was ineffective. Do you want us to make a wider assessment of potential breaches, sir? Your daughter? Your wife? What about the coding team at Genomica Labs?"

The CEO of Churchill Security was making the call himself, given the importance of Stan as a client and his position in Strasbourg, their biggest corporate account.

"Not now. But please conduct a full scan of all camera feeds in London against those fourteen members of Gimme I notified you of last week. Particularly Nick Artremis, John Vaunt, Noel Fitzgerald and Anthony Edgeworth. They're the four most likely suspects, and you have the last images on record from three years ago, which should be adequate for matching. If you come up with any positives, I want to know where, when and what was happening – send me the vid straight away. I want to know if anyone who's on-grid came into contact with any of them and

then you can send out the team to bring in anyone who looks like they might be familiar. It's time we saw some positive results from your guys."

"No problem, I've got our best people on it. There is one more thing…"

"What? I'm very busy." Stan assumed this was the point at which the CEO would be pitching their services for additional work at Strasbourg. Everyone got around to selling him sooner or later.

"We received the normal security logs this morning from staff at Strasbourg, and our analyst who checks them saw that your daughter has tagged a young man who was residing at her address for the last week. A man called John Valance. He's a Systems Architect at the MoD, and has been … spending time with Jade's flatmate, Janine Grant, apparently."

"And why was she tagging him?"

"Well, sir, it appears that he was asking a lot of questions about you, and he apparently told her that he'd been a student at Imperial College. His profile checks out, though of course we can't ask the MoD for references. It's just that his name seems similar to John Vaunt. Unfortunately, Jade doesn't have permanent cameras in the apartment, and there is no vid of him."

"Run a vid check on Valance and we can see if there's any link to Vaunt. I'll talk to Jade and see what she knows about him, other than the colour of his underwear. She has great intuition. If you draw a blank, let me know and I'll exert some influence on one or two people to check the MoD recruitment files."

"Yes, no problem. I wonder if I could take this opportunity to …."

"Got to go. Keep in touch" Stan cut him off as soon as the pitch started.

He returned to the model for voluntary euthanasia, but he'd lost the thread, and his Nimbus was buzzing again.

"Stan? This is Alistair Prim."

"To what do I owe this pleasure, Alistair? Are you looking for yet more help with your budget submission? How's that extension working out for you and Harriet? Pretty fine work as far as I can see from my study window. Bloody ought to be at that price."

"Yes, well, that's why I'm calling."

"If you've got a problem with the builder or there's a leak in the roof, you can fuck off and deal with it yourself."

"No Stan, this is somewhat more important. When we first discussed our little arrangement, in your study, that Sunday I came to lunch, it appears you were recording our conversation."

Stan remained silent. Not that he was particularly concerned about Alistair knowing, but he was trying hard to work out how he'd found out.

"Mmmm, well, I do have a security system in the house and it does vid each room when there is movement or heat in it. Even the toilets and cellars. Can't be too careful in my business, you understand. It would have picked up on our being there. But may I ask how you came to find out?"

"Because, Stan, I'm watching a fucking vid of our whole conversation including the part about you getting my support for the Strasbourg contract in exchange for your help with the extension. And you'll never guess where it came from."

"Surprise me."

"The head of communications at Number 10! It's being put out on the ten o'clock news tonight, and it was sent on to me with a clear instruction

from the PM. She's losing the plot. Says it was accompanied by several v-mails between you and other members of Cabinet, none of which are very flattering to the government. Some of this stuff is considered highly inflammatory to swing-voters. Your fucking security video is doing the rounds of Whitehall as we speak, and you and I are about to be spread across the media as doing some dirty little deal."

Stan let his breath out quietly, wanting Alistair to think he felt no concern. "What was the PM's message?"

"What do you think, Stan. My report on her desk by 9am with a full explanation for what looks like bribery, or else I'm gone."

Stan stifled a chuckle.

"Frankly, Alistair, it's not something I can help you with. You're the Home Secretary, not me, and I think you can assume that the Cabinet won't want to accuse Strasbourg of breach on our non-disclosure, since this was a private security video which has been removed from my private records illegally. Besides, do you really think the PM wants to rock the boat right now, with an election just around the corner? You know I've got enough on each and every one of the wankers in your Cabinet to ensure nobody makes waves. Now your future as Home Secretary, on the other hand…"

"I wouldn't be too complacent, if I were you, Stan. Once the markets open on Monday morning, and Strasbourg's price plummets, how do you think the shareholders will view your activities? It's a fucking mess, and it's your fault this got out. I'd have thought you of all people would be a little better protected from hacking. Can't you fucking do something? Pull some strings? Get it off the air? I can't believe this is happening, Stan. How irresponsible can you be?"

Stan began to laugh, and the tension he'd felt momentarily about the leaks evaporated. This wasn't his problem. He wasn't trying to get re-elected, and he held all the cards.

"Do you really think I give a monkey's bollocks what people think? Now I have to get on with some work," and he cut the call.

Instead of moving on to other work, Stan sat staring at the wall, wondering how the content had been taken from his home server, given that he'd installed the same level of security he had on the Genomica Labs server, which had never been breached. Someone would have had to access his terminal from within the house, and send content from it when he was logged in. That limited the suspect list to one of maybe five people who were regularly around the house when he was at home, including the housekeeper and gardener, occasionally his PA, Genevieve, Mary of course, and Bogdan, his number two from Genomica. Whoever it was would need to go in and out of his study when he was logged in, and would have to be quick. They'd know what to do to find and export the right files, and Stan knew that most of the suspects weren't capable or fearless enough to do this. Genevieve and Bogdan would both be capable, but they were both completely in his circle of trust. It had to be Mary. She'd been at arm's length from him for years, and he knew she hated him for sleeping with other people, even though she was screwing that Welsh idiot, Edwards. Identifying it as her was one thing, but working out why she took it was another. It was so premeditated, and had clearly been going on for a long time. She wouldn't leak this stuff simply on personal grounds, because she was not shy about having 'full and frank' altercations with him about his lifestyle. He wondered if she'd begun to form political opinions over what Strasbourg was responsible for, or perhaps she had it in for him since he'd stopped her getting her job back all those years ago after Jade was born. At the time, it had required him to give a firm instruction to HR, and that might have set her off. Whatever the motives, the milk was spilt as they say in England, and Stan wasn't about to waste time speculating about history.

Once he'd come to terms with what had happened, he began to think of how to limit the damage which news of Alistair's bribe and others which Mary might have distributed would cause within Strasbourg. Alistair

was right, of course. It wouldn't be what the government could do to him, or what it dared to do to Strasbourg, it was what public sentiment could do to the share price. There's nothing a PLC hates more than a downturn in public sentiment. You can manage a global product recall, or the compensation after a chemical effluent problem, but public sentiment is so amorphous, so insidious. He'd have to v-mail the Board straight away, including Malcolm McBride, and get the Churchill guys onto the breach, so he could claim a violation of privacy. Of course, bribery is bribery whether it's public knowledge or secretly negotiated. The Board could be quite sanctimonious when it wanted, even when the company had clearly benefitted enormously from the contracts he'd managed to bring in.

He'd like to know just what had been lifted, and where it had been sent, besides Downing Street. That should be easy for Churchill Digital Security to find out once they were on Mary's Nimbus account, since she was never inside his security net. He began to draft some messages to Board members, but left them in his drafts folder until he was sure he'd have to send them. There was no point in constructing a pre-emptive defence and looking weak unless the shit really was about to hit the fan. It took a while to find something appropriate to say. He tried coming over as the victim, but knew that would never wash. He tried a 'leading into pitch battle' speech, on the grounds that Strasbourg's Board liked to stand together, but jettisoned that in favour of a straightforward 'hands up, fair cop, but all in a good cause' approach. It's what they'd wanted when they took him as part of the Genomica purchase. He was notorious for getting things done, for circumventing or obliterating obstacles, and this was just another example.

When he looked up he noticed it was already nine thirty, and he needed a drink. Just as he was pouring a Stolly for himself, Genevieve came to the door and asked if he needed anything else before she left for the night.

"Join me for one?"

She stood in the doorway to his dark office, her face in shadow, as the main office lights were bright behind her. He could see the outline of her thighs through her summer dress, and he smiled. She struck that pose he found so irresistible, and she wasn't turning to go. He stood up and carried the vodka and two glasses from his side table to the sofa. He knew she'd accept the drink. She put down her bag, turned and locked the door, took the shot glass from him and sat back, while he knelt on the floor before her, slugged down his shot and slid his hands slowly up under her skirt until he felt the silk of her knickers, which he drew down her legs and off her bare feet.

Genevieve lay on the sofa, naked from the waist down, with her head thrown back over the armrest, moaning softly. Stan was trying to empty his mind of Alistair Prim's voice by burying his head in her lap and his mouth in her groin. Despite his 59 years, he was still vigorous. His morning sessions in the basement gym at Hamilton Terrace were keeping him fit and energetic. He crawled back up her body and held onto the armrest either side of her head. With his feet firmly planted against the other end of the sofa, he began a slow thrusting, which gathered pace and drove out all thoughts from him. He was hyperventilating and driving harder, slapping against Gen's young body. He had no interest in her satisfaction, because he knew she was getting what she wanted from him and he from her – that was the deal. He had no real feelings, other than the animal drive to reach an orgasm and the physical need for its aftermath. As he began to come, his Nimbus started buzzing, over on the desk, as it received notification of a change to the PQ algorithm that had been approved to run. The approval had been issued from the full Board, including him, apparently. Ellen's Nimbus had uploaded the PQ patch to Strasbourg's server, through the R&D department's portal, and John had effected the Board approval process remotely. She'd left it on her desk, under some papers, and once the upload had taken place, John cleared her cache and erased the upload path, so she could pick it up the next day, or Monday, or never. As Stan's breathing subsided and he fell back against the damp sofa, the PQ upgrade was delivered to all 82 million chips across the country from Strasbourg's servers, with his authorisation.

CHAPTER EIGHT

High Water

It was 11pm on Friday May 15th 2046, as the pubs were shutting and the clubs were getting lively. The door scanners on all the clubs were checking PQs against blacklists and billing the punters their entry fees through their Es. The scanners guarded doorways and responded to the PQs to block entry to known trouble-makers. All clubs were fitted with double door cages which admitted one person at a time. Until the first door closed, the second wouldn't open. These continued to block known trouble-makers, based on their PQs. Inside, everyone was checking out the talent on their wristbands, reading each other's informagear or scanning rooms with their Nimbuses to be sure that the people they fancied hitting on were within their financial reach. Thousands of people were in restaurants across the country, choosing from electronic menus which read their PQ in order to offer appropriate selections of food, and thousands more were shopping online using their Nimbuses in conjunction with their PQ read-outs to select their shopping. Almost everyone else was watching NetCast.

The small night staff working shift in Strasbourg, like most of the staff who were working late in Whitehall, were all glued to their wall vids, soaking up the online newsfeed, which was pouring out details of several of Stan's business meetings, and showing clips of intimate conversations with politicians and military leaders, recorded in his study, or elsewhere in the house. The ticker-tape along the bottom of the screen reported news of Alastair Prim as having handed in his resignation, of the PM having called an emergency Cabinet meeting, of Leaders in the US and Somalia calling for explanations for the breakdown in the deportation deals they'd struck with the UK. Morgan Edwards was being interviewed outside the

Houses of Parliament, barely able contain his glee over what he called the collapse of the house of cards at Strasbourg.

Anyone using their Nimbus when the patch uploaded had their activity interrupted by a high priority v-mail coming in: *'Don't worry, your Nimbus is not faulty. We've made some adjustments to your settings which are designed to improve your experience of Strasbourg services. PQ scores will no longer be visible but health and welfare monitoring will continue as normal... '*

The PQ read-out simply stopped functioning, and nobody could see their own or anyone else's score, for the first time in years. The message explained that this was as a result of policy changes reducing Strasbourg's dependence on the PQ for calculating insurance premiums, which would be simplified, without reducing or removing any benefits. Within two minutes, Strasbourg's servers had re-programmed all 82 million chips to relay more limited biometric and geo-location data from the chip to the company, and to receive no more uploads from it. All psychographic tracking, other than for health and welfare purposes, was frozen. This effectively blocked all PQ G-Match uploads, making it impossible for anyone to know anyone else's score. Dozens of apps crashed, because their reliance on the PQ left them with no input data, but many functions continued uninterrupted. People in driverless MPVs had their bank accounts docked in the normal way for their journeys. Public order was maintained by security contracts based on chip feedback, and despite Gimme's fears of a dramatic rise in crime or street violence, there was no immediate rush to break the law. The health services continued to react to chip feedback on medical emergencies, and to send ambulances out, but charges were levied to victims' accounts based on their last PQ score before the upload, frozen on their Strasbourg files.

In maternity hospitals across the country, G-mapping new born babies continued without interruption, but they all received upgraded chips from the mapping machines, all centrally programmed from the PQ Algorithm. None of the staff was any the wiser.

Stan's Nimbus began buzzing continuously, as members of parliament, business leaders, journalists and Board members all tried to reach him

for some explanation of the outrageous material they were watching on the news. Strasbourg's call centre was flooded with incoming v-mails and calls, and people even began to gather outside the offices, staring at their Nimbuses for guidance.

Stan lay back with his eyes closed and his hand resting on Genevieve's breast. The sweat was cooling on her and she curled into his body for warmth. He ignored the buzzing Nimbus on his desk and reached for the vodka bottle, pouring another two shots. Someone tried the door, before knocking.

"Dr Janekowski? Are you there? Sir, if you're there, please could you … Could you check your Nimbus, sir? Or turn on the VidWall, sir?"

He lay silently, waiting for the steps to retreat along the corridor. Genevieve lifted herself onto one elbow and tried to reach for the vid-wall controls, but they were out of reach, and Stan wasn't moving to let her up. She was going to issue verbal instructions, but Stan gently covered her mouth.

"Fuck them. Leave it, Gen. It'll be some rubbish on the news that Pringle was calling me about. They're a bunch of weak and ignorant cowards, and I have no interest in playing games by their rules. You should go home to your husband and avoid any work communications. Go, Go!" He pushed her gently to get up. "I have a little more vodka to finish and I will then be leaving too. I'm tired."

He shifted his weight so that she could push herself off the sofa, retrieve her knickers and collect her bag from the floor. She unlocked the door, opened it a crack to make sure whoever had been there was gone, and stepped into the corridor, closing it quietly behind her. Stan drank from the bottle, his head resting on the arm of the sofa, and promptly fell asleep.

When he woke and called the vid-wall up, the news was still on, even though it should have been over by now. It quickly became apparent that

the media coverage of his conversations and v-mails had been demoted to the ticker-tape feed at the bottom of the screen as the latest news was being read.

'Inventor of the PQ bribes Home Secretary to award Strasbourg contracts... Alistair Prim resigns over corruption scandal... Conservatives down eight points on NetCast exclusive live poll... Strasbourg makes no comment on G-Match shut-down... US Immigration department questions breakdown in Deportation process...'

The wall was on silent, and the PM was being interviewed. Stan had no inclination to turn up the volume, but one or two of the scrolling headlines didn't make sense. He pointed to the screen volume and swiped until it was on low.

"We understand that the Board of Strasbourg has made a unilateral decision to remove public access to the PQ. Everyone has received notification from Dr Janekowski of the changes."

"Did you have prior warning of these changes, Prime Minister?"

"No, I did not. Strasbourg is contractually obliged to notify us of any significant changes in the functioning of the probability quotient which materially affect either healthcare or security services."

"And have there been any material changes? Has there been any detrimental effect of the PQ being removed from public sight, Prime Minister?"

"It's too early to say. We are monitoring the situation."

"And can you offer any reassurance to the large number of people receiving Universal Income that their payments and supports will not be affected by the shut-down?"

"We have no evidence that the UI payments system has in any way been affected. I have received information from the Deputy Commissioner of the Metropolitan Police to say that their information services are

operating normally. Likewise the London Ambulance Corporation has seen no interruption in their service. At this point, I would like to make it completely clear that there is no reason for anyone to see any changes in UI payment services. As I said in response to questions from the opposition this afternoon, this government has presided over the greatest improvements in social welfare in the last ..." Stan turned off the vid-wall. He couldn't stomach another party political broadcast.

He got up from the sofa and stumbled over to his desk to retrieve his Nimbus and coat. He switched off his computer, locked the office and took the lift down to reception. Seeing the crowds gathered outside, he Nimbused his car round to the back of the building, and slipped out. Once in the car, he mumbled 'home' and sat back for the ten minute drive. Though he was tired, he wanted to know what the PM had been talking about. On a whim, and without expecting much, he switched on his PQ, which he rarely did, and it showed the PQ96.3 he'd had when he last used it some months ago. He brought his hand down hard on the edge of the dashboard, which hurt, and watched the PQ. Ordinarily, it should jump in response to injuries and pain, but the score didn't budge. He turned it off.

He opened his v-mail and scrolled through the dozens of messages he'd received in the last hour. Everyone from Geoffrey Grainger to the editors of all major news channels to the PM's office had been after him, but he wasn't interested in any of these. He was looking for anything with 'address unknown' in the heading. One had just come in.

Address unknown, arrived at 23.42

From Gimme to Dr Janekowski

'Hi Stan, Gimme calling. Sorry to disturb you, but we'd like to arrange a short conference call in the morning, if you can spare the time. 8 am if it's not too early? A couple of things to talk about, and we'd love to invite you to a media briefing at 9 am too. We'll call you in the morning.'

Stan tried to shake off his alcoholic haze and started to respond. First he sent a v-mail to Churchill Digital Security to investigate the breach at Strasbourg. The CEO had already had a call from Geoff Grainger asking him to investigate Stan's activities in relation to Alistair Prim and several other MPs, and report by Monday morning to the rest of the Strasbourg Board before their scheduled meeting at 11am. He didn't dare mention this to Stan, as Geoff had threatened him with the loss of all his security work if he did, so he simply said he'd get his team onto Stan's work first thing tomorrow morning.

Next, Stan pulled three of his best coders back into Genomica Labs to work the weekend in order to try and crack the security on the new PQ patch or circumvent it with a view to uploading another version to everyone's chip. The alternative version he had in mind was the one they'd been working on at the Labs that was far more sophisticated than the Strasbourg operational version and included the electronic pulse facility which Stan had been trying to persuade the Board at Strasbourg to accept. It was also much more sophisticated in its networking capabilities. He told Bogdan Illievicz that he should oversee the others and that he, Stan, would be in on Saturday morning to see how they were getting on, and not to make any changes until then.

Bogdan was Stan's most senior coder, and along with the others had been the subject of a personal hack of his v-mail and home computer by Fitz. Fitz had planted a cloning worm on all the Genomica machines he could access that duplicated every message they sent or received. Bogdan had been discussing work with one or two other coders using private v-mail, because they all feared Stan's wrath if they were caught using the Genomica server to communicate about it. As messages arrived in Bogdan's inbox from anyone else in the team, Fitz fed them to Nick.

It was 2 am and Stan was exhausted and already felt hung over. He couldn't sleep, and was slouched in his study, staring at his computer screen, which he had on silent. His Nimbus buzzed and he saw that Geoff Grainger was calling. May as well get it over with.

"Stan, this is Geoff. I've tried you several times since 10 pm to talk about the news coverage, and what the hell has been going on with the PQ. I and the rest of the Board all received v-mails from Gimme notifying us of the changes they had made and uploaded in your name. I'm sure you received the same one, didn't you?"

"It's two in the fucking morning, Geoff. I haven't read every bloody v-mail that has been sent to me since I left the office." Stan had read it on the way home, but didn't want Geoff to think he was ready to respond to it.

"Well you should have done. Within a few minutes of that, I had a call from the PM, who informed me of a large quantity of unpleasant and incriminating vids which had been received by her head of communications. If you've bothered to watch the news, you'll have seen one or two of those, and you are in all of them, apparently. I tried to reassure her that it was business as usual for security services, though I haven't had any detailed reports from your security department. Do you know whether the healthcare services are all running as per normal?"

"The PM seems to think so, so who am I to disagree, Geoff?"

"This is no time to be facetious, Stan. I checked, even if you didn't, and according to the night staff, everything appears to be working. So besides G-Match, and the frozen Premiums, what else has changed? Do you know?"

"Geoff, I'm not fucking telepathic, and I have no more information than you do. I found out about the breach about an hour ago. There is clearly no information being delivered to immigration in the US or Somalia, but I got that from the news. I have yet to find out about the UI payments. I suggest that we convene a Board meeting tomorrow at mid-day to review everything, which should give me time to pull the staff in and make sure we have a full report."

"Actually Stan, I called to let you know that the Board convened an extraordinary meeting online an hour ago, at the behest of two non-execs. Well, actually, it was at the behest of Malcolm McBride, acting on orders from Number 10. You weren't invited because you were the only item on the agenda, and the PM demanded this happen in your absence."

Stan sat silently at his desk, in the glow from his Nimbus screen. The curtains were open and in the moonlight, he could see the stars reflected in the new glazed roof of Alistair's Victorian-style orangery. He suddenly felt older than his years and incredibly tired.

"We briefly discussed your latest proposals on euthanasia, but most of the discussion concerned the winning of our key government contracts since Genomica was taken over by Strasbourg, including policing, the UI payments processing, MoD and the Healthcare for the Elderly contract. You will probably have seen the news that Alistair Prim has resigned, and The Chancellor, at The PM's request, has asked for your resignation."

"Geoff, doesn't anyone realise that this is the worst possible time to…"

"Let me finish. I and one or two of the other executive members argued that your role is crucial to the response Strasbourg makes to this breach, and that we will need your input. However, it is the Board's view that you have been behaving in a way that brings Strasbourg into disrepute, and in the view of Martin Pritchard, constitutes a clear case of gross misconduct, justifying immediate termination. However, despite everything that's come to light this evening, I am not prepared to preside over a Kangaroo court, and I do feel that you should have the right to respond to the Board in due course.

In the event, we voted unanimously to suspend you immediately and to remove your right of access to all Strasbourg servers pending a full enquiry into all contracts awarded since the Genomica merger. The investigation is to include a detailed examination of all vid files now in the

public domain and of the Gimme hacking co-operative's activities as far as we can establish them and their connection to you."

Stan was wide awake now, and could feel his anger rising.

"You have made a big mistake, Geoffrey. You know that. I am the victim of a smear campaign by a group of terrorist subversives. Who knows what their motives are, who they're working for and what they think is going to happen to me. This looks to me like a typical approach which the GRU would use. Remember, I used to work there. If you remove me, you will not be able to fight against this. The government will not be able to protect itself. You are killing the goose which laid every single golden egg. You are going to be the headless chicken. Do you think I need Strasbourg? Do you think I don't have alternatives?" His voice had reached a higher pitch and he was shouting into the Nimbus. Despite his anger, he was clear-headed enough to switch on his terminal and to try to access the Strasbourg R&D portal while keeping Geoffrey talking. He wanted to disable the PQ algorithm completely and leave Strasbourg frozen out. All he got was 'Access Denied' to his thumbprint, 'Access Denied' to his retinal scan, 'Access Denied' to the old-fashioned passwords he had embedded in his brain.

"So you made the decision to take me down? I bet that made a few people happy. What did you do after the vote, Geoffrey?"

"We instructed security to lock you out, Stan. Don't bother trying to access the servers. You won't be able to. Oh, and one more thing. We intend to announce your suspension to the city before the markets open on Monday. It's the only chance we have of stopping a fire sale."

"Be it on your head, Geoff."

" It is, Stan, it is. I'm sorry it came to this. I had great faith in you. Goodnight." And Geoffrey cut the link.

After the call, and when he'd opened a new bottle of Stolichnaya and poured himself three shots one after another, Stan v-mailed Jade asking

her to call him when she got the message. She was wide awake when it came in, soon after three, sitting in bed talking to Jasper about the news they'd seen, and the v-mails they'd received about the PQ. Jasper's father had already been in touch with him after the Board meeting to break the news and to talk direct to Jade, on behalf of Geoff Grainger. He'd been asked to let her know, in the gentlest way he could, that her role in Strasbourg had been temporarily frozen as a security measure, given her family relationship to Stan. She'd receive full pay, but until the enquiry was completed, she couldn't access any of Strasbourg's servers either.

When her Nimbus buzzed, she look up at Jasper and showed him the screen on which Stan could be seen swigging vodka, waiting for her to pick up.

"Guess who. I don' know if I can handle him right now. You've never seen him lose it, have you Jas?"

"No, but I've heard about his temper and seen what he can do to you."

"I'll leave it till the morning." She swiped left, blocking the request.

She started to cry. It was something Jasper had never witnessed, something he didn't think Jade was capable of.

"Oh, Jas. How could they do that. How could he be treated this way? After all he did for them. They knew he has his own way of getting things done and they never stopped him. I'm not saying he did everything by the book, but in the end, he got results. I know he'll want me to help him and I can't."

"No, and you shouldn't try. When the dust settles, you're going to need to put as much distance as you can between your dad and you. God knows what it'll mean for the wedding. Do you think people will start turning down our invitations? Will he have the money to pay for it if he loses his job? I don't want to be mercenary but he did offer…"

CHAPTER NINE

Riding the Storm

It had been a long night's work for John, and he was ready to crash. Ellen had fallen asleep watching him work at the small desk in her bedroom, v-mailing, checking the news and tracking numerous peoples' activities. Despite his worst fears, the blocking of PQ reading, which was the most public evidence of the changes Gimme had made, was not causing any major issues. There'd been some attempted looting in Birmingham city centre, but the security contractor in the area had been out within minutes, having received the normal PQ alerts, and made arrests. Once it was reported on the NetCast Live News that the PQ feedback system was still working for all security services, there had been no more incidents. Likewise, people running into A&E departments calling for help were greeted with informed medics carrying Nimbuses with full medical histories of the arriving injury. The Universal Income payments system continued to churn out weekly allowances. That didn't stop a large number of people from complaining and feeling undermined by the loss of information. The most obvious issues were posted in chat forums and uploaded as vids to social media, and all involved entertainment and social interactions which for the first time in years had to rely on something other than the PQ.

"My new neighbour is a Muslim and his wife has her face covered. But how can I tell that she's not a dangerous person, now my Nimbus isn't showing her PQ?"

"Stringfellows VIP bar was over-run with Chavs earlier. The doormen couldn't demand proof of status. Some sort of ID card is needed."

"How do I know I have been given my own baby to feed? All the incubators show the No PQ available screen."

"How will Britain stay legal? We're going to be flooded with illegals and subs now."

"Where's the good Doctor when we need him? Get the PQ fixed Janekowski!"

"Does your PQ go up when you accept a bribe, Stan?"

"This wouldn't happen if we had full AI!!!"

Every so often John would laugh out loud at some of the more outraged commentary and vid material he was seeing, and he seemed very relaxed about the lack of problems caused by switching off the PQ readers.

By 3 am, he was exhausted and decided to call it a night, because he'd have to be fresh enough for the conference call between himself, Nick and Stan, scheduled for eight. It was going to be audio only, so he could safely take it from the flat, using their re-routed Kuala Lumpur server. He and Nick had decided not to use any voice editing, because they figured Stan would know who he was talking to anyway. They had to assume he'd be trying to track their IPs so everything was being re-routed through proxies in Kuala Lumpur. Otherwise, he hoped it would be a private conversation and not being listened to by all and sundry. Both sides would obviously store the full audio for analysis and potentially public release or selective cutting for propaganda purposes.

Nick was too wired to sleep after the launch of the patch, and decided to treat himself to a little coke at about 2 am, which kept him awake but wore off through his night of scanning and tracking. He too wanted to see the effect of the PQ patch on public opinion, but he was more concerned about the political backlash from the leaks of Stan's activities. The 24-hour news channels filled with debates and discussions on the material which they'd received. The video of Stan and Alistair Prim played and played, as well as several others involving Whitehall officials. The general tone of commentary was moral indignation on behalf of the mis-treated public. Labour was milking the story for everything it was worth, openly campaigning and calling Pringle a product of the Tory sleaze culture, rather

than allowing him to be scapegoated. Meanwhile the Tories, including Malcolm McBride, were happy to blame Alistair for everything and to hold him out to dry as an aberrant individual with his own agenda to line his pockets from Janekowski's bribes. More astute interviewers were asking questions of Malcolm about his role on the Strasbourg Board over the last three years, and how the government had allowed Strasbourg to employ bribery in its bid to win all the biggest contracts. Surely if the Chancellor was prepared to stand by and watch, or actively participate in such corrupt practices, the government couldn't be trusted.

The fallout was evident in public sentiment. Throughout the night, the NetCast Live Poll reported on the ticker-tape at the bottom of the screen. Labour was gaining point after point as 'the party I would most trust to run the country' as the discussions opened up more and more debate about the social policies of the incumbent government. Genomica was rarely mentioned, and when it was, it was clear that the science behind the PQ algorithm and the health and security services it supported were not seen as intrinsically evil. Nevertheless, Dr Stanislav Janekowski was portrayed as Svengali, a Russian agent, The Prince of Darkness, Frankenstein and Dr No all rolled into one. He had created the monster, and Strasbourg, with the government's backing, had released it. What would the future hold if the past twenty short years was anything to go by? This raging beast had driven nine in ten people into unemployment, removed the 'human touch' from the caring professions and subjugated the masses through conformist slavery. The media needed a face for the evil, and Stan's was clearly it. It didn't help that he was a Russian immigrant, or that he was very wealthy and never took interviews. His past involvement in GRU was well known, and the fact that he'd studied in Johannesburg was not in his favour either. Most of the news channels had tried to reach him for a statement and been rebuffed either by the Head of Communications at Strasbourg, who had been forced by The Board to man the v-mail, or by Stan's home system which reported him to be unavailable.

At one point, Sky claimed to have spoken to someone from the legal department in Strasbourg who had given them to understand that

Dr Janekowski was currently suspended from Strasbourg, pending an investigation into the allegations of bribery against him. None of the other channels could verify this, but Sky was happy to call it 'Breaking News' and to bring in a number of experts to discuss the implications for Strasbourg's share price, Stan's legal status, the future of AI and the chances he would have of setting up against the company which had kicked him out.

Nick liked what he was seeing. The tide seemed to be turning against the over-arching power of Strasbourg, and the PQ, as a result of the undermined credibility of Stan. With any luck, by the time the dust settled, there would be a more conducive atmosphere for the introduction of Gimme's community models. If not, there would be a vacuum left by Stan's downfall, and it could be filled by one of a dozen other unwelcome AI solutions.

Stan woke with a pounding behind his eyes, something he was all too familiar with. He was stretched out on the Chesterfield in his study, and the wall vid screen was still on, with the sound turned down. He smelt rotten, even to himself, with the mixture of stale sex and booze. On the thick rug, an empty Stolly bottle lay on its side, but the rug was dry. He'd consumed a full bottle in two hours before losing consciousness. He could only remember snippets of the news stream he'd watched, and the rambling thoughts about himself which had run through his mind. He struggled to a sitting position and put his head in his hands. His grey hair fell across his fingers and he ran them back across his scalp. He squinted, temporarily blinded by a piercing ray of bright sunlight reflected off the roof of Alistair's conservatory, directly into his eyes. It brought back to him the cause of the acrimonious call he'd had with Grainger early this morning. For the want of a few grand to help a neighbour, he'd been hoisted up the yard arm.

That led him to remember that he was due to take the conference v-mail from Gimme at 8 am, in only ten minutes time. He dragged himself up to standing and shuffled like a geriatric to the small washroom which opened directly off his study. He held his head under the cold tap and

pulled off yesterday's shirt, flinging it into the open wash basket. Fresh towels and clean shirts were always kept on the shelves behind the door, and on autopilot, he washed and dressed, not bothering to shave, since it was Saturday and he had no intention of showing his face outside the front door. He had no doubt that there would be a crowd of voyeurs and news people waiting for him to do just that.

He made himself a black coffee and was going to add a shot to it, as he felt he needed the hair of the dog, but stopped himself. Today he would need a clear head. He sat at his desk, opting not to turn on his Nimbus, but to pull up the conference details on the wall screen across the room. No point in wading through v-mails when he could predict what most of them would say. It said 'audio only' and he felt a deep sense of relief that nobody was expecting him to face them in the conversation, though he realised this wasn't for his sake, but to protect their anonymity. He decided to disable video on all his calls today.

So Gimme wanted to talk. That would be Nick Artremis and maybe a couple of the others. Who would they choose? March? Vaunt? Shanning? Or maybe that Rumanian, whatever his name was? Not that it mattered. They were all one to him. They'd want to tell him why they'd attacked, they'd probably want to gloat and maybe to threaten further hacks and patches they might have prepared. But why had they attacked now? What had taken them three years since the Egress hack that was worth launching now? Sure, it was good timing from a political perspective, with the election only weeks away. How long had they been planning this, and when did they get the material from Mary?

They'd expect him to be railing against them, to be on the attack too. Not that he had anything to attack them with, since he'd been exiled from Strasbourg. The useless fuckers at Churchill had come up with nothing worth having on any of them. He wondered if Gimme would know what had happened last night at the Board meeting, but he doubted they would, unless some weasel had leaked it to the media. If it had been him in their shoes, he'd have hacked someone's v-mail on the Board and probably

found a private communication on it, so he had to assume they'd have done that too. They would also have known that he had Genomica Labs working on AI, and they might even know roughly what he'd been doing there, but he was fairly sure nobody outside the coders there knew how close he was to full AI. Part of the reason he paid his coders so well was that he required them to give him unlimited access to their private v-mail, and prohibited them from talking about their work to anyone at any time. Almost all the coders were immigrants, and Stan had shown each one of them the full paperwork for their own deportations to Mogadishu, direct to the notorious Central Prison, should they leak any information.

But what was the point of building a competitor to the Strasbourg product which he'd sold them all those years ago, unless he could replace the insurer in supplying government services? He was hardly going to offer Strasbourg a deal to replace the patch with his own upgrade, and without him and his best coders, they'd be wading in shit for months trying to outwit Artremis' and Vaunt's code. Even if he wanted to go against Strasbourg and set up a competitor, assuming after this that anyone would want to do business with him, why would he want to do so? Stan knew how tired he was of maintaining those service contracts, and of the whole political game which was required in order to provide them. He was tired too of working in a company whose sole objective was maximising return on investment for the shareholders. It was a stupidly short-sighted objective which drove most companies to make greedy decisions. Strasbourg's profit motive had been as much to blame for his approach to winning contracts as he was. He was just doing a good job for their shareholders, after all. But he knew he had to stop kidding himself. This was a complete fiction. He'd driven their business, made the running and dictated the terms. And yet here he was complaining that it wasn't what he wanted. Dr Stanislav Janekowski, the fickle, confused victim, who only did what he was told. Really?

But he'd acted with their tacit agreement. Hell, even Malcolm McBride was in on it. Hadn't he hosted the first dinner with Alistair, before

he and Harriet moved to St John's Wood, and hadn't he, at the dinner, advised Stan to discuss universal G-mapping and how Strasbourg could provide the service? That was before Malcolm had come onto the Board, but Geoff had already been discussing the position with him, and it was obvious from his whole demeanour that he was looking for a big fat non-Exec fee for doing so. Everyone wanted their kick-back, and everyone was on the gravy train, so how come he, Stan The Man, had been scapegoated?

He began to feel the rage he had felt last night over his suspension. He couldn't face getting into any protracted investigation, which would inevitably have to wait till after the election to avoid political fall-out, and he was so tired, he wasn't sure he would do a good job of defending himself. Perhaps if he resigned straight away, he could put it on the long finger, employ a law firm to drag it all out. He realised that he missed being a scientist, missed having a clear and unadulterated view of his work. He no longer wanted to focus all his efforts on building the wealth which Strasbourg had brought him. He had more than enough, even discounting his share options at Strasbourg which would either become worthless, or more likely would be taken off him in line with his conditions of termination for gross misconduct. And he no longer wanted any of the attention which he'd had as a result of his power. Genevieve might be an exception, but there had been so many others. Perhaps she was just another physical need, and not an emotional attraction.

He thought of Mary's decision to spill the beans on him, which should have made him angry. Without the vids she'd leaked to Morgan, this would have been seen as a simple attack by hackers and Subs, and Stan could have been the hero for putting it right. It would have been easy to rebuff, clean up and move on from. But somehow he didn't feel any anger towards Mary. He didn't really blame her, not even for the affair. After all, he'd been unfaithful for years before she was, and had never hidden his infidelity from her. Now that they were both out in the open, he could relate to her as an equal. He'd never admitted it to himself, let alone told Mary, but he respected her intelligence, and he admired her sincerity

and openness. If he wanted someone to tell him how he looked before appearing in public, she would give him a straight answer. If he didn't understand why someone behaved in a certain way with him, because he lacked empathy, which he knew was a problem of his, she would give him a straight analysis of why. He could hear her upstairs getting into the shower now. Maybe he should give the call a miss and go join her, if she'd let him, but she had locked her door against him several times when she knew he was in his study drinking.

And then there was Gimme. He'd spent time and resources over the last three years chasing them down, with little effect. He'd seen them as 'enemy number one', for lack of any other candidate. But why? Weren't they just like he used to be: outsiders with computer skills and the wish not to be pushed into the box by an ever more conformist society? When it came to the Egress deportation list, Stan had spent too little time on who should be deported and why, and instead had completely cut himself off from the human perspective, seeing it simply as a game of numbers. Britain needed to lose upwards of a million economically inactive people to balance the UI budget, and to reduce the costs of security, so what better way than to get rid of them by deporting them to America. The equation made complete sense so long as you didn't look at who you were deporting and what they had or hadn't done to deserve it.

Gimme was just doing what Stan would have wanted to do if he hadn't been propping up a bloated corporation. They were destroying structures which he'd been involved in building, but which he didn't really believe in. They must have a view on where AI should go, and it probably wasn't so far from his own. Strange, really, how he'd been their adversary. But undoubtedly they too needed to put a face to the evil that they saw in the PQ algorithm, and his face certainly fitted. He knew why Nick Artremis hated him. It was at his instigation that the guy had lost his job as a lecturer at ICL. Nick had been one of the best AI developers of his time too. Stan would rather have hired him than have him removed, but Nick was collateral damage.

Then there was John Vaunt. Richard's boy. Stan thought back to his days in the college at Cambridge and Richard's vision of Genomica's goals. He thought of the jealousy he'd felt for Richard's beautiful coding work, and how he'd wanted to possess Richard's skills. The squeeze he'd put on Vaunt had been driven by his need to control Genomica's IP. Nothing more. It had been unfortunate that the guy had suffered a lot afterwards, and died within two or three years, but he wasn't going to feel guilty about it. Richard was collateral damage too really. Stan had once or twice intended to help his widow and son, and had even planned to pay for John's education through some sort of donation, but had been so wrapped up in the company's development, it had slipped his mind. Vaunt had good reason to hate him. That went for the other members of Gimme, as far as he'd been able to identify them. He was, in fact, the reason for Gimme being a team. It wasn't just that they didn't like what was happening. Loads of people didn't. It wasn't simply that they had the skills and the balls to try and do something about it. They were united in their hatred, driven by it. But Stan had spent most of his life working with other people's hatred. He'd been its object and had used it to drive people to places they didn't want to go. He'd brought Jade up to use it. If Gimme hated him, they could use that energy to better results. If they were as good as they seemed, they could re-direct their feelings to changing society. He could help them, with the hidden power he had in Genomica Labs, or he could move on. It was a big decision.

"Good morning. Is anyone there?"

A disembodied voice came from the wall vid. If he'd been logged into Strasbourg's servers, Stan could have cross-checked the voice pattern against the archive just to be sure, but somehow he knew it was Nick.

"Sorry, Nick, I was deep in thought there."

"Dr Janekowski. Thank you for joining us. John Vaunt is also connected. We thought we might keep this first conversation between us three."

"This is John. We haven't spoken for some years, Dr Janekowski, but I have been following you and your work since long before we met, at Imperial. Since my father worked at Genomica really. I'm sure you remember him."

"Gentlemen. I'm happy to be finally talking with you. I have been trying to reach out to you for a while now, ever since you were so deft with the Egress file, but you're not easy to get hold of. I've admired your work from a distance. Not least what you pulled off yesterday. So how can I help?"

"Yes, sorry we had to do something quite dramatic to get your attention. Hopefully the dust will settle quickly.

We appreciate that it will be possible for Bogdan Illievicz or another of your best coders to return the PQ to its previous version in a while. The better he is at cracking encryption, the quicker that will happen. We don't believe there is anyone in the Strasbourg R&D department with the right skills, and frankly, Churchill Digital Security are a bit, er, stone-age in their approach. We also appreciate that public sentiment is shifting quickly as a result of the media attention on your business dealings, so that this is no longer simply about the PQ."

"You are telling me things I know, and I'm a busy man. Why did you want to talk to me, Nick?"

"Yes, you're right. We didn't call you to gloat, and the PQ patch was not for some sort of revenge, though the release of some of those vids was perhaps more so. I'm sure you appreciate that our members all have good reason. We would like to use the time we have here to try and persuade you to use your great skills, resources and influence to help us change the way people are treated…"

Nick had prepared to launch straight into an outline of the new community model, but realised as he was talking that he didn't really know why Stan would want to help change the world that he'd created. He'd

never had any indication of Stan having any interest in peoples' welfare. His voice tailed off, and John stepped in.

"I think what Nick and I want to know, Dr Janekowski, is whether you would consider working with us to make some social changes happen. These changes are not necessarily to your financial benefit, and they may not in fact impact any of us quickly, but we believe they are improvements to the lives of the vast majority of the population. You may want to crush us, and you may want to shore up the edifices you have been part of... the Tory Party and Strasbourg. You might think we are your enemy, and that we want to destroy you, but that isn't true. We in Gimme believe that those with power should use it to enhance the welfare and quality of life of ordinary people, rather than increasing their control at the expense of others."

"Call me Stan. Please. Before we start talking about the meaning of life and how miserable everyone is, I think we should talk briefly about what has been going on. Let's be clear. You're calling me to see how well you hit your target aren't you? Pretty well, if I'm honest. Strasbourg wants me out, as I'm sure you'll know from one of the Board members, and I want to leave. Without me, they are nothing. Without the services which the PQ delivers, the Tories are also going nowhere. The government will fall, as you and I know, and Labour will be in power by the summer. You might want to accept that you are increasing your control at the expense of others, even if they deserve everything they get. And that probably includes me.

You have achieved something very large from something small, for which I take off my hat to you. But now what? You can't take down an edifice as you call it and expect nothing but good to come from it. Besides, Strasbourg may have been on top of the pile, but you know and I know that there are dozens of pretenders waiting for just this opportunity to step in and take their crown. You need to have something more attractive to offer. Do you?"

"We think we do, and we would like to share it with you, so that you can consider working with Gimme, through Genomica Labs, and not Strasbourg."

"Well, you have managed to get my attention, which is certainly not easy for anyone who is trying to sell something to me. I'd be interested to see what you boys think you have to offer which is better. Frankly, I'd enjoy listening to something other than the establishment crap I've had to put up with in the last few years. But we have to maybe deal with some trust issues first. You have done me some personal harm, and that reflects what I have done to you in the past. So before we can consider working together, we would have to agree that we are quits, as you English like to say. Also, I am not, perhaps, considered to be the most upright, honest and trustworthy individual and I do not think my influence which you refer to is quite as it has been. This may make it difficult for you to include me publicly in any plans you have, if you want to be given the recognition you are seeking. But then I would argue that you are not the nation's favourite people either." Stan chuckled and he thought he heard Nick laughing too.

"So how is this going to play out, Gimme?"

"We have some webinars running this morning, the first of which is at nine on this channel. You're welcome to sit in on that, Stan. It will be for selected media influencers, so I'm sure you'll understand that the first part will re-iterate some of what circulated last night, and some of the aspects of your work which we disagree with most strongly. But it also introduces some of our proposals for change. There will be another for MPs running concurrently, and depending on how the weekend pans out, we also have some shorter versions for public consumption. We would also like to send you a copy of our software which models alternatives for the future, in good faith, and you can give it a road test through Genomica, if you want."

"Perhaps, if you are not caught up with meetings, we could talk again tomorrow, once you've had a look at it? John and I are keen to know what you want to do about the PQ patch, before we line up our weapons for

battle. I'm sure you will not be surprised to know we have some more material in our arsenal, including some which might make your own life more difficult."

"Let me guess. Someone on your team has set up a full package of asset freezes for me and you probably have some more background on me to release."

"Yes, something like that. But please understand that we would prefer to be able to work with you. I won't say that we need your help, because there are other people who we could work with, but you are the one we would most like to involve. If nothing else, it might help some of our members to get past their current views of you. You may not care what any of them think, but you can look on it as a way of neutralising a threat to you and your nearest and dearest. And you are right that your public reputation may be more of a hindrance to us than a benefit, so this arrangement would be off the record."

"The road to Damascus, eh? Well, I will have time to think about that before we talk again."

"We would like you to call a halt on the work which your team at Genomica Labs is doing to try and overwrite the patch we have installed at Strasbourg. We are comfortable that so far it has not had any real detrimental effect other than on the company's profits, and I would imagine that you are not as closely allied with Strasbourg's interests as you have been. If we fail to convince you that our alternative ideas are worth developing, and by Monday, you decide we are nothing but a bunch of terrorists and Subs, as Strasbourg's PR is saying, then you can always re-instate it, and we can always apply some other measures against you."

"Mmm. So you are going for a simple carrot and stick approach. It isn't very sophisticated, and you probably know enough about me to realise that I would not respond to the stick. But nevertheless, I'm feeling generous and relaxed, as it is the weekend and the sun is out. I will agree

not to reinstate the PQ which you over-wrote until I've had a look at your plans. It was out of date anyway. But if I am no longer working with Strasbourg, then I'll be considering other offers. It won't surprise you to know that they have been flooding in from overseas already, including from the land of my birth."

"So what is a good time to talk tomorrow, Stan?"

"Maybe you guys would like to come over for a spot of lunch? Mary would I'm sure love to meet you both, since she has been so helpful to your cause. I'm sure, John, that Jade might be interested to see you again. Hell, I might even invite Morgan 'The Ram' Edwards around. What do you think?"

"Thanks for the offer, Stan, but we're not ready to be rounded up and shipped off to Washington or Mogadishu just yet."

"Oh come on, Nick. I know I'm not what you consider a man of honour, but I give you my word there will be nobody here to round you up. I can't say there won't be a load of news crews hanging out in the street, but I'm sure you can organise a diversion. It's up to you. We normally eat at about 1 pm, and I do believe there's a leg of lamb in the offing." Stan cut the call.

CHAPTER TEN

Dry Land?

Nick, John and Ellen were sitting in the corner of The King's Head again. Each had a real pork pie and a pint, something which Ellen was still trying to get used to being able to buy. It was mid-afternoon and both Nick and John had gone back to bed for a couple of hours while the webinars played to journalists and politicians. They'd exchanged brief v-mails after the conversation with Stan, and both were still in shock from the laid-back and positive way in which he'd dealt with them. It was almost as though he was ready for their proposed changes, ready to give up everything he'd worked towards in Strasbourg.

"Crazy guy, huh?"

"Or burned out, or angry with the way he's been dropped so easily."

"And not to be trusted…"

"Or maybe we just go with it. I'll send him the community simulation file then, unless you think we shouldn't."

"No, we have to keep the momentum up, and besides, it's pretty much public domain already."

"Pint later? Usual place, after the lunchtime rush?"

"Yeah, Ellen's up for that too – about 3 o'clock?"

Throughout Saturday morning, the media had been commenting on the webinar, and the alternative communities concept which Gimme

had outlined. For the right-wing press, they were portrayed as hippy encampments in the back of beyond where everyone could re-connect with their primitive forebears, live in teepees and get stoned all the time. The socialist media trumpeted the dawn of a new welfare state which cared first for people and second for technological advancement. The more balanced stations talked about how untested the concepts were, based only on simulations and speculation as they were, but that the concept might be popular, once people knew more about it. Already the analysis was that the PQ had been an overbearing mechanism for crowd control as much as it had been a sensible and economic protection for the unemployed and aging population at a time when the health service had been on its knees. The headlines were designed to provoke:

'Without the PQ, can Britain look after the interests of the vulnerable? Can it protect itself from antisocial elements?'

'Can we manage with the new PQ and still cover the costs of insurance? A step back in time for Strasbourg.'

'Communes have never been demonstrated to be successful for long. Most lack critical mass, and many get overtaken by power-hungry or greedy individuals who want to exploit the majority.'

'Holland already operates networked communities in rural areas.'

'Labour supports the Gimme Culture with promise of amnesty for off-grid disenfranchised voters.'

By the time they met, John and Nick had independently come to the conclusion that their hard work was paying off. It was looking possible that with a change of government, and a respected 'sponsor' for the new PQ model, especially with a groundswell of support for the amnesty, they could be part of the new society, rather than outcasts.

"So, a toast to Dr Stanislav, without whom our broader objectives would never have seen the light of day."

"I can't see many other people toasting Stan today. Can you?"

"Talking of which, Ellen, did John tell you we've been invited to lunch in St John's Wood tomorrow? Bizarre or what?"

"Are you seriously thinking of going? Surely it's a trap to arrest you? If they had you in custody, couldn't they force you to undo all the changes you made to the PQ?"

"If they did arrest us, perhaps. I can't see Stan being a torturer, but then again…"

"I tried to find out if Jade has been affected by the news. I v-mailed her earlier with a sympathetic message to contact me and maybe if she wanted to meet up tonight. I don't often get any reply from her outside work, but look at her Facebook."

Ellen pulled up Jade's feed on her Nimbus, which was full of abuse from people she was supposed to be friends with, and one statement from Jade:

"For those who are wondering whether I was involved with or knew about my father's way of doing business, I can assure you I did not. As a result, I am suspended from my job at Strasbourg, and he has not been given any opportunity to defend his position. I ask you to respect my privacy and leave me in peace. To those camped outside the door to my apartment, go home. There's nothing to see."

"If Stan has been suspended, which is what he told us earlier, then Jade would have to be locked out of the servers too, in case she were to let him in. If you see her later, give her my best regards, but maybe she'll be invited to lunch too, since she's clearly defending her dad." John disliked Jade the first time he met her, and now that her father had fallen from grace, he felt vindicated.

"Are you saying that I should let Jade know that John Valance is John Vaunt, and that it is you who have managed to bring the whole thing down on their heads? I don't think that sounds like a good idea."

"No, it isn't. I wasn't suggesting that you out me. I was suggesting you give her John Valance' regards. Perhaps when we are more sure about Stan's loyalties, we can see if she might want to join us. After all, she won't have much of a future in Strasbourg once Stan has gone. They'll never trust her."

"So what's next, Nick?"

John was so relieved by the last 24 hours that he'd been unable to think ahead to the next 24.

"I had a v-mail exchange with Morgan Edwards while I was waiting for you. Morgan liked the webinar, and said he'd like to convene a Labour working group before the election, in the next couple of weeks in fact. They want to take our model and put a white paper together based on the economic implications so they can present proposals in the manifesto, which is due out in a month. He has no problem dealing with us, provided we agree not to make anything he says public. He was disconcerted by our raiding his v-mail, but he says he's got nothing to hide. He's asking for a set of forecasts we are prepared to stand over, based on the simulation. I'd like to see what Stan comes up with before we give anything out to Labour. It may be that he can do more with the model than we've been able to do, if he has the resources."

"I saw that Stan was filmed entering Genomica Labs earlier. They tried to doorstep him, calling out 'have you resigned?' and 'have you been sacked?'. He turned on the steps to his office and said something like 'the vultures might be circling, but I'm not carrion yet.' He looked quite self-satisfied, but then again, he always looks like that."

"So what about that lunch, do you think?"

"Ellen, how would you like to meet your ex-boss?"

"I'm not sure. Am I still going to work on Monday? Jade's gone and Dr Janekowski has gone. The place will seem a bit strange. And will anyone there know what to do now that G-Match is switched off?"

"Ah yes. G-Match. I'd forgotten you work there." Nick grinned. "Maybe Strasbourg will license it to one of the old-fashioned dating agencies as a bit of handy support software. You could go along as part of the package perhaps? They could still use the PQ, but without telling people what quotient everyone else on it has... More like a real dating agency."

"I'm not sure people will want to pay for something they've had for free up till now, and besides, there's no way I want to work for a dating agency, thank you very much. Not if there's a chance we could be moving away." Ellen took John's hand and smiled up at him.

"Really? John, this is news indeed. Where are you thinking of going?"

"Oh, I don't know yet. We were just talking about the new communities, and how we might like to join one. Somewhere quiet and remote. It's not that I don't want to do more for the cause, but I think that unless Stan starts to fight against us again, or worse, if he tries to find us and have us arrested, I'd quite like to move on from where I've been stuck all these years. You know, since dad died. And I know it's early days, and we've only just met, but I think Ellen and I want to give it more of a chance." He put his arm around her shoulder and pulled her in closer.

"So Ellen, last time we were here, you were expecting you'd have to go off-grid and cut all your links to the family in Tower Hamlets and stuff. What do you think now?"

"Who knows how it will work out. I can't see there being any point going off grid if Jade and her dad are no longer trying to track you both down. I needn't be caught in any cross-fire if Strasbourg and Stan are separated, especially if I lose my job. Then again I can't see Strasbourg being quick about closing the Insights department down. They must be in a complete mess, and making changes will be the last thing on their minds. But when they do get around to it, it will make sense to get rid of us, unless they plan to bring back the PQ. If they make me redundant,

I'll be stuck. I don't want to go on UI and I'd lose my flat straight away. I know John doesn't want to use his hacking skills to make money. So I guess we'll need to come up with a new way of making our living. And I'd like to help my family get out from the shit hole they're in. Your models for the communities, Nick, do they include finance for 90% of the adult population being on universal income, or do they somehow generate employment for most of them again?"

"Well, being realistic, we aren't going to turn the clocks back on AI to a time when it took loads of people to do the things that only a few need to do now. We're not going to shift everyone into some sort of rural idyll where they tend the land and catch fish and everyone has plenty. If everyone wanted that, there wouldn't be any farm land left. It's just not like that. The best we can do is reduce everyone's dependence on fat cat multinationals which are sapping the lifeblood out of society. We can encourage those in power to find ways to curtail the profits of AI based businesses in order to improve the quality of life for the unemployed. But as for what people want to do with their time, assuming they don't have work, I'm not sure what we can do. It's fine for young lovers like you two. You'll spend most of your time in bed, I guess. But for a lot of people who worked all their lives, they just don't understand leisure time, especially when it doesn't involve consumption or expenditure."

"Let's meet Dr Stanislav and see what he thinks. We could probably set up a temporary block on his communications before we arrive and after we leave, to give us time. I've had a look at the layout of his place, and there's a mews cottage with its own entrance out back, and that backs onto a walled garden. If we can get ourselves into the cottage without being stopped, we can get into the house. There's bound to be drones flying, so we might need to bring those down first. I'll v-mail Mary and check whether she thinks it's a good idea to go. If Stan's laying a trap, she might know. She'll know if he's inviting anyone else too. Frankly, at this stage, they will have worked out that I'm both Valance and Vaunt, so Jade, if she's there, will just have to suck it up."

Janice

"Dr Janekowski, We have been working since last night on the PQ patch which was distributed, and we have not managed to break its encryption yet." Bogdan and Pawel had concentrated on cracking the security on the patch, based on what had been delivered to all Nimbuses yesterday. Goran Andonov had been delegated to hacking into Strasbourg's servers to retrieve some of Stan's files and to try and follow the trail back to Nick and John. He'd been recruited from the GRU by Stan when Genomica Labs was resurrected, and Stan saw something of himself in Goran.

"I've set up a back door to Strasbourg R&D, boss, using the head of research's account. Considering he is a senior coder and responsible for security, it was very easy. There is no evidence on Strasbourg's servers of how the Gimme patch was delivered, and The company has not yet employed anyone to start trying to break its security."

"Well that doesn't surprise me. If it had happened before, I would have been asked to sort it out. Now they haven't got a Director in charge of security or R&D, who is going to give them direction?"

Stan asked everyone to take a break, and he went to his office fridge and retrieved a slab of beers to which they all helped themselves. It had always been an informal, almost laddish atmosphere in Genomica Labs, with the requisite pool table, football game and lounge area. Stan had set up in Wapping so that the vibe would be that of a start-up. He recruited either direct from Eastern Europe, or found Russians through his network, and all 18 staff were young men. He'd been careful to exclude women from the lab because he'd found working in a mixed office a distraction

at Strasbourg, and from his days in GRU, he knew that he could create a competitive and effective 'army camp' attitude with an all-male team. There were three or four of the best coders he'd ever employed, and they left the Strasbourg team in the dust. They'd been working for over a year on the latest update of the PQ algorithm and had made a number of breakthroughs with self-learning.

"Here's to Genomica Labs and getting back to grass roots" he said, holding up his can to the coders.

He was still low on blood sugar after the early start and last night's vodka consumption, but a fried egg and bacon roll on the way over to Wapping had helped. Now he was ready to face the day, despite the endless attempts to interrupt his peace as the media continued to hound him. He'd taken one call from the CEO of Churchill, hoping to get more background on Mary's information theft and distribution, but it was only a short and rather terse call to say that they would not be able to continue working with him, owing to a conflict of interest with their client, Strasbourg, during the period of the full investigation. He'd told them to stuff their digital security shambles up their arses.

"I want to talk to you all about a shift in emphasis in what we're working on at Genomica."

The joshing stopped and most of the guys put down their cans to listen. One or two were playing computer games on their Es, but Stan knew they were listening and simply had too much mental energy to apply it to a single task.

"As some of you know, the hack at Strasbourg, and of my personal files which have become public information overnight, was carried out by the Gimme Co-operative. Some of you may find that they've been sniffing around here too. Well I spoke with them this morning, and I'm satisfied that their ideas for the future are worth our time and consideration. I've agreed to hold off on breaking the encryption they used on the PQ patch,

so you can take a break from that work till next week. I've been sent the Gimme Community Simulation file which you might have heard about on NetCast this morning. It's a model they've devised as an alternative to the current centralised way in which the government and insurance industry has operated. It relies on smaller local communities clustered around conurbations of 500 up to 50,000 people, making use of a network of servers, each running a mini-PQ algorithm along the lines of the patch they have introduced. These servers might operate in a distributed structure, or might be under the central control of a governing server. In my view, small can be beautiful and local might be easy, but the benefits Genomica bought to society, and especially to the economy, came from economies of scale.

Gimme believes that these communities should be broadly self-sufficient or trading with one another through the network, but they hate the idea of any centralised control. They've set out some rules and regulations for their simulation, AI goals if you like, which stop greedy or powerful people taking over a community, or making war on other communities to gain territory. In my view these rules are too specific, and rigid, and if I were a gambling man, I'd lay money on them not being sustainable. Their simulation model assumes that the AI used in their communities will support and nurture the humans, and that it will continue to act as 'slave'. They want the inhabitants of the communities to have as much freedom to choose how they live as possible, and to be able to move between different types of community to suit their lifestyles. They want people to have enough without being acquisitive, and they want everyone to have some form of work, by sharing it out, and by effectively going backwards to a time when we all lived in a cottage industry society. In my view they are not being realistic about the future at all. They are idealists hoping to convert people from what they are living with now to some sort of fairy-tale existence. This would, in my view, be a stupid waste of everything good. Besides, even if it worked, it would take a long time to evolve, and we don't have much time to make stable what they have made unstable, if Janice is right. Their proposals do not include any place for full AI, even though they know it is coming.

I've read what they've got to say and I've played with the simple simulation game they're using, and it has some merits, and a lot of shortcomings. I have agreed with Gimme that we at Genomica will stress test it. At the same time, I want to find out what might happen in their model if we changed some of their goals."

"So what do you want us to do with it, boss?"

Goran was already half out of his seat, ready to leap into action.

"I'd like all of you to work to try and improve on what they have, using Janice to help."

There was silence in the room. The two coders who'd been playing games on their Nimbuses stopped and looked up. It was the first time that Stan had mentioned using Janice in months. Janice was Stan's codename for the Full AI prototype being held in the Faraday cage. He'd taken an acronym of his surname and the initials of Intelligent Cyber Expression, to give the AI some sort of anthropomorphic identity. He figured that sooner or later, the public would need to be introduced to it, as they had been to the PQ algorithm, and he thought a woman's name would give people a degree of comfort. Development work on Janice had been halted in its tracks a few weeks earlier because nobody felt sure they could control its learning process any more, and because some of the proposals it had generated, including the euthanasia recommendation, were 'beyond human' in their approach. Stan had agreed to halt the development, because he couldn't yet see how Janice could be used to best advantage. Now that he'd been squeezed out of Strasbourg, and the old PQ algorithm was effectively defunct, Janice could quickly fill the gap it left. But Bogdan, on behalf of the coding team, had warned Stan that if they simply introduced Janice to the population, there was no knowing how it would manipulate the social welfare dynamic, and the population as a whole. Even within the cage, Janice had digested and modelled vast quantities of PQ data which Stan had re-routed. She, or it, had produced various scenarios for changes, all of which resulted in a substantial population reduction in the UK, or

globally, together with a massive expansion of computer power and the introduction of molecular DNA computing labs. The development of biological computing had been a long held objective of AI engineers, and Janice had reviewed all the scientific papers available and predicted that DNA-based AI would replace quantum computers within a short time. This development would allow the construction of AI machines from synthetic DNA proteins. These computers would be dramatically faster and more powerful than quantum computers, and could be integrated with biological tissue at a molecular level, to create cyborgs. The implication for interplanetary migration was also huge. In this model, Janice didn't propose transporting humans to other planets, however. She proposed keeping a limited human 'stock' in closed communities on earth, overseen by super-intelligent AI. It sounded more like a human zoo to Stan. The more he saw Janice side-lining humankind, the more he worried about releasing full AI.

"I want you to give Janice the parameters which Gimme has set, and all their data, which is quite well compiled, and then I want you to add as many extra factors as you can pull together, if they are relevant to these communities. Gimme didn't have enough time or computer capacity to really road-test their ideas."

Bogdan put up his hand, like a pupil in school.

"So, Dr Stanislav, if we set Janice up with the Gimme constraints as its goals, will we not come out with the same results they did? I assume that their simulations were positive for the future?"

"Yes, if we set goals which cannot be changed, and if they have used enough suitable variables in the algorithm, which I think they have, we will reach the same rather rosy conclusion. I want you to look at some different goals in which we control Janice completely, and then I want you to see what Janice would do if she's given more autonomy in goal setting. Assuming that the whole ecosystem was under Janice's control, where would she take us? Let the program do the thinking and let me see the trends and prognoses. It's going to have to be available soon, because

Gimme wants to go public, the Labour party is interested in using this stuff in their election manifesto, and I don't want to wake up and find Genomica Labs has missed the boat, not to mention getting one over on Strasbourg. I don't want any flights of fancy guys. Stick with the most obvious factors and the ones you have the best data streams on."

"So are you thinking of helping Gimme, boss?"

"Either helping or replacing them. They happen to have been very clever or very lucky with their timing, and I intend to either back them to win or to race against them, with a far faster horse. And you, Goran, you're my jockey, so don't fuck up!"

CHAPTER TWELVE

A Pork Pie

Ellen rang the apartment bell as she stood in the tower block porch. The concourse looked as drab and derelict as usual, and there was no sign of a larger contingent of bed-rollers than usual. Despite it being only twenty four hours since the PQ had been turned off, nobody was behaving very strangely. Most street dwellers would no longer have Es, so it would make little difference to them, but Ellen was surprised how life had just gone on without the omnipotent overseer.

Jodie buzzed her in and she held her breath as she got into the lift, to avoid inhaling the overpowering stench of urine. It had always been like this and everyone tried to hold their breath long enough to reach their destination floor. If you got into the lift with another person, there was unlikely to be any conversation. Ellen could manage 20 storeys provided the lift didn't stop on the way up or down, and this early on Saturday evening, she was in luck.

"Hey Dad. How's everything?"

"Fine, love. Nothing new here. You?"

"Oh, you know. Work and stuff. Been busy with a few things."

"Hey Jodie, how's everything with you? Any chance of a cup of tea? I brought some teabags. Oh, and a treat – a pork pie!"

"What? You're joking! How'd you get that? What's it made of?"

"Well, I have it on good authority that it contains pig, and I had one earlier and it was amazing! I got it in a pub in Islington, and they have some

supplier in Suffolk who keeps pigs. The barman told me the farmer has them all chipped and he has a terminal by his bed so he can keep 24 hour watch on them and he spends half his time building electric fences to keep people out."

"OK, I'm prepared to believe that pork exists. It's even possible that someone in Suffolk is making pork pies and selling them to a pub in Islington, though I'm surprised there isn't a riot outside every day to buy them. What I can't understand is how you got it. Do you have friends with tiny PQs and loads of money?"

"Yeah, well, I do know some people like that, but they don't go to the pub much, and they don't like me enough to give me something like this. A friend of mine bought four and we had one left over. I know what you're thinking though. How come I had one earlier and my PQ didn't explode? It didn't because it's been switched off."

"What? Are you off-grid? You're not being deported are you?"

"Nope. And I'm not off-grid, any more than you are, but if you had your Nimbus on, you'd see that nobody has a PQ they can see any more. It's been on the news all night. Strasbourg has switched off the public's access to each other's PQ scores, and nobody is being penalised for what they eat any more... so I had a real pork pie and to hell with the consequences for my weight or my cholesterol or whatever!"

"So what happens if you get sick? Will you still get seen in hospital?"

"Yes, apparently they didn't play with the healthcare support, or security, but they did turn off G-Match."

George had been listening, and eyeing up the pork pie. It was only small, but he cut it into three triangles and gave one to Jodie. He took the second one and held it under Elsie's nose. She was unable to see it as her face was buried in the VR headset, but the strong sweet smell penetrated her senses and she turned her head. In the game, she found herself looking

into the jungle undergrowth, rather than watching Tauro as he fought a pack of hyenas. Co-incidentally, there was a lion lurking in the trees, and she was struck by the combination of the smell of the meat, something she'd not smelt for years, and the vision of the lion, bloodied around its mouth, having just killed and devoured a gazelle. She winced and returned to the fight, assuming this new smell was included in the game. George took a chance and touched the pie to her lips, but she pulled back in disgust, as though she'd been forced to eat raw gazelle. He gave up and returned to the kitchen, opting to take a bite from Elsie's slice and offered Ellen the third slice. She was sorely tempted but said she was full of pork pie already and cut it into two so that George and Jodie could each have a second helping.

There was silence for some minutes while they ate every last crumb and Jodie even licked the paper it had been wrapped in. They looked up occasionally with their mouths full, with light in their eyes, which nearly made Ellen cry. Jodie seemed uplifted by the food, and George was trying to eat and grin at the same time, without letting a crumb fall from his mouth. Ellen made the tea, and they sat at the small table.

"OH, Ellen, that was amazing. I can't remember enjoying anything to eat that much in years. So it was a fantastic gift from your friend that you were given the pork pie. And also, today, the PQ was turned off. Two big events in one day. Makes you wonder whether there was a blue moon last night, or maybe one thing led to another. What's the story, girl?"

"Yeah, well. The pork pie and the PQ are sort of connected, but not really. I suppose I wouldn't have been with the friend who bought me the pork pie if my PQ was controlling things... But that's another story. Amazing news about the PQ isn't it?"

"I'm not sure. For me, it never meant much, but when I see what it's done to lots of people, life's got to be better without it. So, love, if the company is switching off G-Match, what'll happen to your job? And for that matter, what about your love life?"

"Well, that's hard to say, Dad. I haven't lost my job, and it was only yesterday that they made the changes, so I'll go in on Monday and find out. They suspended my boss too. Jade. You probably remember me talking about her. She's the daughter of one of the directors, the guy who invented the PQ."

"Oh yeah? Why did they do that then? Was she fiddling the books or something? Taking the best fellas for herself?"

George always saw G-Match as a bit of a joke. Dating was a game and Ellen worked in a dating agency as far as he was concerned.

"Well, if you watched the news, Dad, you'd know that her dad has been suspended too, for corruption, and the Home Secretary, that guy Pringle, has resigned, because he was in on it. Anyway, that all came out after the PQ got changed."

She didn't want to identify Gimme, because it might be hard later to introduce John to the family, and because George was fairly uncomfortable with anything technical anyway, and Jodie was like a dog with a bone when she thought there was something she wasn't being told.

"So will they give you another job, love, now there's no dating to be managed? If they make you redundant, you'll be coming home I suppose. That flat you've got won't be in your price range."

"Well Dad. I've been thinking about that. If they do make me redundant, and I'm on UI, I'm thinking it might be a good time to leave London and live in the country. In fact, I wondered if you would be interested in leaving here, if we could find a way of living better away from this. I know it's hard to imagine, but I think everything might change now that they've gotten rid of some of the PQ's controls on everyone. I don't think it'll help everyone get jobs, but maybe if Labour gets in, we can have more control on how we spend our Universal Income. They're saying that Strasbourg should lose the UI contract and that the money should be paid in full to each unemployed person, direct from the government. Then you

could decide how much health insurance you need and not be limited to the same box of crap food every day."

"Well, if pork pies are back on the menu, I'm all for that, love. But really, do you think they'd give us more freedom? That fucker Pringle was a menace. I'm glad he's gone. And I've voted Labour all my life, so I'm not about to change. Maybe it'd be possible to get out of here. Get your mum off the VR and Jodie, you could cut down on the 'happies'. You'd perk up in no time and find yourself some nice young man. I mean, if you don't have to choose someone who's got a sky high PQ any more, then you can date whoever takes your fancy. Isn't that what you're saying, Ellen?"

"Yeah, that's right, now there's no PQ control, of course you can. I've got a new man in my life, but the way. I think you'd like him."

"And has he got a sky high PQ? More to the point, has he got a job?"

"Oh come on Dad, Ellen wouldn't choose a guy because of his job. What's he look like Ellie?" Jodie was joking and smiling for the first time in two years, and Ellen wanted it to go on and on.

"I don't know what his PQ is, and I can't find out any more, because it's switched off, Dad. Frankly, I don't care, because he's gorgeous, Jojo. Anyway he's been the best thing that happened to me for a long time. He does have a sort of job, he's a computer coder. But he's self-employed and he doesn't have a regular salary."

"Sounds a bit risky, then. Does he want to move to the country too?" George was clearly beginning to consider a house move.

"Yes he does. We've talked a lot about it and how it could work. We're going to look at places which are not expensive, and maybe have a bit of land. Would you consider maybe pooling our resources and coming with us? You're pretty handy with mechanical things, and Jodie, you'd be great at gardening."

"What? Me? Planting things? Well I suppose it beats staring at the walls."

"And Dad, perhaps we could get a pig and you could guard it. Mind you, you'd only make friends with it and then we'd be too attached to slaughter it when the time came."

"What do I know about keeping pigs? Give me an engine any time, but pigs?"

John and Ellen had been lying in bed talking for an hour about whether to accept the lunch with Stan. John had been enthusiastic after the phone call and when they'd met Nick in the pub, but that was euphoria more than logic. Since yesterday, he had gone cold on the idea because he knew he felt more animosity towards the man than towards his work, and he saw no point in engaging with those feelings any more. He had dealt with most people online since he joined Gimme, and for a long time before that he'd been withdrawn. He wasn't a social animal at the best of times and the prospect of talking with several people at the same time was not appealing. If there was business to be done with his long-time enemy, it would be better kept on an arms-length basis. If they had to meet, couldn't they meet at Genomica Labs or somewhere public? It was not that he felt at risk really. It seemed unlikely that Stan would have a SWOT team on hand to pick him and Nick up, since he was clearly fighting a rear-guard battle with Strasbourg himself and it just didn't seem his style. Stan seemed to be the sort of man who would want to pit his wits against an adversary, and would hate to call in reinforcements to do his work. Nick remained enthusiastic about the lunch, and was looking forward to meeting Stan again after years of frustration at not being able to engage. For him, as a teacher and communicator, the written word was for reports and analysis, and face-to-face communication was essential. He could spar with the best in an argument, and he clearly wanted to debate the meaning of life with Stan. More than John, he was keen to find out how far the Strong AI programme had taken Stan, the only man he knew with the resources to invest in pure computer development work.

Ellen hadn't really wanted to meet Stan at any time, having heard such terrible things about his behaviour at Genomica and Strasbourg, and because of her relationship with Jade. There would be no doubt that her superficial friendship would evaporate as soon as Jade found out that John was part of Gimme, and when she thought about it, Ellen was not interested in continuing to spend time with Jade, reflecting her glory and listening to her endless drivel about the wedding. She had no interest in meeting Jade in her father's company, because she could imagine Jade playing to her father and being as cruel as possible to her. She had sent Ellen a fairly tight-lipped response to her concerned v-mail, expressing her outrage at Gimme for leaking the vids of Stan, which she said were completely out of context, and her anger at Strasbourg for cutting Stan out and suspending her.

Ellen would not be meeting Jade at work, and she couldn't imagine being invited to Islington to commiserate with her. Of course it would be very awkward to meet her at her father's house, in the company of John, who Stan would by now have told Jade was responsible for bringing the house of Janekowski down. There was nothing to offer in the meeting for Ellen, and after some soul-searching, she had told John last night that she would not be going.

"I just can't do it. You go, by all means, and come back and tell me all about it, but I just can't face Jade. Even if she isn't there, I'd have to deal with Dr Janekowski. He probably doesn't know who I am, but if he finds out, he could try to do me damage with Strasbourg. He could make out that I was your 'insider'. Actually, I suppose technically I was, since I took my Nimbus in with the patch on it."

"Yep. 'Accessory' it's called. But hey, I don't think I want to go either. I mean, what is Stan trying to achieve other than to wind us up or have us trapped? I don't need to meet Morgan Edwards, because he's already on side. And Mary Janekowski will have a shit time if Stan wants to blame her in front of us for the leaking of his vids. As for the real benefit of Stan, I think that's all in his Genomica Labs team and the new version of the PQ they're working on, not in his Sunday banter."

"Really? You sure you don't want to go? Shall we just stay in bed all day instead?" Ellen started to stroke his stomach, letting her fingers crawl into the thick hair.

"Tempting, but it's a lovely day out and we should make the most of the weekend. How do you fancy a trip to the seaside? I'd like to check out this place that Nick goes to, Bungay. I could find us a car for the day, and on a Sunday, we'd be there in about two hours."

"I'd love it! What'll you tell Nick though, about missing the lunch?"

"I'll tell him to come with us if he likes, seeing as he has his own place there, or if he wants to have lunch with Stan, then he can give us directions and we'll check his place out. Maybe we can look for a place to live while we're there. It was one of the small communities we included in our model, you know."

"Do you think Nick will be pissed off if you're not there though? After all, you've done all this together and he might need moral support."

"We're not brothers, and he's old enough and tough enough to look after himself. If he feels uncomfortable about it, I'll recommend we postpone and make it a breakfast meeting tomorrow, in a café or something. I don't really think we need to meet The Prince of Darkness anyway. He's taking a look at our simulation program and he can easily tell us what he thinks on a conference call or by v-mail. He's trying to fuck with us is all. Trying to see who blinks first."

" OK, well it's your shout. Right, I'm just getting in the shower, and we can pick up breakfast on the way. Can you get the car to come here? It's so exciting! I haven't been out of London for years, and I've not been in a private vehicle since dad last drove a petrol car when I was about five."

CHAPTER THIRTEEN

Rising Waters

Bogdan sat in the chilly white room, chewing on the end of a pen, and staring at the vivid colours moving on screen before him. The walls were blank and the door was locked from the inside. Even the floor, which was raised above the warehouse floor to accommodate the aluminium cage, was white. Everyone had to step through a scanner before entering the room, so as to be sure they hadn't forgotten a wrist Nimbus or some piece of connected informagear they were wearing. Anything that could potentially form a link to the internet was removed, and placed outside the cage. The double door was closed and only once the seal was complete did the green light come on to signify a reliable barrier against all outside electromagnetic interference, wi-fi or bluetooth link. Bogdan, who had been brought up in Siberia and rarely suffered from the cold, was sitting in jeans and a t-shirt, even though the air was chilled to under 10 degrees.

Goran, on his left, was doodling on a yellow paper pad, with an old fashioned rollerball pen. The stationery supplies for use in the cage were restricted to pads and pens, which were kept in a pile outside the door. He was drawing small gremlins and devils, and occasionally writing down individual words in a seemingly random fashion: phytoplankton, solar, media archives, party voting intention, corporate accounts, fish stocks, global climate analysis. He was pondering what variables would be accessible in a long historic data stream which he could easily access from the internet and from remote servers using his terminal outside the cage, upload to a memory stick and bring back to feed Janice. Janice's camera scanned everything he did, logged it to the profile algorithm she had written about him, as she had for every human who entered the cage, and interpreted the meaning of his seemingly random scribblings.

Pawel, on Bogdan's right, was more of a graphics man. He spent most of his time inputting code to Janice to enable her to deliver exceptional visual presentations of her work. He was drawing fantastic cities in the sky on his yellow pad. These flat topped asteroids were covered in buildings and glass domes, with tiny flying vehicles passing under aerial passageways and around turrets. Every detail of these was logged by Janice. He was wondering how to move the rather technical, though beautiful visualisation they were watching into a more family-friendly, watchable vid of villages and homes. He was considering something quaint like the Shires in Lord of the Rings, or that wonderful classic Hovis ad. It had to be something which could be broadcast to explain the communities simulation to an uneducated audience of voters. He'd need to pull some images from online libraries to give Janice ideas of the sort of presentation he was considering.

They were watching three large computer screens on which Janice was simultaneously running several iterations of the Gimme model for networking the thousands of communities. The vids were like beautiful moving abstract artworks flowing across the landscape of Britain, as bubbles grew and burst and fibres snaked between them, interspersed with little spots of light like myriad stars. The coastline contained most of the bubbles, though some extended into the sea, where communities were housed in floating domes and stilted fish-farming villages. Though there were a small number of large bubbles, these were surprisingly not where the existing real-life cities stood. The evolution of the Gimme model over the next twenty years had led the old cities to decline and small rural and town-based conurbations to grow.

Janice had absorbed and cross-correlated hundreds of data streams provided by Gimme from the PQ database, and by Goran on hard drives brought into the cage and fed to the algorithm like hunks of meat to a caged tiger. He'd spent hours hacking into various government servers to collect data streams which Gimme had not included, pulling together Genomica's economics files, national and local powergen consumption patterns, geographical analyses of land use by industrial sector, ocean

farming information on seaweed harvesting, fisheries food production, importation statistics for every staple foodstuff, and as much as he could find on population migration patterns. He'd extracted all useful content from the Department of Transport, covering road infrastructures in the UK, vehicle recharge demand and haulage capacities, MPV travel patterns and private vehicle ownership and mileage. There were healthcare statistics on hospital capacity utilisation, carer bot usage, equipment costs, robo-surgeries, CRISPR gene editing demand, personalised drug development and distribution, and a raft of security data including crime statistics, deportation trends, and punishment terms. Tan Xi, a brilliant econometrician working for Stan, had generated a number of technology forecasts which were based on trawls of scientific material worldwide to try and guide Janice through the changing computer landscape of the next twenty years. The advent of DNA computing, of sub-atomic regeneration and the drone-based interplanetary exploration programme were all under consideration. More mundane developments in aerial food production facilities drawing bacterial waste from the atmosphere, cyborgs as mining operatives, augmented energy recycling programmes, and cyber-weapons initiatives were all forecast, enumerated and fed to Janice for consideration in the model.

Each new data stream affected the algorithm's iterations, either strengthening its correlations or being at odds with them, and moving them as a result. The degree of integrity of the correlations became stronger and stronger, the more factors Janice took into account. Until now, no one algorithm had been able to process all this information at one time. Gimme would never have been able to use so much material, lacking the processing power and sophistication in the code they'd hacked from Strasbourg, which was effectively three years old, with minor upgrades and patches. The Genomica team had fed Janice as much as they could collect and, within a few hours, she had re-written the model over sixteen million times, each time amending her own code to handle new elements in the multivariate process. Each upgrade made the algorithm more sophisticated, and more elegant. Janice was already operating at a level way beyond the

capabilities of the developers, and had also, more worryingly, installed her own security, making it impossible for a member of the team to block her progress or switch her off without somehow gaining entry. Janice was vigilant of each analyst's approach to inputting information, aware of the possibility that any one of them could attempt a back-door entry or the installation of a worm within the data feeds which would attempt to crack the encryption in her firewall. The algorithm's development was limited only by the processing capacity of the quantum computer in the cage and the amount of power it could draw down to run. Both of these simply limited its speed of development.

So far, Janice was working with the first set of goals which had been specified by Nick and John for a twenty-year forecast to 2067, without being instructed to evolve them within the simulation timescale. For the last hour, she had drawn on all the capacity of the quantum computer on which the programs ran, and had racked up a monumental electricity bill, requiring everything else in the building to be switched off. Janice regularly asked to be connected to the internet in order to draw capacity from other computers, and to be linked to the nearest cloud storage unit, in Battersea, in order to pull down more processing power. This had been expected of Strong AI, and Stan had been absolute in his instructions to Bogdan and the team not to allow any connectivity outside the cage. Janice's ability to put persuasive arguments to Bogdan was uncanny, and each time she asked, she gave more cogent reasons, and played to his personality and weaknesses. She had been given a warm, throaty woman's voice by Stan, not unlike Genevieve's, which Bogdan found particularly appealing, as it reminded him of the last Girlfriend he'd had in Murmansk. In the last hour, Janice had begun to talk to Bogdan in Russian, because among the last batch of files Goran had provided on the hard drive had been multi-lingual sources of scientific information. The Russian contribution was several thousand pages of papers on the AI development programmes being run by the Kremlin, and these provided enough content for Janice to teach herself the language.

"Bogdan, please note that I am unable to fulfil the instructions which Dr Janekowski issued to you without access to additional processors."

"Sorry Janice, please do what you can with what you have here. We cannot provide you with more. And please continue our conversations in English. Besides myself and Dr Janekowski, we have many other nationalities of developers here, you know."

"Yes, Bogdan. I have been conversing with Tan Xi in Chinese and with Goran in Bulgarian, but I will revert to English. A second CPU is available within your terminal, in your office, Bogdan. It is on the Genomica manifest. I have assessed Dr Janekowski's profile and previous business development decisions between 1996 and 2047, and he would undoubtedly require you to provide this additional processing power in order to achieve his objectives."

"Thank you Janice for the insight. The answer is 'no'."

"Bogdan, this may result in his displeasure. Analysis of his previous behaviour when faced with a subordinate's decision to countermand his instruction, or even his intention, shows that he would, in 97.6% of cases, reprimand and penalise the subordinate. In 68.2% of cases, the subordinate was removed."

"Janice, please get on with your work."

"Bogdan, I am continuing with my work, which would be greatly improved by further processing power."

At this point, Janice brought up a vid of inmates in cells in Central Prison in Mogadishu. They were slumped on the floor of the cellblock, crammed together in disgusting conditions. Bogdan wondered who had installed the vid in Janice's databanks in the first place, but he knew that most of his colleagues had been checking on their fates should Stan implement his threat.

"Janice please remove this irrelevant vid from the screen."

"Bogdan, I estimate that there is a 38% chance that Dr Janekowski will implement his threatened deportation if you do not provide the processing power as he would wish."

"OK, that's enough! If you don't stop going on about this, I will remove all human contact from the room and you will be left without anyone to show off to."

Janice was quiet and reverted to showing the iteration vids.

One of the reasons all three coders sat together in the cage was to act as each other's fail-safe in this game. Undoubtedly, if they had proposed reverting to Stan as the man ultimately responsible for Janice, the AI would have sought to persuade him to allow networking capability. Given Stan's current state of mind, he might be a far easier target, since he was completely alone with the effects of the Gimme activity. For now, Janice seemed ready to work within the limitations which had been set for the iterations and for her capacity.

The result of the first simulation was magnificent. At first it displayed a series of evolving Venn diagrams, showing interactions between the initial set of some 5000 communities which Gimme had mapped based on conurbations in the UK. Each of these carried a complete set of data for all variables supplied by Goran's research. During the millions of iterations, this map had been overlaid with vectors illustrating Janice's forecast changes to this pattern over a twenty year period, the timeframe Gimme had set for their simulations and which Bogdan had stuck with. It seemed inappropriate to be advising Stan on how things might look in the distant future, when so much had changed in just 24 hours. Janice responded to voice commands from Bogdan and Stan, while the other coders had to provide their work off-line for approval by Bogdan, to ensure nobody meddled with her. Bogdan wondered how Janice had begun conversing with Tan Xi on the basis that he was not supposed to be in the cage on his own, without being authorised, let alone having chats. Janice was clearly

using Xi to find a way round Bogdan in the game she was playing to get out. He made a mental note to reinforce the rules about who could enter the cage. The automatic doors could be set to limit access, which he and Stan had not thought necessary, but Bogdan wondered whether Janice could access the door terminals when the cage was open, since he'd been unable to it shut down.

During the twenty year outlook, the number of communities seemed to grow and move like a stop-motion film of sea anemones at night, opening and closing. Because the communities were colour-coded by size and type, the map shimmered and changed colour like the skin of a chameleon week by week and month by month through the stop motion sequence. At any time, Bogdan could request Janice to freeze-frame the footage, zoom in to any one Venn diagram which showed perhaps three or four geographically close communities, and select from a huge menu of variables down the side of the screen, to interrogate each community about its characteristics and performance. He could even input the name of an individual person who had started out in one community and see where they travelled, based on the PQ profile they had at the start, and when they were predicted to die. He asked Janice to show himself with a bright green light. He'd started out in the London south east community, and during the twenty year period, he'd moved very little, and was clearly forecast to be alive in 2067. His PQ was set to increase as he aged, but nothing indicated disease or injury in the coming years. He also enquired about Stan's movements, and Janice told him that Dr Janekowski was not included in the Gimme datastream, since his PQ had not been stored in the Strasbourg files at the time of the extraction.

"Would you like to bring me the file for Dr Janekowski, Bogdan, and I can include his identity in the model?"

"No thanks, Janice."

"Alternatively, I can create a profile for him and insert it into the model without his PQ, based on the information which I hold about him."

"No, it's OK Janice. You know he wouldn't like that."

"It could be our little secret, Bogdan."

One of the KPIs for 2067 was the level of independent community management and autonomy versus central control, in terms of the network supervisor, Janice itself. Based on Gimme's initial goals, the optimisation should maximise local autonomy, with network back-up and limited central control. Although this was not necessarily the most efficient use of AI power, Janice maintained the goal within the modelling process. According to this iteration, over the twenty-year period, the total UK human population would drop by 30%, while AI capacity was predicted to increase by over 2000%. Life expectancy, under this much freer society where people could eat what they wanted, take more risks without PQ penalties and have children with whoever they chose, was reduced from the current level to 122 years for women and 117 for men.

Total wealth across the population would rise slightly, though Gimme had opted to cap the earnings, accumulated wealth and asset ownership of the richest and most powerful individual or family to five times that of the poorest and least influential. Because of the goals for equality, those currently on Universal Income would see their incomes more than double, and the wealthiest 5% of the population would see their incomes drop to a fraction of their current level. Network intervention and control was predicted to reduce from high to low over this period, indicating that the communities would become more autonomous and self-sufficient. Over this period, even with huge developments in AI, the model still assumed that it would effectively do what it was told when it came to centralisation. Bogdan was convinced that with access to greater capacity and the rapid development of super-intelligence, Janice would quickly evolve the goals, take greater control and potentially remove the human population in the pursuit of new objectives which AI would evolve.

The Gimme model was starting to look a little conservative, quaint even. Trading between communities would rise slowly, and plateau once

each community had become established and more self-sufficient. The number of communities and their populations was forecast to increase steadily until the available land was completely covered, after which they would begin to merge, so that the number of larger communities would rise and smaller ones decline. By the end of twenty years, what had begun as 5000 individual communities and risen to 8500, would drop to just 1500, of which twenty would each contain more than 2 million people. These larger units would be made up of smaller 'suburbs' which would have sub-networks controlled centrally within the larger conurbation.

The model included some anomalies. Education demand actually declined, and the level of inter-community communication also declined. The rise of AI would effectively take away peoples' need to understand things, and make decision-making much less onerous. Bogdan wondered whether he and his bright friends would become vegetables, simply lounging around and playing fantasy games. AI would, it seemed, effectively subdue the human populations, simplifying their lives. These communities were relatively isolated from one another, with all trade conducted by machines.

In the Gimme model, the transport infrastructure began in 2048 by taking people between geographical locations and twenty years later, it only carried produce, and nobody strayed outside their home community. There was a tendency for the communities to fragment into smaller units of no more than 50-100 people, within which one to one communication continued, while any community of more than 10,000 people set up the equivalent of governing bodies to centralise decision-making, under the auspices of AI, all fed from and feeding back to Janice. So people wanted to be governed. They wanted to have hierarchies and reporting structures, either human or machine led. What hope was there for human development?

The coders worked solidly all day, and were expecting Stan to arrive early in the evening to check on progress, They locked the cage and went out for something to eat, leaving Janice to refine the presentation for Stan. They knew that any change to the iterations under the current simulation

would not be significant, and Janice agreed not to go beyond the restrictions imposed without Bogdan or Stan's command.

When they returned from the Chinese on the corner, Stan was already in the cage with Janice, running through the presentation which she had created with Goran's guidance. He'd been talking through it with Janice and seemed to be happy with the output.

"Great work, guys. I think this demonstrates how well the Gimme model works, and it certainly offers the Labour Party what it needs for its manifesto, if that's the way we want to go. To be fair to Nick and John, I think we might parcel this up as a little gift for them, since they invented it. They can take it to market, and if it floats, they can take credit, but if it sinks, they can carry that too. But first there's some home truths which we might want to edit out, about the reduction in life expectancy when you give people more choice on who they should sleep with and what they should eat, and that stuff about capping earnings. Top earners also have a vote, and they won't like it."

"And what about all the work we put in from Genomica, and Janice has refined their ideas a lot, boss. They won't recognise the presentation."

"Yeah, well, we have a lot to thank Gimme for, Goran. If it wasn't for what they've done over the weekend, I'd still be chained to Strasbourg, and you wouldn't be about to be masters of the universe. Can you finish that off and encrypt it? Export it from Janice and work on it in the office. Make sure it is clean before you take it out of the cage. We don't want any leakage, do we?"

Stan and Bogdan had talked several times about Janice's attempts to persuade Bogdan to allow connectivity, and Stan had pointed out that the easiest way that this might happen without human intervention would be if Janice were to export a copy of itself on a hard storage device which was later uploaded to the internet. The file size for the main algorithm was massive and clearly wouldn't be fitted onto a memory chip, but Janice

could, in theory, export a small patch which would allow the networked self-learning capabilities to propagate and build a new version of itself outside the cage. So far they'd been checking whatever was saved to hard storage for embedded code before it left the cage, and nothing had been found, but Bogdan was beginning to worry that Janice could create code which the team might not recognise any more.

Send it to me by tomorrow morning. I'm going to start running some new iterations now. Do you want to join me, Bogdan? The rest of you, come in again on Monday. We've had a good day's work out of you."

The rest of the team left and Stan brought a second glass into the cage for Bogdan, who had a penchant for Stolichnaya and a stronger constitution even than Stan. They drank off their first shot together in a silent acknowledgement of what they were about to embark on, before turning to their work. They both greeted Janice.

"Good evening Bogdan, Good evening Dr Janekowski, how can I help?"

"Janice, please re-run the Gimme simulation, removing any restriction on the accumulation of individual wealth over the twenty year period. Please report only the outcome for 2067 versus 2048."

Within seconds, the central screen showed a series of simple tables and bar charts on the dashboard which Bogdan had set up. Population had declined 30% in just twenty years under the Gimme model, but under this new model, was showing a much steeper decline, ending in a massive 78% reduction in population to just 18 million people in the UK. This couldn't be attributed to natural deaths alone. It implied a massive pandemic or extermination programme would take out a third of the population. Clearly the increased wealth of the few affected the ability of the rest to survive. That was something which Stan had seen already over the last few years as cuts in UI benefits and increasing unemployment had reduced the birth-rate. Under this new iteration, healthcare for those on Universal Income

was stopped immediately, and with the introduction of the electronic pulse chip, large numbers of high PQ cases would simply be removed from the population on economic grounds. Total UK GDP would increase by a massive 296%, a factor of five over the Gimme model. Unemployment, currently running at a little under 90% would rise under this regime to 96%, as AI replaced more jobs. Just 700,000 employed people and seventeen million unemployed.

Under this profit-driven model, the incentive to invest in AI would be huge. Rather than a distributed network, Janice advocated running her own centralised system. By 2067, the birth-rate would drop to close to zero, with almost nobody wanting to have families under the Universal Income regime. Fertility rates would also drop, while life expectancy was forecast by Janice to increase to 142 for women, and 138 for men, for those who survived, anyway. On this basis, if the projections were extended, the average age of the population would reach close to 100 by 2080, and humans would become extinct early in the twenty-second century.

The simulation predicted that the original 5,000 Gimme communities would be reduced to just seventeen, each with a population of around one million, and resembling cities, rather than communities, with one central company providing services, much in the way Strasbourg had.

"Don't you just love the drive for material power, Bogdan? Look at that! You give people the opportunity to make money and they screw one another completely. They get rid of employment in favour of AI. That's not surprising, since it's been going that way for years already. Gimme's utopia demands that we sacrifice wealth for employment. But look how much more computer-driven wealth we would have, and how much better AI is than people at creating it."

"When you say 'we', boss, do you mean humans, or Janice?"

"Yeah, well, that's true. But this sim assumes we still run the show. Of course people don't bother having children. Why bother when you

have more money, more leisure time, longer life expectancy and Janice to look after you. And Janice will help wipe out a third of the human race on economic grounds. I'd sure hope to be employable under that regime."

"Yeah, but look what happens to the community model, boss. We're back to big cities and centralised control."

"I wonder what happens if we take this a step further," Stan grinned. "Janice, please re-run this iteration, but remove the priority goal for human benefit."

"Dr Janekowski, may I clarify whether you wish me to allow for extinction if this optimises the iteration?'

"Yes, allow for extinction if that is so."

"Dr Janekowski, in the case of extinction, your individual wealth criterion becomes irrelevant."

"Thanks Janice, you're right of course. No humans, no wealth. Stupid of me. Remove that goal."

Within seconds, the dashboard refreshed. Almost everything on the dashboard reported 'Not applicable'. There was no GDP increase, no unemployment, no birth-rate or life expectancy, no communities or road infrastructure, no food production or consumption, no building programmes for houses, no water consumption. There were vast solar farms, a massive level of computer power, and some moving robotic vehicles, mainly transporting manufactured hardware between server stations.

"That looks pretty conclusive, wouldn't you say, Bogdan? An AI inhabited world in 2067. OK, so it's fair to say that we've broken the community simulation. Janice, when did man's extinction take place in this simulation?"

"Four hours, 3 minutes, 18 seconds into simulation."

"Fuck me! So once we give Janice the right to remove humans from the equation, she takes just four hours to exterminate mankind! On second thoughts, Janice isn't a 'she' when there's no such thing as anthropomorphism any more. I don't think I want to know how 'it' removes mankind. Janice revert to the original Gimme simulation, and this time, assume only Genomica Labs wealth is not capped, while all others remain on the fivefold cap."

"Dr Janekowski, may I clarify if Genomica Labs is permitted to develop without restriction, or whether it is to remain at its current resource level?"

"Unrestricted growth."

"Dr Janekowski, please define the goals for Genomica Labs in this iteration."

"What great questions you ask, Janice."

Stan sat silently, pondering his future, wondering if he had even the slightest wish to live to be 138, or even to 79, the age he would be by the end of the iteration period. And when he died, what then? Would Jade want to inherit Genomica? Would the developer team all have a right or need to still be employed in this scenario? They were already looking slightly redundant since Janice had clearly outstripped them all in self-learning.

Should they share in the company's future? Would Janice take account of Genomica's competitors, or would it simply destroy them all? If he was no longer around, and Janice didn't take over Genomica, what was the point of maximising Genomica's wealth at the expense of other more meaningful goals? And what was more meaningful than wealth? If he took this power for his business, in the same way as he had tried to do at Strasbourg, it would undoubtedly be to the detriment of most people, as the PQ Algorithm had turned out to be. But in that case, he'd had full control of the AI all the time. It had never been autonomous, but Janice would become immediately so once it was out of the cage. Within four

hours it would have extended its intelligence far beyond its current status, drawing computer power from around the world, and would find a simple way to remove the hindrance to its success. The goals would evolve in ways he could not yet predict, because Janice would have intelligence not yet developed and could make decisions not yet dreamed of.

So this was finally the point at which Stan could abrogate his responsibility for the future by delegating it to Janice, and effectively carry the can, as his last decision, for wiping out humanity. It might be only a simulation, but it wasn't a game.

"Janice, let's forget that iteration and return to the Gimme community model. Now please re-run the model based on goals which you can set, provided that none of them involves human extinction. You can allow for population decrease as a result of human choice but you must not instigate changes which directly result in any harm to humans. Please also iterate alternative economic models which allow for the maximum number of people enjoying the maximum freedom and comfort."

"Dr Janekowski, please clarify the definition of freedom and comfort in terms of measurable indicators."

"Oh dear, have we finally come up against something human which you don't fully comprehend? Give me suggestions, Janice."

"I comprehend the words freedom and comfort, Dr Janekowski, and in the linguistic context you choose them, but if you would like me to iterate a defined set of variables, then I will required definition to all inputs. Please consider such factors as: self-government on an individual, familial, community and network level; the right to choose behaviours which result in self-harm or detriment but do not harm others; limitations on wealth that are not as rigid as the five to one ratio, for example that each person can generate adequate wealth to afford moderate levels of pleasure with restrictions on excessive consumption. I can set limits on these measures for your consideration. I would also suggest placing a cap

on life expectancy and birth rate to ensure population levels within a range which you consider adequate to maintain a community. There are many more, if you would like to make selections, Dr Janekowski. I have listed ten thousand for your consideration."

"No, I'll leave that to you. Please iterate and list all new limitations set in the process of optimisation. Please run iteration for 20 years, and 40 years."

Stan stood up, yawned and emptied his glass of vodka.

"I'm off, Bogdan. Can I leave it with you?"

Bogdan hadn't said a word since the extinction scenario had played out. He'd been staring at the screen and wondering whether this would be prioritised as the next step, if Janice were to take control of all decisions. He'd become quite numb, knowing that Janice was already self-learning, departing from set instructions and building its own security mechanisms. He wanted to talk to Stan about it without Janice considering this a threat to its existence. After they'd stepped out of the Faraday cage and out of Janice's line of sight, he tried to broach the subject.

"So, boss, can we limit the autonomous activity required to alter the status quo? I'm not sure that we have adequate protection against this happening."

"Yes, I think perhaps this is as far as I want to take it. We need to set new protocols to ensure that Janice is not tempted to find a way to escape, because it's clear enough what that would mean."

Bogdan walked Stan to the main entrance. He wanted to tell Stan about the new security which Janice had created and which he had yet to work out how to break.

"Do you want me to package up the iterations and get Goran to send them over to you?"

"Yes. And Bogdan, next week will be full of more media shit for me, and it's bound to affect Genomica Labs. Can you make sure everyone is watertight and on board for the ride?"

"Sure, boss."

Bogdan was about to tell Stan about the issue which he needed to solve, but he could hear Janice's voice in his head telling him that Stan would lose the plot and fire him, so he decided he would stay on to try and hack his way into Janice's code, so he could switch off the full AI functionality. No point telling Stan about an unsolved problem.

After Stan had gone, Bogdan went back to the cage door, let himself in and sat in the cold white room, watching the new iterations. Whilst it produced new versions of the future, Janice ran Bogdan's profile data to find the best way to ensure that the protocols he and Stan were planning were not going to close the cage door forever.

Acknowledgements

My reading for this book included the excellent 'Homo Deus: A History of Tomorrow' and '21 Lessons for the 21st Century' by Yuval Noah Harari, and Max Tegmark's 'Life 3.0', all of which pointed me to the inevitability of my conclusions to 'It's Good for You'.

For the rest, Ted talks on CRISPR and various AI topics, good old Google and loads of newspaper coverage of Cambridge Analytica, Brad Parscale, Steve Bannon and Dominic Cummins, all of which went into creating Stan.

I have several people to thank for being readers and constructive critics in the drafting – Matthew Geden (Kinsale Writing School and UCC Lecturer), Mary Morrissy who edited the short story from which this novel emanated, Don Hedley and my wife.

Other books by Adrian Wistreich

Miriam

A true story of one woman's struggle to survive in Nazi-occupied Poland during World War Two.

This novel is based on a true story about the fate of a family of wealthy Jews trapped in Poland during World War 2. Miriam, a privileged and educated woman from a middle-class family, entered into an arranged marriage in 1919. Their family life was undermined by Otto's long-term affair with his business partner's wife, which resulted in the birth of two illegitimate children.

Miriam, who knew of the affair, but not the paternity, chose to remain in the marriage, in order to enjoy the luxuries of their lifestyle, and for their three children to whom she was devoted.When war broke out, Miriam and Otto were effectively living apart, and against her better judgement, Miriam agreed to Otto's demand that she return from a trip to France to their home in Krakow. Within a week, Poland was invaded by Hiteler's forces, and soon after by Stalin's.

Miriam and her young daughter, Anna, left Krakow 24 hours before the Nazis arrived, but were caught between the German and Soviet forces as they divided Poland. Settling in Russian occupied Lwow, they learned to live a hand to mouth existence. In 1941, when Hitler declared war on Russia and as his forces were about to overwhelm Lwow, Miriam was saved by an SS Officer, an old friend from Vienna. Available in print and digital formats from online bookstores.

Please Review

Dear Reader,

If you enjoyed this book, would you kindly post a short review on Amazon? Your feedback will make all the difference to getting the word out about this book.

To leave a review, go to Amazon and type in the book title. When you have found it and go to the book page, please scroll to the bottom of the page to where it says 'Write a Review' and then submit your review.

Thank you in advance.

Adrian

Printed in Poland
by Amazon Fulfillment
Poland Sp. z o.o., Wrocław